KT-462-961

Telephone: MOUntview 3343.

RESERVE COLLECTION

HIGHGATE LITERARY & SCIENTIFIC INSTITUTION

11, SOUTH GROVE, N.6.

4386

Time allowed FOURTEEN Days.

Date Issued	Date Issued	Date Issued
30 JUN 1947	10 DEC 1977	
20 JUN 1947	14 OCT 1985	
2 JUL 1947		
9 JUL 1947		
31 JUL 1947		
24 OCT 1947		
31 OCT 1947		
-7 JAN 1948		
10 FEB 1948		
3 MAR 1948		
12 NOV 1948		
22 JAN 1949		
1 FEB 1949		
12 FEB 1949		
2 APR 1953		
7 NOV 1959		

2000.4.46

THE LIBRARY OF ENGLISH ART
GENERAL EDITOR: C. M. WEEKLEY

ENGLISH DOMESTIC SILVER

THE LIBRARY OF ENGLISH ART

General Editor: C. M. Weekley

First Titles

ENGLISH WATER-COLOURS

LAURENCE BINYON, C.H.

Lately Keeper of Prints and Drawings, British Museum

ENGLISH POTTERY AND PORCELAIN

W. B. HONEY

Assistant Keeper, Department of Ceramics, Victoria & Albert Museum

ENGLISH NEEDLEWORK

A. F. KENDRICK

Formerly Keeper of the Department of Textiles, Victoria & Albert Museum

ENGLISH DOMESTIC SILVER

C. C. OMAN

Assistant Keeper, Department of Metalwork, Victoria & Albert Museum

In Preparation

ENGLISH FURNITURE

JOHN GLOAG

Author of 'Time, Taste and Furniture', etc.

ENGLISH GLASS

W. A. THORPE

Author of 'A History of English and Irish Glass', etc.
Assistant Keeper in the Victoria & Albert Museum

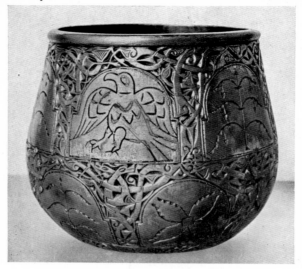

1. THE FEJØ BOWL. Early eighth century
National Museum, Copenhagen

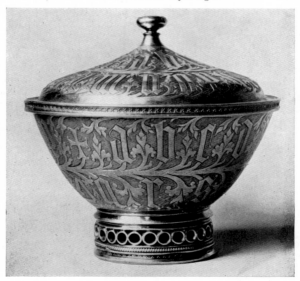

2. THE STUDLEY BOWL. Late fourteenth century
Victoria and Albert Museum

ENGLISH DOMESTIC SILVER

BY

CHARLES OMAN

KEEPER OF THE DEPARTMENT OF METALWORK
VICTORIA AND ALBERT MUSEUM

SECOND EDITION

With twenty-four pages of illustrations
from photographs
and two from line drawings

4386
739.2

ADAM & CHARLES BLACK
4, 5 & 6 SOHO SQUARE LONDON W.1
1947

FIRST EDITION 1934
SECOND EDITION 1947

The United States
THE MACMILLAN COMPANY, NEW YORK

Australia and New Zealand
THE OXFORD UNIVERSITY PRESS, MELBOURNE

Canada
THE MACMILLAN COMPANY OF CANADA, TORONTO

South Africa
THE OXFORD UNIVERSITY PRESS, CAPE TOWN

India and Burma
MACMILLAN AND COMPANY LIMITED
BOMBAY CALCUTTA MADRAS

PRINTED IN GREAT BRITAIN
BY R. & R. CLARK LTD. EDINBURGH

PREFACE TO THE FIRST EDITION

EXACTLY sixty years have elapsed since Chaffers published his pioneer work on English hall-marks, but despite the great advance which has been made in the study of English silver, it would be idle to pretend that the last word has yet been written on the subject. As long as this remains the case every writer must aim at being something more than an abbreviator of the work of his predecessors. Several subjects to which little or no attention has been paid in past books are here included, such as the section on the heraldic engraving on plate. Prominence is given to the subject of falsification.

The value of an art-book depends largely on the choice of illustrations. In the present work the minimum has been allotted to the pieces made before 1660, which do not come within the reach of the ordinary collector. The remainder show the most characteristic forms of decoration used in more recent times and the most typical shapes of those objects which are of greatest interest to the collector. One plate is devoted to illustrating the manner in which early plate was maltreated in the nineteenth century and two to the neglected subject of heraldic engraving.

The critic will soon discover that no allusion is made to many of the most celebrated examples of English

silversmiths' work. It has been felt, however, that it is unfair to refer at every turn to objects which cannot be illustrated or to works to which the majority of readers are unlikely to have ready access. It is impossible, of course, to avoid referring to objects which are not illustrated, but it is hoped that the reader in search of an illustration will usually be able to find one with the aid of the brief bibliography.

The repeated references to objects in the national collection fall into quite a different category. Whilst the reader may be excused the possession of the more expensive books, he may fairly be expected to possess or to be ready to acquire the two little books, each containing twenty photogravure plates, sold for sixpence each at the Victoria and Albert Museum and entitled 'A Picture-book of English Domestic Silver, 14th–16th century', and '17th century' (referred to in the text as P.B. I and P.B. II respectively).

Whilst providing a short introduction to the subject of the marking of plate, the writer has not felt it necessary to provide any illustrations. At best a few pages of reproductions of hall-marks in a book of the present size would be much less handy than Bradbury's pocket-book, whilst for makers' marks nothing short of the wholesale and accurate reproduction on the lines of Jackson's standard book is of any use.

The writer would like to express his deep indebtedness to the various owners of plate, both individual and corporate, who have so generously allowed him to reproduce pieces in their collections; and to the numerous individuals who have provided him with information. Thanks are especially due to his col-

leagues at the Victoria and Albert Museum, and also to Mr. Francis Buckley, Mr. A. J. Collins, Mr. A. J. H. Edwards, Miss Joan Evans, and Mr. P. A. S. Phillips.

<div align="right">C. C. O.</div>

Kensington, 1933

PREFACE TO THE SECOND EDITION

THE demand for a fresh edition has afforded the author a welcome opportunity to bring his work up to date, since English silver is a subject upon which the last word has by no means yet been written.

The bibliography now includes several important works which appeared in the years just preceding the war, whilst a book on early spoons is awaited from Commander G. E. P. How, R.N., to whom the author is indebted for a number of valuable suggestions and corrections. The author would like to express his gratitude to Mr. Frederick Bradbury and to the late Mr. E. Alfred Jones for similar help.

<div align="right">C. C. O.</div>

Kensington, 1945

CONTENTS

PART I

THE MIDDLE AGES AND THE RENAISSANCE

PART II

THE MODERN PERIOD

LIST OF ILLUSTRATIONS

xi

In the Text

PART I

THE MIDDLE AGES AND THE
RENAISSANCE

ENGLISH DOMESTIC SILVER

CHAPTER I

THE GOLDSMITH THROUGH THE AGES

NO work of art can be properly appreciated if it is considered entirely apart from its maker, and it is necessary, therefore, before approaching the subject of English domestic silver, to obtain some idea of the successive phases in the history of the craft of the workers in the precious metals.

The inclusion of what is called indifferently goldsmiths' or silversmiths' work amongst the minor arts (as opposed to the major arts of architecture, painting and sculpture) is a comparatively recent arrangement. Throughout the Middle Ages and down to the end of the sixteenth century goldsmiths ranked as highly as any other sort of artist but from the seventh to the eleventh century they had definitely been supreme.

It would be idle to pretend that the period during which the status of the goldsmith ranked highest, was also the greatest in the history of English domestic silver. Tragically few examples of the secular plate of this age have survived and contemporary records clearly show that the works of greatest importance were made in the service of the Church. This does not, of course, imply that the rich altar frontals, shrines and chalices which were made for wealthy abbeys were usually the work of monkish goldsmiths. A certain number of goldsmiths appear to have entered monasteries during the

3

earlier part of the Middle Ages whilst monasticism still held a strong appeal for the popular imagination, but there is little evidence that skill as a goldsmith was often acquired by those who had already entered the cloister. The number and importance of goldsmith monks must not be exaggerated even though, in the remoter periods, their names have been recorded by monastic chroniclers more often than those of their lay contemporaries with whom they worked side by side in the abbey workshops. From the twelfth century, when Government records come to supplement monastic chronicles, we begin to see clearly how small is the number of the known monastic goldsmiths as compared to the lay.

It is important, then, to realise that the ordinary goldsmith, even in the early Middle Ages, was not a monk vowed to a life which relieved him of the normal cares of the struggle for existence but a layman following a highly skilled profession, of economic importance, and accounted remunerative. Since precious metals formed the raw materials of the goldsmith's craft, it was always necessary that those who followed the profession should possess business as well as artistic talent. As a consequence the medieval goldsmith frequently did not confine himself to the production of plate and jewellery but dabbled in many lucrative side lines. Like the members of several of the other richer crafts they often acted as pawnbrokers. Their administrative, as well as their technical and artistic capacity, made them especially useful to the Crown, particularly during the twelfth and thirteenth centuries when the machinery of government was becoming rapidly more complicated. At this time we find the royal goldsmiths not only providing the King with costly works of art but administering the

mints and exchanges and supervising the erection and decoration of the royal buildings.

It is not, therefore, surprising that as early as 1180 the London goldsmiths should have had a gild of their own, for which they were fined the sum of 45 marks (which they probably never paid), because it had been founded without the royal licence. It was not, however, until 1327 that they received their first charter from Edward III. It particularly ordained that the gold-smiths should all have their shops in the High Street of the Cheap (where the majority were already established) and that no silver or gold should be sold elsewhere in London than in the King's Exchange or the Cheap. Complaint had been made that there had been gold-smiths working in obscure streets where, being free from supervision, they were able to buy and melt stolen plate and to manufacture new plate of base alloy which they were able to pass off on unwary customers. Of their later medieval charters that of 1462 is of great importance. In it the company was not only granted the use of a common seal but was entrusted with the super-vision of the craft throughout England with power to punish offenders. Of the history of hall-marking we shall speak in a later chapter.

As a body it always ranked amongst the most power-ful of the London gilds. In 1267 the Goldsmiths had their celebrated battle against the Taylors in which five hundred men are said to have been engaged (including those unattached to either gild) and which resulted a few days later in the hanging of a number of the com-batants who had had the misfortune to be apprehended. Similar incidents are reported in later years. Numeric-ally it never ranked amongst the greater gilds. In 1477

its membership was 198, including 41 foreigners, but in 1483 it had sunk to 149. In 1469 it was called upon to provide 100 men for the city watch, seven other companies having to provide a larger number. On the other hand seventeen goldsmiths had acted as lord mayor before the year 1524, several of whom had held office on more than one occasion.

Amongst the more peaceful and picturesque activities of the goldsmiths was their devotion to St. Dunstan, who in his lifetime had certainly been a good patron of their craft and whom his Post-Conquest biographers credited both with a practical knowledge of their art and with the celebrated victory over a devil. In the saint's honour the goldsmiths kept a light in the church of St. John Zacchary which remained the centre of the goldsmiths' quarter up to the seventeenth century. On St. Dunstan's Eve and twice on his day the members of the company went in procession to St. Paul's in which was a chapel dedicated to their patron, and sustained themselves with a dinner in his honour at which was used a cup surmounted by his effigy. These functions came to an end at the Reformation, and in 1547 is recorded the destruction both of St. Dunstan's Cup and of the silver-gilt figure of the saint which adorned Goldsmiths' Hall.

The history of the gild during the Renaissance was a checkered one. The latter part of the sixteenth and the early years of the seventeenth century saw a return of corporate prosperity but in 1627 the company was forced to sell plate to the value of £407 in order to pay its contribution to a forced loan which the King had levied on the City. During the Civil War period Goldsmiths' Hall became the Parliament's exchequer.

Besides its routine work of preserving the standard

and purity of gold and silver work, the principal activity of the company during the Renaissance seems to have been a struggle to preserve the trade as far as possible in English hands and to limit the intrusion of foreigners—a matter to which we will have to recur later. In 1571 it was enacted that no craftsman might become a master until he had produced a 'masterpiece'. The type of object to be made was not prescribed, as it was by some German gilds, and no piece made for this purpose has ever been identified. The custom had apparently fallen into disuse by 1607 when it was re-enacted with the professed aim of raising the standard of general proficiency amongst young craftsmen who, it was complained, were tending to specialise in the making of certain objects or the use of certain techniques and thus compared unfavourably with foreign workmen. It is unlikely that this order had more than a transient effect as the tendency to specialise certainly did not disappear.

Though the fortunes of individual goldsmiths could not remain unaffected by the political and religious changes, the times were certainly propitious. The prosperity of the London goldsmiths was shared by their provincial brethren whose gilds began to function with much greater efficiency than previously. The tendency for goldsmiths to seek prosperity outside the stricter limits of their profession became increasingly marked. Thus in 1589 John Spilman, a German, obtained a licence to set up a paper-mill at Dartford, whilst in 1609 Hugh Myddelton undertook the construction of the New River to supply London with water. The important part played by goldsmiths in the development of banking in this country was largely the unexpected result of

the seizure by Charles I in 1640 of the deposits of the precious metals which they and other merchants had been wont to store for safety in the Tower. This tyrannical act obliged goldsmiths henceforth to assume the responsibility for the keeping of their own reserves and forced them to construct strong-rooms in their houses. Before long they began to accept for safe-keeping the money of their clients who at first paid for this privilege but soon began to receive interest in return for permitting the goldsmith the temporary use of their deposit.

When, with the Restoration, we enter the modern period in the history of English domestic silver we find the craft definitely fallen in popular esteem from its place amongst the major arts. This decline was for a time obscured by the important part played in the national affairs by the goldsmith bankers, but when the two professions became distinct in the eighteenth century the change in the status of the goldsmith is evident. The goldsmith, however great his artistic proficiency, had become no more than a superior craftsman or a prosperous tradesman. An increasing tendency towards specialisation is visible both amongst firms and craftsmen, though much elasticity remained even to the end of our period. The decline in the social status of the goldsmith did not signify any decrease in the demand for his service and there can be no doubt of the general prosperity of the trade.

Another change which dates from the end of the seventeenth century is the gradual decline in the importance of the Goldsmiths' Company in common with all the other City gilds. In 1679 the author of *The Touchstone* bewails the number of goldsmiths who chose

to be members of other companies. The Goldsmiths'
Company, however, no longer excluded members of
other crafts so that it is not surprising that it should
gradually have come to take less and less interest in
trade matters. It is not improbable that its prestige with
members of the trade suffered at the close of the seven-
teenth century, from its inability to obtain from the
Government any species of protection for the native
craftsmen from the competition of the Huguenot gold-
smiths who settled in this country in large numbers in
the years following the revocation of the Edict of
Nantes. Though at first the Company returned sym-
pathetic answers to those who petitioned them to take
action against the invaders, it became obvious after the
Revolution that it was useless to attempt to persuade
the Government, which owed its existence to the de-
position of a Catholic king, to take action against
industrious foreigners who had been driven from their
country because they were Protestants.

Even though the collection of the revenues of the
Company's estates would appear to have been the main
interest of the members during the eighteenth century,
we must not overlook the fact that at this same period
the efficiency of the assay-office was greater than ever
before.

CHAPTER II

THE MIDDLE AGES

THE use of domestic silver in the first half of the seventh century is attested by Bede, who records that St. Oswald, King of Northumbria, was served with food in a silver dish. A charter of Bertulf, King of Mercia, records the gift in the year 801 of a large and finely worked silver dish to the Cathedral of Worcester, whilst amongst the extensive presents of plate made by Athelstan in 934 to the shrine of St. Cuthbert were two silver covered cups.

Though it is probable that plate never descended very far in the social scale in Anglo-Saxon England, it is likely that its use was as widespread in this country as anywhere else in Western Europe. There can be little doubt that the upper classes were well acquainted with the use of plate in the tenth and eleventh centuries. Ethelgiva (*d.* 985), wife of Earl Aylwin who founded Ramsey Abbey, is recorded to have presented its refectory with 'two silver cups of twelve marks according to the weight of the husting of London'. William of Poitiers, when speaking of the spoils taken home by the Normans after the conquest of England, says 'the vessels of silver or gold were marvelled at, of which the number and decoration would be impossible to relate'. He adds that the English were great drinkers and favoured especially ox-horns tipped at each end with

metal. These drinking-horns are clearly depicted in the scene of Harold feasting in the Bayeux Tapestry. The Sutton Hoo ship-burial, discovered in 1939, yielded the British Museum the silver mounts of six to nine horns dating before the middle of the seventh century but no complete silver-mounted horn is yet known.

It is impossible to give with any certainty a list of the few surviving pieces of Anglo-Saxon domestic silver (excluding for the moment spoons), since a Continental origin has been claimed for all of them. A bowl in the Yorkshire Museum, York, which was found at Great Ormside, Cumberland, is certainly amongst the most interesting survivors. It is probably North English work of the beginning of the eighth century and is of silver and copper-gilt, embossed with birds and beasts and studded with enamelled bosses. Still more attractive is the nielloed silver bowl from Fejø (Frontispiece, 1) in the National Museum, Copenhagen. Its decoration of birds and beasts with fantastic interlacing seems to indicate that it was made in the south of England towards the end of the eighth century. An embossed silver bowl from Ribe in the National Museum, Copenhagen, a second from Halton Moor, Yorkshire, and a third with a cover, both in the British Museum, are perhaps more probably of Continental origin and are dated variously from the ninth to the beginning of the eleventh century.

A number of silver spoons of different dates and very various designs have been discovered. A little two-pronged fork in the British Museum, found at Sevington, Wiltshire, suggests a greater refinement than might be expected at the end of the ninth century when it appears to have been made.

11

However uncertain may be the extent of the use of domestic plate before the Norman Conquest, there can be no doubt that there was a steady increase in its popularity during the succeeding centuries. Plate was acquired not only to serve the everyday needs of the purchaser but also from other motives.

The custom of giving presents of plate, often indistinguishable from bribes, to important persons appeared early. Already at the end of the thirteenth century the accounts of the wealthy and aristocratic cleric Bogo de Clare, who was notorious in a lax age for the number of livings which he had accumulated, show that in six months of the year 1285 he spent £21 : 4 : 8 on seven silver cups for presentation. In 1371 the City of London presented the Black Prince with a handsome gift of plate costing £173 : 8 : 11 on his return from Aquitaine. The position of a royal duke naturally entailed huge goldsmiths' bills as may be judged from an order signed on 13 April 1373 by John of Gaunt at his palace of the Savoy. The delivery of the following handsome presents is commanded—to his brother the Black Prince and to his wife a gold cup each, to four other notables a silver-gilt cup apiece and to one a ewer as well, to another a silver box with the arms of England and Castille, all the work of the celebrated goldsmith Sir Nicholas Twyford. Two other persons received a silver-gilt cup and a ewer made by John Chichester, two more got a silver-gilt cup each by Thomas Rainham, whilst another two each received a silver-gilt cup by an unnamed goldsmith.

The extent to which the love of collecting plate was carried at the close of the Middle Ages can be traced in the inventory of the plate of Sir John Fastolf, taken

after his death in 1459. He was a Norfolk man who had succeeded in accumulating a considerable fortune partly as a result of his distinguished services in the French Wars thirty years earlier, and partly through a fortunate marriage with a rich widow. His domestic silver weighed no less than 1175 lb. troy, whilst his chapel plate contributed another 110 lb. Hardly less impressive is the detailed list of plate in the will prepared in 1509 by John de Vere, 13th Earl of Oxford, from which it appears that he possessed 1116 lb. troy of domestic silver as well as 108 lb. in the form of plate for his chapel. The inventory of royal plate composed in 1520 gives us a still more vivid impression of the wealth of goldsmiths' work which then abounded in this country. Henry VIII was, indeed, a hardened and unscrupulous collector, as is shown by the number of items which are catalogued as having been forfeited on the execution of the Duke of Buckingham ('Ducke of buck') and by those formerly belonging to his Boleyn 'in-laws' and to Wolsey which appear in the inventories of 1532 and 1550 in the Renaissance period.

The accumulation of plate was not entirely due to love of ostentation. Until about a hundred years ago the family plate was regarded merely as a reserve of capital which could be easily realised in an emergency. Such a realisation almost inevitably consigned the plate to the melting-pot unless circumstances allowed it to be pledged. The forced loans which the Tudor and Stuart sovereigns repeatedly levied on the City formed a constant drain on the resources of the city companies which was very detrimental to their collections of plate. The Great Fire not only was the direct cause of the destruction of the plate of several companies but brought

about the sacrifice of that of others in the cause of re-
building the halls which had been destroyed. More
spectacular was the general melting of plate which took
place during the Civil War and under the Common-
wealth, when vast hoards of plate belonging to owners
whose economic stability in ordinary times would have
been assured, were sacrificed voluntarily or involuntarily
in the form of loans to support the cause of King or
Parliament. On this occasion the collecting of plate
was systematic and ruthless, the contributions varying
according to the wealth of the owners from the $106\frac{1}{4}$ oz.
'lent' to the Parliament by the gentry of the lathe of
Aylesford, Kent, to the 1610 lb. provided for the King's
use by twelve of the Oxford colleges.

It has frequently been assumed that this tragedy had
been foreshadowed in the fifteenth century by a general
melting of baronial plate during the Wars of the Roses,
and this assumption has generally been accepted as the
explanation of the present rarity of early medieval silver.
There does not appear to be any evidence to support
this contention and it may be taken for certain that
plate which was melted at this time must have been
illegally sold abroad as bullion and not coined into
money as it was in the Civil War. The Wars of the
Roses saw the opening of no emergency mints and the
surviving accounts of the London mint suggest no
extraordinary activity. Of course some plate must have
been destroyed and much must have changed hands,
especially during the frenzied weeks between Wake-
field and Towton, but the greater rarity of the plate of
the earlier Middle Ages as compared with that of the
fifteenth and sixteenth centuries must be explained
otherwise.

After all, the survival of nearly all the extant examples of plate of the latter period is due not to having been treasured as family heirlooms but to their presentation at an early date to some college or city company which managed to preserve them through the vicissitudes of the sixteenth and seventeenth centuries. The universities successfully avoided being involved in the Wars of the Roses and the citizens of London intervened as little as possible. Fate ordained that the two colleges which have preserved most of their plate (Corpus Christi College, Oxford, and Christ's College, Cambridge) should have been founded and richly endowed early in the sixteenth century. Had the choice fallen on two other colleges of earlier foundation the result might have been different.

On the other hand the immense realisation of capital which occurred on the Dissolution of the Monasteries must have consigned to the melting-pot immense quantities of domestic plate from the monastic refectories and abbots' dining-halls. Much of this must have belonged to the early Middle Ages. The abbeys were already wealthy in the thirteenth century when the city gilds were still in their infancy and most of the colleges as yet unfounded. Many of the abbeys, moreover, were at the time of the Dissolution not nearly as prosperous as they had once been, so that it is probable that what plate they retained was mostly old.

Much more deadly to the preservation of plate than the extravagances of reckless heirs and the exactions of needy governments have been the ravages occasioned by the changes of fashion. The idea that the masterpieces of the past were heirlooms to be handed down to succeeding generations is of comparatively recent

growth and plate was particularly late in attracting the attention of the antiquarian collector. The illogicality of the situation in regard to plate was realised in the early eighteenth century by Matthew Prior who writes in his 'Alma':

My copper-lamps at any rate,
For being true antique, I bought:
Yet wisely melted down my plate,
On modern models to be wrought:
And trifles I alike pursue,
Because they're old, because they're new.

A careful examination of the lengthy accounts for the plate made by or through Robert Amadas for Cardinal Wolsey between 1517 and 1530 shows that nearly all was made from unwanted pieces of domestic and religious goldsmiths' work. The callousness with which the destruction of old-fashioned plate was regarded is further illustrated in the account given by George Cavendish, Wolsey's gentleman-usher, of the plate sacrificed by his master to regain the King's favour after he had resigned the Great Seal on 18 November 1529. He says: 'In the Gilt Chamber was set out upon tables nothing but all gilt plate; and a cupboard standing under a window, was garnished entirely with plate of clean gold, whereof some was set with pearl and rich stones. And in the Council Chamber was set all white plate and parcel-gilt, and under the tables, in both chambers, were set baskets with old plate, which was not esteemed but for broken plate and old.'

It is probable that the destruction of medieval plate was particularly severe about this time. A number of items which appear in a list of royal plate sent to be melted in 1533, can be recognised as having been in

existence for a comparatively short time but because they had probably been made in the Gothic style they were already considered as out-of-date.

When we consider the powerful incentives which have contributed to the destruction of old plate, we cannot but be grateful to those who, from diverse and often obscure motives, have helped to preserve what remains. If we owe much to the indolence and lack of economic sense which urged some of our ancestors to cling to their old plate or that of the community to which they belonged, we must also allow that certain of them laid a certain value on the historic associations connected with some of their treasures. The fact that an object was a gift from some celebrated person of the past was unfortunately not always enough to secure its preservation. Those who felt some compunction at the destruction of a piece with historic associations were often content to compromise with their consciences and whilst consigning it to the melting-pot, to register a vow to replace it with a piece of similar value (which meant weight) when the opportunity occurred. It not at all infrequently happens that a piece which is inscribed as having been presented on some particular occasion is demonstrably of later date and may even be found to bear a hall-mark perhaps even of the nineteenth century. The earliest surviving instance of this practice is the Pusey horn, of which we shall have to speak, but the instances of this species of falsification in more recent centuries are innumerable.

After an examination of a quantity of medieval wills and inventories, it will be found that on the whole the range of utensils made in the precious metals was comparatively small. In nearly every inventory of the plate

of persons of exceptional wealth unfamiliar items will be found but ordinarily the plate of baron and merchant differ from each other only in quantity.

Drinking-vessels form the largest item (*beakers, bowls, cups, goblets, godets, hanaps, mazers, peces,* etc.— names about which it is not always safe to dogmatise). The rest usually consists of rosewater ewers and basins, salts, spoons, candlesticks, dishes, pots and spice-plates. As there are no surviving examples of the last four items we shall not be troubled with them.

The form of most of the drinking-vessels in use during the Middle Ages may be classified roughly into two classes—those deriving from the beaker and those deriving from the bowl.

It has been suggested that the beaker originated from the use of a straight section of an ox-horn with one end stopped up. The use of beakers can be traced in this country to the eleventh century by means of manuscript illustrations. By the fourteenth century they appear to have become very popular and several are depicted in the Louttrell and 'Queen Mary' psalters. Beakers are mentioned in a York will of 1346 and in the accounts of the treasurer of Edward Prince of Wales in 1348.

Since this book first appeared the writer has helped to show that the mark on the beaker given by Bishop William Bateman (*d.* 1354) to Trinity Hall, Cambridge, proves that it was made at Avignon. The number of medieval beakers is therefore three, since a recent attempt to claim an English origin for the 'Founder's Cup' of Oriel College must be resisted.

All three English beakers belong to the close of the Middle Ages and differ in pattern. The earliest is in the

possession of Lady Louis Mountbatten and bears the hall-mark for 1496.[1] It is a delightful little vessel of silver-gilt, standing only $3\frac{1}{4}$ inches high and having the lower part of the side decorated with curious projecting vertical ribs.

Of still less ambitious proportions but equally attractive is the small beaker $2\frac{1}{4}$ inches high, which formed part of the Pierpont Morgan Collection. Its exterior is decorated with the scale pattern popular about the time when it was made in 1525.

The only medieval beaker of ambitious proportions is the one of 1507, which was one of the rich pieces of plate with which Lady Margaret Beaufort, mother of Henry VII, endowed Christ's College, Cambridge, which she had founded. It stands $9\frac{1}{2}$ inches high, and consists of a shaped base formerly set with precious stones, a spreading drum engraved with a trellis studded with marguerites and enclosing Tudor roses and portcullises, and a cover similarly decorated and surmounted by a knop framed by six portcullises from which sprout four marguerites.

The one standing cup which derives its shape from the beaker is of no less importance. The so-called 'King John Cup' belonging to the Corporation of King's Lynn, dates from about the middle of the fourteenth century. It is 15 inches high (including the finial which is not original) and both cup and foot are decorated in

[1] Except when it is specially stated to the contrary, all objects described as being hall-marked in the following pages must be understood to have been assayed in London. As will be explained in Chapter VII, the date-letter is changed in May, so that to be accurate the present object should be described as being of the year 1496–97 but it seems simpler to use the shorter form as above. In order to avoid the frequent repetition of the word 'hall-marked' in the following pages, many objects are referred to as 'of the year'. When an object is described as 'dated' it should be understood to be unhall-marked.

translucent enamel with figures of men and women in hunting costume. Though the enamel is recorded to have been repaired on four occasions during the seventeenth and eighteenth centuries, the cup is still one of the most interesting examples of English medieval art.

Drinking-bowls of silver were, as we have seen, used in Anglo-Saxon times and continued to be made down to the end of the sixteenth century. No examples of later medieval date have survived unless we include here the celebrated Studley Bowl (Frontispiece, 2) of admittedly doubtful use. Nothing is known of its history except that it was used as an alms-bowl at Studley Royal Church, near Ripon, for some forty years before it was given to the Victoria and Albert Museum. It consists of a gilt bowl and cover engraved with foliage which separates the letters of the alphabet (with *j*, *u* and *w* wanting) and certain alternative forms and contractions consummately executed in the old English script of the late fourteenth century.

The more popular, though less highly esteemed, form of drinking-bowl was the mazer. The word mazer belongs to the same root as the old High-German *masa*, meaning a spot, and the bowls received their name from being made of the spotted wood of the maple. We are here concerned only with the mazers mounted in silver, others were mounted in gilt metal or not mounted at all. The usual silver mounts of a mazer were a band round the lip and a circular medallion in the bottom of the inside of the bowl which was usually referred to as the 'print' or 'boss'. The importance of the piece was sometimes increased by the addition of a foot. Covers were not unusual though very few have survived.

The earlier mazers, those made from the fourteenth

PLATE I

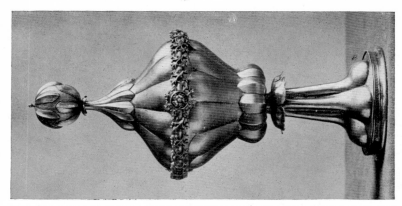

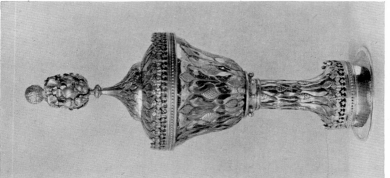

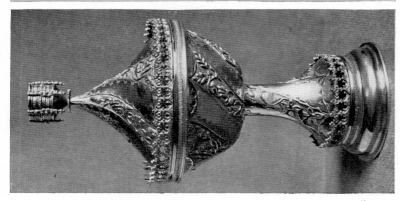

PLATE I

3

THE FOUNDRESS'S CUP

Gilt.

No marks.

1435–40.

Height, 12¾ in.

Christ's College, Cambridge.

4

THE WARDEN'S GRACE CUP

Gilt.

No marks.

About 1480.

Height, 15¾ in.

New College, Oxford.

5

THE RICHMOND CUP

Gilt.

Maker's mark, *a wreath.*

About 1500.

Height, 12½ in.

Armourers' and Brasiers' Company.

to the early years of the fifteenth century, are usually deep and have narrow lip-bands, whilst the later examples are shallower but have wider bands which help to increase their capacity. The band naturally lent itself to an inscription and was usually so decorated. Some inscriptions are religious, some magical, whilst others try to point a moral as on the late fourteenth-century Rokewode Mazer (P.B. I, 2 [1]) in the Victoria and Albert Museum, which reads:

> Hold ȝoure tunge and sey þe best
> and let ȝoure neȝbore sitte in rest
> Hoe so lustyþe god to plese
> let hys neyȝbore lyve in ese.

The prints are very variously decorated. Two early fourteenth-century mazers belonging to Harbledown Hospital, near Canterbury, have silver-gilt prints embossed in one case with a fight between a lion and a dragon and in the other with Guy of Warwick spearing a dragon. The late fifteenth-century mazer belonging to Fairford Church, Glos., has a print set with a crystal, a material which was supposed to help to detect poison. Most prints, however, consist of a medallion enriched with translucent enamel depicting a saint, a religious device, a coat-of-arms or a floral motif. The mazer presented towards the end of the fourteenth century by John Northwode to Corpus Christi College, Cambridge, is most unusual. The place of the print is taken by a hexagonal silver-gilt column with a battlemented top surmounted by a swan. The column is pierced at its base

[1] The references P.B. I and P.B. II denote respectively the 'Picture Book of English Domestic Silver, 14th–16th century' and the 'Picture Book of English Domestic Silver, 17th century', produced by the Victoria and Albert Museum. Each contains twenty pages of photogravure illustrations and costs sixpence.

and contains a tube which rises to within a short distance of the top. By this device the bowl can never be completely filled as the liquid begins to pour out at the bottom as soon as the level of the top of the tube has been reached. A mazer with a similar battlemented column, presented to St. Albans Abbey in 1431, is illustrated in a book of benefactors of that house.

Although there survive rather fewer than fifty medieval mazers, their erstwhile popularity may be gathered from the fact that in 1328 the refectory of Christ Church, Canterbury, possessed 182, in 1437 that of Battle had 32, in 1446 that of Durham had 49, whilst at the Dissolution that of Westminster had 51. It must always be remembered, however, that the mazer was the drinking-vessel of the well-to-do rather than the wealthy.

We must now approach the bowl-shaped drinking-vessels which are equipped with feet. A few mazers are so treated of which perhaps the finest is of the year 1529 and belongs to All Souls College, Oxford. Though with a gadrooned stem and spreading circular stem characteristic of late medieval silversmiths' work, it has also a band of cast openwork showing masks and floral swags which show that renaissance ornament was already beginning to be studied.

Two silver drinking-bowls equipped with feet may be mentioned. The first was formerly used as a communion cup at Kimpton Church, Hants, but was acquired recently by the Victoria and Albert Museum. It is gilt and stands 4 inches high and consists of a hemispherical bowl on a spreading base with a band of pierced quatrefoils. The bowl used as the communion cup at Marston Church, Oxon, is very similar except

that it is not gilt with the exception of the three standing hounds which act as feet and add an inch to its height. Both bowls belong to the latter half of the fifteenth century.

Manuscript illustrations show that the most popular form of covered standing cup in the thirteenth century had a rounded bowl, a stem with or without a knop and a fair-sized spreading foot. The cover resembled an inverted bowl and was surmounted by a finial. The earliest surviving standing cup which derives its form from a bowl, is the Foundress's Cup of Christ's College, Cambridge (Plate I, 3). Though presented to the college by Lady Margaret Beaufort, it must have been made between 1435 and 1440, as inside the bowl it has an enamelled print with the arms of Humphrey, Duke of Gloucester, and those of his wife. The whole is most attractively decorated with spiral bands, alternately plain and embossed with sprays of oak, vine and rose.

The prevailing form of bowl shown on the surviving standing cups of the late fifteenth and early sixteenth centuries, resembles an inverted bell. The cover slopes gently upwards to an elaborate knop. This pattern can certainly be traced back to 1417 when Simon Patrington, Bishop of St. Davids, bequeathed a 'silver gilt cup in the form of a bell, with its cover'. Only two examples need be mentioned of which the Warden's Grace Cup of New College, Oxford (Plate I, 4), is the more important. It is most effectively decorated with a species of pineapple ornament, whilst the knob consists of leaf-work surmounted by a melon. It must date about 1480 since the 'Anathema Cup' of Pembroke College, Cambridge, bears the hall-mark for 1481 and is an unornamented example of much the same design. This last

was presented to the college in 1494 by Thomas Langton, Bishop of Winchester, and formerly a fellow. It owes its name to the inscription "qui alienaverit anathema sit". The cover which it is recorded to have possessed has long since disappeared.

The beautiful Richmond Cup (Plate I, 5), belonging to the Armourers' and Brasiers' Company, is of quite a different form and is usually dated about 1500. It is attractively decorated with gadrooning and the curious shape of the bowl suggests a flower rather than an inverted bell. It was probably to cups of this shape that the name 'columbine' was applied in wills and inventories from the fourteenth to the sixteenth century. Amongst the royal plate pledged in 1383 to the *condottiere* captain Sir Robert Knollys, was a great hanap of gold in the form of a columbine, enamelled inside with the king sitting in a ship. In the will of Thomas Champnes, of Frome, who died in 1505, is mentioned 'a pece of silver and gilt called a Colymbeine pece' and in the Wolsey inventories is 'oone standing Pece with a Cover like a Cullombine'. At any rate the shape of the cup in question is much more like that of the columbine flower than the German cups known by this name.

The last type of medieval cup deriving from the bowl, to which we must refer, made its appearance at the very beginning of the sixteenth century and remained in vogue for some eighty years. The characteristics of this group, a low moulded foot and a short straight-sided bowl, have aptly earned it the name of 'font-shaped'. The covers (when they are used) are nearly flat and have a knob with flattened top suitable for a coat-of-arms. The design is a particularly pleasing one and all the seven medieval cups of this design are

masterpieces of artistic taste, although differing considerably in detail from one another. The Victoria and Albert Museum is fortunate in the possession of the earliest example (P.B. I, 4) which belonged to the Sussex family of Campion and was made in 1500. It has no cover and the side of the bowl is engraved with Soli Deo Honor et Gloria, divided by pomegranates and with a flower at the beginning. The Goldsmiths' Company owns the Cressener Cup of 1503, which is still simpler as it is practically undecorated except for the enamelled arms on the cover, of Sir John Cressener who obtained his knighthood for his services at the siege of Tournai in 1513. A strong contrast to it is provided by the cup of 1515 belonging to Corpus Christi College, Oxford, which has an all-over pine-apple decoration and a knob engraved with a Tudor rose.

Besides these standard varieties of drinking-vessels, a considerable range of fancy ones was used. Although silver-mounted drinking-horns had been in general use in Anglo-Saxon times, references to them in later medieval wills and inventories of plate are relatively uncommon. Four, indeed, appear in the 1420 inventory of Battle Abbey but such a number is exceptional. It may be surmised that their use had become confined in polite society to ceremonial occasions. An indication of this is given in the will of William Carent, a Somersetshire squire who died in 1406 and bequeathed 'a horn with cover of silver and gilt in which I was accustomed to drink on the Feast of the Nativity of Our Lord'.

Only five medieval drinking-horns have come down to our times. These, unlike the earlier examples, are equipped with feet so that they could be set down. The small end of the horn is always finished as a head, some-

times that of a man, at others that of a monster. Three
of the survivors, those belonging to Corpus Christi
College, Cambridge, Queen's College, Oxford, and
Lord Lee of Fareham, have been mounted in the four-
teenth century, whilst those belonging to Christ's
Hospital and to the Victoria and Albert Museum have
been so treated in the fifteenth. This last is traditionally
said to have been given by Cnut to William Pusey to-
gether with the manor of that name as a reward for
having saved him from a surprise attack by the Saxons.
On the fifteenth-century silver band to which are
attached the legs, is inscribed:

> I Kyng knoude geve wyllyam peuse
> thys horne to hold by thy lond.

Whilst the use of drinking-horns was hallowed by
tradition, that of silver-mounted coconut-shells appears
to have arisen when these objects were little known in
this country and were esteemed for their rarity. There
seems to have been also, at any rate in the seventeenth
century, some idea that wine drunk from them acquired
medicinal properties. In John Parkinson's *Theatrum
Botanicum* (1640) it is mentioned that they were credited
with protective powers against colic, epilepsy and
rheumatic disorders.

The first mention that has been found of a coconut
cup occurs in a Durham will of 1259 but none of the
surviving examples can date before the middle of the
fifteenth century. Their popularity seems to have in-
creased towards the close of the Middle Ages and no
fewer than eleven occur in an inventory of the plate of
Winchester College taken in the reign of Henry VIII.
A number survive, chiefly in the possession of Oxford
and Cambridge Colleges, owing their preservation

PLATE II

6

WARDEN HILL'S SALT

Gilt.
No marks.
About 1490.
Height, 14½ in.
New College, Oxford.

7

THE HOWARD GRACE CUP

Ivory, with gilt mounts set with pearls and garnets.
Maker's mark, *three implements crossed.*
Hall-mark for 1525.
Height, 12½ in.
Victoria and Albert Museum.

8

THE BOLEYN CUP

Gilt.
Maker's mark, *a mount of lilies* (?).
Hall-mark for 1535.
Height, 12½ in.
Cirencester Church.

PLATE II

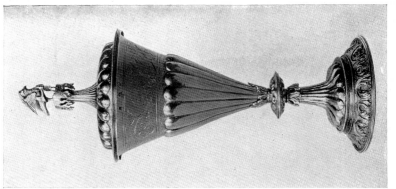

8

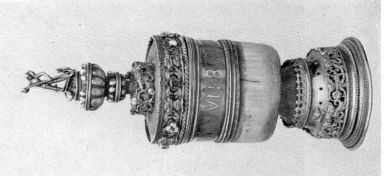

7

6

chiefly, as in the case of mazers, to the fact that the amount of silver used in their mounting was not sufficient to make them worth breaking up except when times were particularly severe. Their mounting usually consists of a foot resembling that of a standing cup, which is joined to a lip-band by three or four vertical strips.

The two finest coconut cups both belong to New College, Oxford, and date about 1480. One is fashioned like an oak growing within a fenced enclosure. Around the trunk are rabbit-holes but the rabbits have unfortunately all disappeared. The tree extends upwards five branches which hold the nut and join the lip-band. The other is more conventional. Its wide lip-band is inscribed with the words of the Angelic Salutation. Three pierced straps secure the nut to the spreading base which is richly decorated and is supported on three feet in the form of angels holding scrolls with AVE MARIA. A few examples have covers.

The importance attributed to the salt in medieval times is so well known that it is unnecessary to say much about it here. The normal usage with regard to the salts can be gathered from the fifteenth- and sixteenth-century books of 'curtesy' and 'nurture' and we may quote a passage from Wynkin de Worde's *Boke of Kervynge* (1508): 'Set your salt on the ryght side where your soverayne shall sytte . . . and at every ende of yᵉ table set a salte sellar . . . and when your soverayne's table is thus arayed, cover all other bordes with salts trenchours & cuppes'.

The allowance of silver salts for the high table, it will be noticed, was small and it is unlikely that it would be more generous for the lower tables. There is some

indication that the salt increased in importance as the Middle Ages drew towards their close. The salts captured with Piers Gaveston in 1313 weighed only 11, 11, 8 and 6 ounces, the last one being of gold. During the fifteenth and early sixteenth centuries the weights run much heavier and the lightest weights given in some of the largest inventories are almost as heavy as those given above. Of the nine salts in the imposing list of plate belonging to Sir John Fastolf (*d.* 1459), all, except one which weighed 5 ounces, were obviously large and decorative pieces. Of the twenty salts in the equally impressive will of the Earl of Oxford, drawn up five years after the appearance of the *Boke of Kervynge*, there are only four which weigh as little as those taken with Gaveston.

It is much to be regretted that a quite unnecessary complication has been added to the study of the records of medieval salt-cellars by the fact that Jackson and others have not realised that *salsarium* (saucer) is not the same as *saleria* or *salerium* (salt-cellar).

The scarcity of salt-cellars was naturally a great strain on the good breeding of the young and the books of 'curtesy' and 'nurture' express themselves strongly on the habit of dipping the meat directly in the salt-cellar, instead of having removed some salt from it previously with a clean knife. The *Babees Bok* (about 1475) expresses itself thus:

> The salte also touche nat in his salere
> With nokyns mete, but lay it honestly
> On your Trenchour, for that is curtesy.

It is very much to be regretted that we know nothing of the standard patterns of medieval salts used before the middle of the fifteenth century. The adjectives

applied to them in wills and inventories, such as square
or round, are useless and when we do get an explicit
description, it is clear that the object is a fancy one.
Illuminated manuscripts do not help in this connection
as it is not really possible to distinguish in dining scenes
a covered salt from a covered cup.

The normal type of salt in use during the latter part
of the fifteenth and the first quarter of the sixteenth
century was shaped like an hour-glass. At present ten
examples appear to be known, all of which originally
had covers, of which some are now lost. Indubitably
the finest is the example given by Walter Hill to New
College, Oxford (Plate II, 6), of which he was warden
from 1475 to 1494. Its general appearance can be
gathered from the illustration but it may be noted that
the triangular panels in the cover are filled with purple
glass with a diaper pattern.

Of much the same date is the hexagonal salt made
for Bishop Fox, founder of Corpus Christi College,
Oxford, whilst he was Bishop of Exeter, 1487–92. It is
decorated with openwork panels depicting pelicans
(chosen from the bishop's arms), hounds, hares and
stags. The knop has six panels each reproducing a
group of the Coronation of the Virgin and the cover is
surmounted by a knob of stags and of pelicans holding
pearls. Although the design is pleasing enough the
standard of execution falls below the average maintained
by English medieval goldsmiths.

Of the remaining eight hour-glass salts, six are of
sexfoil form and range from about 1500 when the two
examples at Christ's College, Cambridge, were made,
to 1522, the date of the second of the pair belonging to
the Ironmongers' Company. An extremely interesting

example of 1508, in private possession, which made its appearance comparatively recently, is decorated with the mermaid badge of the Berkeley family and is of octofoil design. The last reminiscence of the hour-glass shape is seen in a salt-cellar of 1522, belonging to the Goldsmiths' Company, the detail of which is entirely in the Renaissance style.

The use of salts in fancy shapes became popular in the later Middle Ages. Amongst those mentioned in the royal inventories are a salt in the form of a crowned falcon with a collar of SS, and one in the form of a dragon issuing from a whelk-shell (1399), two in the form of a man and a woman holding the receptacles for the salt in their hands (1439), one in the form of a castle with four salt-cellars at the corners (1450), one in the form of a man wearing a kendal hood standing on a base enamelled green and white (1461), one in the form of a mermaid holding a crystal receptacle, and another with a cover 'sett About wt thre kinge of Colayne' (1520). Of those in the possession of private persons may be quoted two in the form of dogs in the will of Edmund Earl of March (1381), and one with a crystal salt supported by a 'Moryon' (Moor) in the will made in 1509 by the Earl of Oxford.

To this class belongs the 'Giant Salt' at All Souls College, Oxford, a work of the middle of the fifteenth century. It consists of the figure of a huntsman supporting on his hand a crystal bowl and cover to contain the salt. Around his feet are minute figures of a bagpiper, huntsmen, hounds and stags, which are surrounded by the castellated wall which forms the base. The giant, the minor figures and the surface on which they disport themselves, are all tricked out in opaque

paint. This piece is frequently described as German but there is in fact no reason to suppose that it was made anywhere else than in this country. There is no German salt-cellar of this period to which it can profitably be compared and if certain of its details are suggestive of a German origin others appear distinctly English. It would be nearer the mark to suggest that it is the work either of a German who had worked some time in this country or of an Englishman who had come under German influence.

It is very wrong to suppose that the German and Netherlandish influence of which we shall have to speak when treating of the Renaissance, was in any way new. Amongst the goldsmiths who worked for John of Gaunt were Herman Orfeuer and Gerard van Swett and the records of the fifteenth century abound with the names of foreign goldsmiths who worked in this country, who seem to have been mainly Netherlandish or German. In the year 1445 the Goldsmiths' Company swore in no less than sixty-two alien 'allowes' or licensed workers. There still survives one piece which is generally accepted as having been made in this country and which is of indubitably German design. This cup was formerly an heirloom of the Rodney family with whose arms it is engraved. It is now in the possession of Lord Swaythling. The cup has a curved handle and is bulbous in form, as is also its cover. It belongs to a type of drinking-vessel extremely popular in Germany during the fourteenth and fifteenth centuries but which is not otherwise traceable in this country.

One further salt of a fancy design must be mentioned. This is at New College, Oxford, and appears to date about 1500. The salt was placed in a crystal bowl which

rests on the head of a monkey, pensively scratching his head and seated on a square cushion. The base is supported on three feet in the form of bearded and hairy wild men of the woods or 'wodewoses' who were popular characters in medieval pageantry.

Until the popularisation of the use of forks, a ewer and basin formed a very necessary part of the furnishing of every dining-hall. Throughout the Middle Ages and for some time later it was customary for a diner to enjoy the intimacy of sharing a dish with one, two or three fellows, according to his station. Every diner was accordingly expected to wash his hands before the meal for the comfort of those with whom he was to eat and again afterwards for his own. The *Lytylle Childrenes Lytil Boke* (*c.* 1480) recommends its readers to allow those more worthy to wash first and after having washed to refrain from spitting in the basin.

Those who could not afford silver ewers and basins made use of ones of base metal. Attractive enamelled copper basins from Limoges were popular in this country in the thirteenth century and brass ewers in the form of lions and horsemen were in use down to the close of the Middle Ages. Silver ewers and basins are, however, of common occurrence in wills and inventories but the amount of precious metal expended on their manufacture rendered them extremely liable to be consigned to the melting-pot in times of financial stringency. As a result no ewers and very few basins have survived.

Amongst the treasures with which Bishop Fox endowed his college of Corpus Christi, Oxford, was a magnificent pair of basins $16\frac{3}{4}$ inches in diameter and decorated with an enamelled boss with the donor's arms and with embossed rays. They bear respectively the

hall-marks for 1493 and 1514. The later one had evidently been made to match the former which had at the same time been altered by the addition of the owner's arms as Bishop of Winchester, to which see he had been translated in 1501.

The wide divergence of type displayed by the surviving examples of Anglo-Saxon silver spoons seems to suggest that such articles were rare luxuries during that period. The more extensive manufacture of silver spoons may be included amongst the symptoms of the growth of civilised habits during the twelfth century. In 1160 the abbot of St. Albans is recorded as giving silver spoons together with other objects of plate to the newly elected abbot of Westminster in the hope (entirely unfulfilled) that the latter would adopt a more conciliatory attitude in settling the outstanding disputes between the two abbeys. Even at the end of the Middle Ages when silver spoons were widely used, a certain glamour still surrounded them. They were, of course, the first pieces of plate that a rising yeoman or citizen would acquire and bequests of single spoons are numerous. Hugh Rhodes in his *Boke of Nurture* (sixteenth century) specially warns his readers that when dining they should take care of their spoons when not in actual use lest they should get stolen—a curious comment on the morals of diners or servants.

The spoon may be described as having three parts, the bowl, the stem (known in medieval times as the stele or stalk) and the end or knop.

When Jackson published his monumental book in 1911, he recorded the celebrated Coronation Spoon as the only example attributable to the period between the Norman Conquest and the latter half of the fourteenth

century. Since then excavations during the last eleven years have added six examples in varying states of preservation, to help to bridge this gap. One of the four spoons discovered in 1922 in the ruins of the nunnery at Iona and now in the National Museum of Antiquities, Edinburgh, is here illustrated (Plate III, 9). The bowl, it will be noted, is a pointed oval and is engraved with conventional foliage. A monster's head joins the bowl to the stem which is divided into two parts, the one an oblong strip and the other rounded and ending in a knop suggesting some sort of fruit. The decoration both on the bowl and on the flat part of the stem suggests a date about the end of the twelfth century. The other examples which composed the find present a generally similar appearance as does also an example found during excavations at Taunton Castle and now at the museum therein. In the example from Pevensey Castle, now at the British Museum, the flat portion of the stem swells towards its middle whilst the rounded part is twisted and ends in an animal's head. The Coronation Spoon, though belonging to this group, must be excluded from this survey as being of ritualistic use.

A further gap exists in the series of English spoons between the group which has just been described and those which were in use in the latter part of the fourteenth century. This can only be filled in by the inclusion of two examples in the National Museum of Antiquities, Edinburgh. Though both were found in Scotland, it seems fair to suppose that the spoons in use in that country at this time would probably be very similar to those in use in England. The first was found in 1785 in the churchyard of Brechin together with coins of which the latest belonged to the reign of

PLATE III

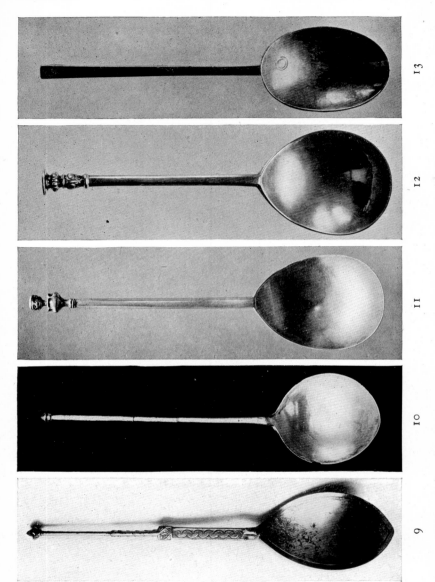

PLATE III

SPOONS

9

DIAMOND-POINT
No marks.
Late 12th century.
Length, 7 15/16 in.
National Museum of Antiquities, Edinburgh.

10

DIAMOND-POINT
No marks.
About 1330.
Length, 6½ in.
National Museum of Antiquities, Edinburgh.

11

MAIDEN-HEAD
No marks.
About 1530.
Length, 6⅝ in.
Victoria and Albert Museum.

12

SEAL-HEAD
Parcel-gilt.
Maker's mark, CW.
Hall-mark for 1607.
Length, 6½ in.
Victoria and Albert Museum.

13

PURITAN
Maker's mark, a rose in an indented circle.
About 1660.
Length, 7 in.
Victoria and Albert Museum.

Edward II. It has an almost circular bowl (Plate III, 10) and a rounded stem ending in a knop which is generally known as 'diamond-pointed' and which was to remain popular till the beginning of the sixteenth century. The second was found in Windymains Water, Haddington, in 1813, and is only $5\frac{1}{2}$ inches long or an inch shorter than the former from which it differs only in having an 'acorn knop' (Plate IV, 14). The first mention of this type of knop occurs in a will of 1348, and its popularity was as prolonged as that of the 'diamond-pointed'. The transition from the thirteenth-century spoon with a pointed bowl to the fourteenth-century spoon with a circular one can be seen in an intermediate stage in a pair of French spoons at the Victoria and Albert Museum. These formed part of a hoard of plate discovered at Rouen and evidently buried about 1330. They are $7\frac{1}{2}$ inches long and have circular bowls, rounded stems and 'acorn knops' but still retain the early feature of a dragon-head at the junction of the bowl and the stem. This last feature is wanting from the two 'diamond-pointed' spoons found at the same time. It is sincerely to be hoped that excavations in England will yield up further evidence regarding the spoons of this period.

The spoons of the later Middle Ages are relatively plentiful. They have a fig-shaped bowl, and a tapering polygonal stem ending in a knop. The bowl and stem are made in one piece, the end of the stem is notched for the attachment of the knop except when the design of the latter is so simple as to make this unnecessary. Few reach the length of 8 inches (which is the average of the surviving twelfth- and thirteenth-century examples) and some are no more than 5 inches long.

The various types differ from each other solely in the form of the knop which is usually gilt. Some knops enjoyed a long and widespread popularity, whilst others were produced only to the customer's order. The 'maidenhead' spoon appears at the close of the fourteenth century (Plate III, 11; Plate IV, 15). The head is usually intended for that of the Virgin. Some examples, however, show the hair braided according to the elaborate fashions which the conventions of sacred iconography allowed only to married women, so that the religious significance is not invariable. The latest examples are a set of 1640 belonging to Christ's Hospital.

The 'lion sejant' appears to have come in during the fifteenth century though no literary evidence has been produced earlier than 1505. The lion is depicted seated either facing or at right angles (Plate IV, 17) to the front of the bowl. The popularity of this type lasted till the reign of Charles I, especially in the provinces.

Spoons 'slipped in lez stalkes', as they are described in the will of Archbishop Rotherham in 1498, have no knops, the stem being merely sloped off (Plate IV, 22). An example of 1487 is known but they were still being made in the second half of the seventeenth century.

Whilst the above varieties were undoubtedly the commonest patterns produced for the ordinary market, there are a number of others which were more or less popular. Amongst these may be classed those with a twisted or 'writhen' knop, Moor's head (Plate IV, 20) gothic pinnacle, the 'fruitlet' (known only from literary sources), and the 'wodewose' (Plate IV, 16). This last is first mentioned in a will of 1486. Two varieties are known in one of which the creature is shown brandish-

ing his club (Plate IV, 16) whilst in the other it droops from his right arm. Some other varieties which can be traced back to the Middle Ages, but of which most of the surviving examples belong to the Renaissance, will be treated of later on.

It was natural that some should prefer more personal spoons. Mentions are made of spoons with armorial knops but none have survived. The family crest or badge was also used. Thus in the inventory made in 1523 of the goods of Dame Margaret Hungerford are mentioned three dozen spoons with knops in the form of sickles. Corpus Christi College, Oxford, possesses six spoons of 1506 with knops in the form of owls and once the property of Bishop Oldham, of Exeter, who evidently pronounced his name 'Owldham' and had three owls in his coat-of-arms.

A refinement for the convenience of travellers which appeared in the fifteenth century were spoons with folding handles. One or two examples survive. Their knops appear generally to have conformed to current patterns though in the will of William Barker, of Lincoln (d. 1530), is mentioned 'a sylver spone folden with a figur of St. John Baptist in the top'.

FROM THE RENAISSANCE TO THE RESTORATION

THE period of the Renaissance saw no change in the attitude of the upper classes towards the accumulation of plate but only in the extent in which they were able to invest their savings and indulge their taste for it. The inventory of the goods of Robert Carre, Earl of Somerset, taken in November 1615 on his arrest for the murder of Sir Thomas Overbury, shows that he was in the possession of 120 oz. of gold plate and 580 lb. of silver plate—a very considerable amount though not comparable to that possessed by the Earl of Oxford a hundred years before. Four splendid inventories exist of the royal plate during the part of the sixteenth century which can be included in the Renaissance. Dated respectively 1532, 1550, 1574 and 1596, they give us a vivid idea of the splendour which surrounded the English court and the importance of the royal patronage. A more meagre list of plate drawn up in 1649 shows us the comparatively unimportant fraction which had survived the attempts of Charles I to govern without parliamentary aid. This, of course, was condemned by the Parliamentary Commissioners to the melting-pot.

The practice of giving rich presents of plate reached absurd dimensions during this period. In the years 1539 and 1540 Henry VIII paid his goldsmith Morgan Wolf

£964 : 18 : 9½ and £888 : 14 : 3 respectively for his New Year's gifts and for certain repairs to his own plate. Amongst the gifts in the latter year were two silver flagons and two salts for Prince Edward, aged two and a quarter years. The lists of plate given away by Queen Elizabeth in 1578 and 1579, mostly the work of Robert Brandon and Hugh Keale, show that she also was a good patron of goldsmiths even though she did not inherit the spendthrift generosity of her father. Foreign ambassadors were wont to receive large gifts of plate carefully graded according to the dignity of the master whom they served. In 1540 the Imperial Ambassador received plate to the value of £310 : 8 : 11¾ and the French Ambassador to the value of £294 : 16 : 8. Henry's successors, if rather more circumspect, were certainly very handsome in their presents. Christian IV of Denmark received on the occasion of his visit to his brother-in-law in 1606, a cup valued at £5000 whilst the members of his council got plate to the value of £2000. Some of the splendid gifts sent by Elizabeth and James I to the Czars of Russia still survive.

The sovereign, of course, also received presents of plate not only from other princes but from his principal subjects who were wont to give him New Year's gifts. On the occasion of royal visits corporations displayed their loyalty in the form of gifts of plate.

The love of plate displayed by the great nobility and by the sovereign was imitated by the lesser landowners and by the mercantile classes. The prosperity with which the Middle Ages closed continued into the succeeding period, though the economic reconstruction which was taking place caused much distress amongst the lowest grades of society. There were further causes, however,

which contributed to the increased manufacture of domestic plate. The influence of the Renaissance was just beginning to affect the appearance of English plate when the financial mismanagement of Henry VIII started the currency on the road to wholesale debasement. Until the monetary reform of 1560–61, there could be no doubt that a sideboard well stocked with plate of a guaranteed purity was a better investment than coffers stuffed with money of varying degrees of baseness and liable to recall on terms unfavourable to the holder.

The Reformation proved less of a disaster to the goldsmiths than to most of the other varieties of artists. Against the loss of ecclesiastical patronage could be credited a great increase of spending power of those who had received grants of abbey lands. It was not merely those who had profited directly by the suppression of the monasteries who found themselves able to expend more on the accumulation of plate. Each year the laity at large had contributed vast sums to the embellishment of churches. This form of expenditure disappeared with the advent to power of the severer reformers and we may well suppose that much of the money thus released was invested in plate. There is no reason to doubt the truthfulness of the Elizabethan writers who tell us of the extraordinary manner in which the use of articles of silver had spread in their day to classes which had never previously been able to afford it.

The vigour of Gothic art was by no means spent at the time of the arrival of the fashion for 'antique work' and pieces purely medieval in style and of the finest workmanship continued to be produced for some time after the first essays in the new style had been made in

43

PLATE IV

Spoon Knops and Ends

14
ACORN

No marks.
About 1340.

15
MAIDENHEAD

Parcel-gilt.
Mark, arms of the
See of Coventry.
Late 14th century.

16
WODEWOSE

Parcel-gilt.
Hall-mark before
1478.

17
LION SEJANT

Parcel-gilt.
Maker's mark, *a
helmet*.
15th century.

18
**APOSTLE (S.
Bartholomew)**

Parcel-gilt.
Maker's mark,
rayed S.
Hall-mark for 1537.

19
SEAL-HEAD

Gilt.
Maker's mark,
rayed S.
Hall-mark for 1543.

20
MOOR'S HEAD

Parcel-gilt.
Marks, *fleur-de-lys,
and W*.
Middle of 16th
century.

21
BUDDHA

Parcel-gilt.
Maker's mark, *RC*.
Middle of 17th
century.

22
SLIP-END

Maker's mark, *SV*.
Hall-mark for 1656.

23
APOSTLE

Parcel-gilt.
Imperfect hall-
mark.
Middle of 17th
century.

24
WAVY END

Maker's mark of
Thomas Spack-
man.
Hall-mark for 1709.

25
OLD ENGLISH

Feather-edge.
Maker's mark of
Walter Tweedie.
Hall-mark for 1773.

National Museum of Antiquities, Edinburgh (No. 14),

and

Victoria and Albert Museum.

PLATE IV

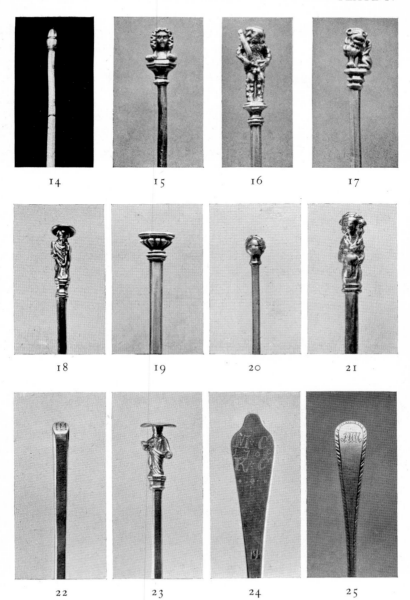

14 15 16 17

18 19 20 21

22 23 24 25

this country. If there is difficulty in discovering a satisfactory date for the beginning of the Renaissance period of English silver, it is no more easy to define its close. Logically we are only entitled to describe as renaissance work such plate as is characterised by the use of ornament derived from classical art. Such work was still being produced in the time of Charles I but there can be no doubt that from the latter days of the reign of Elizabeth the production of plate which owed nothing to antiquity had been growing increasingly popular. If in carrying down the Renaissance to the period of the Commonwealth may be regarded as illogical, it may be argued that the closing of it either at the close of the reign of Elizabeth or that of James I gives equally awkward overlaps.

Though the revival of interest in classical art formed such an important part of the Renaissance as a whole, the debt of the goldsmiths of this period to their Roman and Greek predecessors was inevitably small owing to the restricted range of objects available for imitation. Whilst the goldsmiths of the Renaissance might have imitated the classical forms made known to them by sculptural remains, they preferred for the most part to borrow merely the ornament and to apply it to forms with which they were already familiar or to new ones evolved by themselves.

The earliest date to which we can trace the influence of the Renaissance on English plate is 1520 when there appears in the first of the inventories of the plate of Henry VIII the item: 'A salte parcell gilte well wrought with A naked Child with wingis oon the knoppe'.

The earliest extant piece which shows renaissance influence is the hour-glass salt of 1522, already men-

tioned, belonging to the Goldsmiths' Company. In the extent to which the traditional form has been abandoned it is considerably ahead of most of the work of the first fifteen years of the English Renaissance. It is octagonal, with a stem decorated with radiating scrolls with grotesque masks and a domed cover surmounted by a figure of Hercules. Classical foliage decorates the cover, receptacle, knop and foot.

The Howard Grace Cup, presented by Lord Wakefield to the Victoria and Albert Museum in 1931, which bears the hall-mark for 1525, is very much more conservative both in form and ornament (Plate II, 7). It consists of an ivory font-shaped cup and cover mounted in silver-gilt set with pearls and garnets. The little figure of St. George on the cover might well belong to the end of the fifteenth century and the cresting which holds the foot of the ivory cup is equally gothic. On the other hand, the openwork ornament round the cover and base display masks, vases and classical foliage. The inscription VINVM TVVM BIBE CVM GAVDIO and ESTOTE SOBRII on the mounts of the cup and cover are injunctions to temperance such as are found on other medieval cups. The device of a mitre flanked by the initials T B and two pomegranates has been used to support a tradition that the ivory portion is the 'St. Thomas Cup' bequeathed in 1513 by Sir Edward Howard, Lord Admiral, to Catherine of Aragon, who may have added the mountings. More probably the mitre is the crest of the Berkeley family and the T B the initials of the 15th baron or his son and successor of the same name. Two further points may be noted with regard to this extremely interesting piece and its supposed history. In 1438 there appears in the will of John Stourton 'one

silver cup and cover which belonged to St. Thomas the Martyr' and it may well be that it was this cup (and not the present one) which was afterwards acquired by the lord admiral. The use of ivory cups at the beginning of the sixteenth century can also be traced in the 1513 inventory of the goods of the Earl of Oxford.

Another interesting piece in which gothic and renaissance motifs appear side by side, is a standing dish of 1532 belonging to Arlington Church, North Devon. The dish is decorated with a honeycomb pattern whilst the edge is gilt and engraved in Lombardic letters with ✠ BENEDICTVS DEVS IN DONIS SVIS ET SANCTIS IN OMNIBVS. The spreading foot is plain except for two bands of conventionalised classical foliage, one of which is embossed and the other cast from repeating stamps (a technique which became very popular in the sixteenth century). Two similar pieces of 1528 and 1530, and a cover of 1532, belonging to Rochester Cathedral, afford an interesting contrast as they are gothic throughout.

The original purpose for which these standing dishes served must be considered uncertain and it may well be doubted whether Jackson is right in classing them as drinking-vessels. What is certain is that the word *tazza* in relation to them is to be discouraged. This word was introduced into the English language hardly more than a hundred years ago and is now used by writers on silversmiths' work to denote at least three unrelated types of vessel. There seems to be no valid reason for the retention of a word which merely leads to confusion.

The three vessels which have just been described are all related, though in varying degrees, to the tradition of English gothic silversmiths' work but the same cannot be said of the majority of the pieces produced in

the renaissance style in the last sixty years of the sixteenth century. The Renaissance was late in reaching England and the classical art which is seen reflected in English sixteenth-century plate has for the most part a strong Teutonic flavour. The explanation of this strong foreign influence which is evident in so much of the silver which bears the English hall-marks of this period is threefold.

We have already had occasion to mention that during the latter part of the Middle Ages there had been established in London a strong community of Teutonic silversmiths originating partly from Germany and partly from the Low Countries. Several causes contributed to the reinforcement of this community about the time with which we are now dealing. The Renaissance had reached these countries earlier than England and artists who had already imbibed the elements of the now fashionable style naturally felt attracted to England where it was as yet little known. England was, as has already been shown, a particularly good market for silversmiths' work and was enjoying a period of comparatively stable government which contrasted strongly with the confusion into which the Reformation plunged parts of Germany and the whole of the Low Countries. By the middle of the reign of Elizabeth the number and the success of the Teutonic silversmiths was causing great concern to the native craftsmen who were feeling the effects of this competition. In 1575 and again in 1605 the Goldsmiths' Company forbade its members to accept as apprentices those who were not the children of English parents. It is impossible to tell to what extent either of these ordinances was effective but as neither was retrospective the foreigners already at work would

not be affected. Some certainly were still at work during the reign of James I, such as John Spilman, of Lindau, who had served Queen Elizabeth, received a knighthood from James I and who was still alive in 1622. It would seem, however, that there was some diminution in the number of Teutonic silversmiths in this country in the early seventeenth century which must be attributed partly to the more settled conditions in the Low Countries.

Since the end of the gothic period in Germany the designers of the great schools of goldsmiths, particularly those of Augsburg and Nuremberg, had been in the practice of publishing engravings of their designs which obtained a wide circulation and often remained in use for many years after the artist's death. Whilst the influence of such artists as Hans Brosamer, Pieter Flötner, Paul Flyndt, Jerome Hoffer, Balthasar Sylvius, Virgil Solis and others is easily traceable on English sixteenth-century silversmiths' work, it is only occasionally that we are able to trace the actual source of inspiration. Although designs were published both for parts and for complete objects, the silversmith seldom copied them closely. This course was partly forced on them by the fact that the German designs were not intended for the English market. The designs for cups far outnumbered those for salts, so that the silversmith in this country was forced to rely largely on his own ingenuity when making one of the latter. The deviations of the English silversmith from the original design, even when making a cup, did not necessarily result in an aesthetic loss, since the German originals generally show a more highly developed sense of ornament than of shape.

The third and most disconcerting explanation for the

German appearance of some of the plate which bears English marks of this period, is that German silver was actually imported into this country and received the London hall-mark and the maker's mark of the goldsmith who sponsored it at Goldsmiths' Hall. Attention was first drawn to this subject by Mr. E. Alfred Jones in 1909, when he discovered in the Winter Palace, Petrograd, a cup of entirely German appearance, which bears both an undecipherable German mark, the mark R S belonging to a London goldsmith and the London hall-mark for 1607. Mr. Jones has also collected evidence of the prevalence of Nuremberg plate in this country, including a notice of a London goldsmith who had soldered up again a piece of Nuremberg plate which had been officially cut by the Goldsmiths' Company in 1607.

Of the extent to which German plate had invaded the English market we can obtain striking evidence in the accounts of the royal plate in the second half of the sixteenth and the early seventeenth century. It would also seem that we can find in them further confirmation of the hall-marking of foreign plate with English marks. In the royal inventories of 1574 and 1596 what we take to be the date-letter and the maker's mark on each piece is listed. Occasionally a foreign hall-mark is also recognisable. The following instances may be quoted:

(1574) Item oon standing cup of fflaunders making streken wt the lre ff.

.

Item oon Double Almaine Cup guilt streken wt D also streken with C and a morion head.

Item oon Double Almaine Cup guilt embossed streken wt B and also streken with a small C and a morion head.

.

Item two Almaine Cuppes guilt . . . streken wt a small Romane N both on the fote and the bryme.
(Is this last the Nuremberg hall-mark?)

.

Item oon Aulmaine Cup guilt embossed wt a cover the cup streken wt a Romane A.

.

Item oon Venitian Cup guilt chased bullionwise wtoute a cover streken wt lre o.

Item three Almaine Bolles guilt pounced about the bottomes wt long doppes streken wt a small o wtoute a cover.

(1596) Item oon cup of the Aulmaine making guilt streken wt the lre A.

.

Item one guilte Cuppe wt a Cover streken wt the lre B of the Almayne making.

.

Item one Almayne cuppe guilte embossed wt a cover the cuppe stryken wt a Roman K.

.

Item one white bolle of fflaunders touche . . . stryken on the foote wt the lre N.

In a list of plate sold in 1626 by order of Charles I to his silversmith John Acton, the marks on the English plate are not mentioned and the Nuremberg plate is mentioned as distinct from the other German pieces. A few items of foreign plate may be quoted:

A doble Portugall cupp, with bosses enameled.
One doble Almaine cuppe, chased, with bullions, and stricken with the lre N.
A doble Almaine cup, with bullions, and stricken with lre H.

.

A doble Almaine cuppe, with leaves, Noremborowe making.

When we take into consideration the points which have been enumerated, it will be realised that it is really impossible to form any exact estimate of the character of the German influence on English silversmiths' work of the Renaissance. We may agree that certain pieces are thoroughly German in appearance but how can we decide whether they were imported from Germany or made by some of the Teutonic silversmiths in this country? Again, how can we distinguish the work of one of these latter from that of an Englishman working from a German design? We only reach safer ground again with later years of Elizabeth when English taste seems to have got sated of grotesque masks and heavily massed fruit and foliage and turned to semi-naturalistic floral designs of the type used so extensively on the English embroideries, and other simple forms of decoration. Purely conventionalised floral designs, showing no relation to the German, also appear at the beginning of the seventeenth century but more noticeable is the gradual waning of the desire for richness of effect which resulted in an abandonment of all-over decoration and a more liberal use of engraved instead of embossed and chased work, whereby a greater stress is laid on form.

By the time of the accession of Charles I the increase of the proportion of pieces without or virtually without any applied decoration has become very noticeable. The finest examples of 'Puritan' silver belong mostly to the reign of Charles I though the use of the style was most general during the Commonwealth, when clients had little money to spare for the making of plate and consequently tended to choose the least costly designs. The standard of workmanship at the same time shows a

PLATE V

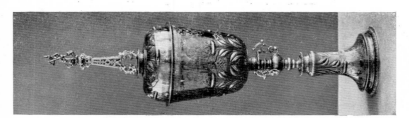

28

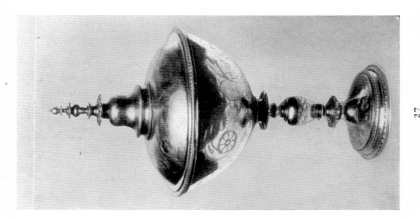

27

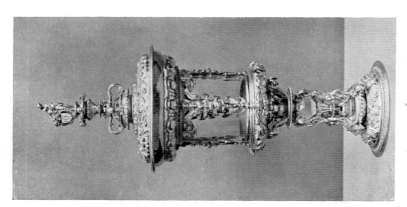

26

PLATE V

28

JOHN FOSTER'S CUP

Gilt.
Maker's mark, *IT*.
Hall-mark for 1611.
Height, 19½ in.
Armourers and Brasiers' Company.

27

ELIZABETH BOWES'S CUP

Gilt.
Maker's mark, *IS monogram* (John Spilman?).
Hall-mark for 1589.
Height, 15¼ in.
F. T. D'Arcy Hutton, Esq.

26

SIR MARTIN BOWES'S CUP

Crystal with gilt mounts.
Maker's mark, *a monogram*.
Hall-mark for 1554.
Height, 19⅜ in.
Goldsmiths' Company.

general decline, as usually happens when the thought of economy is given too much prominence.

It now remains to say something about the more important varieties of plate produced between the arrival of the Renaissance and the Restoration. It is only fair to warn the reader beforehand that certain varieties of plate which appeared during the present period, but become of greater importance later on, will be dealt with in the succeeding chapters.

The cups display a remarkable variety of forms but few of these show any sign of being derived from any of those in use in England at the end of the Middle Ages. The 'font-shaped' cup, indeed, still survived, refurbished with renaissance ornament. The latest example was given by Peter Peterson, a celebrated Norwich goldsmith, to the Corporation of that city in 1575 in return for being excused from holding the office of sheriff.

Some of the new patterns show very evident signs of being derived, through the designs of the German ornamentists, from those which had been in use in Germany at the close of the Middle Ages. Amongst these may be numbered the cups with thistle-shaped bowls including the one made for Jane Seymour in 1536–37 from the design of Hans Holbein now in the Bodleian Library. Amongst extant examples may be mentioned the superb Bowes Cup (Plate V, 26) of 1554 presented to the Goldsmiths' Company by Sir Martin Bowes in 1564.

Cups in the form of a melon or gourd also appear to have become naturalised in this country. Amongst the more notable may be mentioned the melon-shaped cup of 1601 at Magdalen College, Oxford, and the gourd-

shaped one of 1585 belonging to the Armourers' and Brasiers' Company.

A rarer German design is displayed by the celebrated cup of 1535 belonging to Cirencester Church (Plate II, 8). Its tapering bowl and heavy gadrooning strongly suggest the influence of a design by Brosamer. The falcon on the cover is the badge of the Boleyn family and the cup is traditionally believed to have belonged to Anne Boleyn and to have been presented by Queen Elizabeth to her physician Dr. Master, grantee of the lands of Cirencester Abbey.

As the reign of Elizabeth progressed an increasing number of cups begin to appear, which show little or no trace of German influence either in shape or decoration. Two types may be mentioned, both of which are supported on a baluster stem with a spreading but rather narrow foot. Of these one has a shallow bowl with a curved side and domed cover, whilst in the second the bowl and cover are egg-shaped. A good example of the former variety is afforded by a cup of 1589, bearing the mark attributed by Jackson to the German John Spilman. It is believed to have been given by Queen Elizabeth to her god-daughter Elizabeth Bowes on the occasion of her marriage to Timothy Hutton in 1592 (Plate V, 27). A plainer example of 1590 is in the Victoria and Albert Museum (P.B. I, 5). From this variety of covered cup is derived a smaller uncovered one for less ceremonial occasions.

The egg-shaped cup, variously decorated, was predominant during the reign of James I. Two delightfully engraved examples of the years 1601 and 1603 belong respectively to King's Nympton Church, Devon, and to Trinity College, Oxford. A very notable example at the

Victoria and Albert Museum (P.B. II, 1) has the bowl decorated alternately with bands of cast arabesque and with engraved hunting-scenes, whilst the top is surmounted by a pot of flowers. It is of the year 1611 and is the work of an unknown goldsmith from whose hand there survive a number of pieces all of which are extremely fine.

The best known variety of the cup with the egg-shaped bowl and cover is the steeple-cup, of which the earliest surviving example bears hall-mark for 1599. An example of the year 1611, belonging to the Armourers' and Brasiers' Company, presents all the characteristic features (Plate V, 28). The base of these cups is trumpet-shaped, the stem is decorated with three or four brackets, whilst the bowl is embossed with acanthus leaves, fruit and flowers, or sea-monsters—a Dutch motif, extremely popular about this time, and shown on a cup of 1627 at the Victoria and Albert Museum (P.B. II, 3). The most conspicuous feature is, however, the steeple or pinnacle supported on scroll brackets, which surmounts the cover. The popularity of the steeple-cup lasted right down to the Civil War; one of the latest examples, no less than 33 inches in height, was presented to the borough of St. Ives, Cornwall, in 1640.

A few words only can be said about the smaller varieties of cups. The most beautiful one, which was in use during the first quarter of the seventeenth century, has a round or polygonal bowl chased with conventional foliage, a slender stem often decorated with brackets, and a circular base. Another variety, also popular in the first half of the seventeenth century, has a bowl like a champagne-glass on a tapering stem with round base.

The bowls of these are frequently decorated with an embossed diaper possibly imitated from Venetian laticinio glass. Another design has a bell-shaped bowl on a baluster stem with a circular base. Two fine examples of the years 1617 and 1623 are in the Victoria and Albert Museum (P.B. II, 2).

The use of drinking-bowls, as we can tell from inventories, was still common, though extant examples are extremely rare. One of the year 1599 is in the possession of the Whitgift Hospital, Croydon, and has the print engraved with the arms of Archbishop Whitgift. Late in the period with which we have to deal, there began to appear drinking-bowls with cast caryatid handles, with which we shall have much to say in a later section.

A gap exists in the series of beakers during the middle of the sixteenth century. This does not mean that they had temporarily become unfashionable, as nineteen are illustrated in the advertisement of the prizes to be awarded in the State lottery of 1567, which was intended to finance the repair of the ports of the kingdom. These do not differ from the examples of the latter part of the reign of Elizabeth which have survived. These last are about 6 inches high, spreading towards the top, and sometimes with a moulded base. Their decoration usually consists of rather poorly engraved strapwork and floral motifs. It is curious that hardly any examples of standing beakers, a form of vessel extremely popular in Germany, are known with English marks.

Silver tankards do not seem to have come into use before the mid-sixteenth century. Three principal types were used concurrently down to the middle of the seventeenth century and were reproduced in larger sizes as flagons. All have S-scrolled handles but the form of

the thumb-piece varies considerably. The first type, of which the Armourers' and Brasiers' Company possesses an example of 1556, has a bulbous body, short neck, and slightly domed lid. Another variety, more commonly found in the form of flagons, has a cylindrical body, spreading base, and a domed lid with a knob. The third differs from this last in having a tapering cylindrical body. The undecorated tankards of the 'Puritan' style will be dealt with in a succeeding chapter.

The diverse motives which had prompted medieval goldsmiths to mount in silver objects of unprecious materials still operated during the Renaissance, but the extension of the commercial horizon added considerably to the range.

We have already had occasion to mention the Bowes Cup (Plate V, 26) of the Goldsmiths' Company, with its crystal bowl, a material popular since the Middle Ages both for its decorative qualities and for its supposed power of detecting poisons, a superstition which died a very lingering death. The Victoria and Albert Museum possesses a superb cup (P.B. I, 8) with an agate bowl and a stem and base richly chased with lion masks, fruit, strapwork and beautifully modelled snails. It bears the hall-mark for 1567.

Coconut cups still remained in favour, the character of the mounts changing with the times. A good example of about 1580 is at the Victoria and Albert Museum (P.B. I, 16) and has the stem decorated with radiating brackets. Another of 1610 has a baluster stem and a cover surmounted by a miniature steeple.

Ostrich-egg cups appear frequently in medieval wills and inventories, though they were usually described as griffins' eggs, but the surviving examples all belong to

the Renaissance. The most interesting example is dated 1610 and is at Exeter College, Oxford. The egg is mounted in the same way as a coconut, whilst the stem is formed by four ostrich legs and the cover is surmounted by a figure of the bird.

Cups formed from mounted shells can be traced back to the fourteenth century. One presented to the King by Archbishop Reynolds is mentioned in 1329, and others received from two other English nobles occur amongst the royal plate in 1338. No example earlier than the reign of Queen Elizabeth has survived. The most interesting Glynne Cup is of 1579, and belongs to H. N. Gladstone, Esq. It is in the form of a pelican feeding its young, the body of the bird being originally formed of nautilus shell which has been replaced in silver-gilt.

Silver-mounted mazers still continued to be made, though they had now lost much of their former popularity as the class which had formerly used them now aspired to vessels entirely of silver. Elizabethan mazers differ from their late medieval predecessors in having deeper bowls. The mounts are lighter and the lip-band is usually joined by vertical straps to the base.

The mounting of earthenware jugs in silver had been known in the Middle Ages, though the origin of the objects thus honoured is unfortunately not clear. In an inventory of the royal plate in 1323 appears a 'crusekyn de terre garni d'argent' and another in 1399 is described as a 'cruskyn de terre blank' and had an embattled cover enamelled inside with a 'babewyn' (grotesque figure). The fashion obtained during the Renaissance an immense popularity which it is difficult to explain, as the majority of the objects mounted were neither rare nor

PLATE VI

29

ARCHBISHOP PARKER'S SALT

Gilt.
Maker's mark of Robert Danbe.
Hall-mark for 1562.
Height, 11¾ in.
Corpus Christi College, Cambridge.

30

THE VYVYAN SALT

Gilt, with panels of painted glass.
Maker's mark, *WH with a flower* (?).
Hall-mark for 1592.
Height, 15¾ in.
Victoria and Albert Museum.

31

SALT

Gilt.
Maker's mark, *ER.*
Hall-mark for 1599.
Height, 9 in.
Goldsmiths' Company.

PLATE VI

31

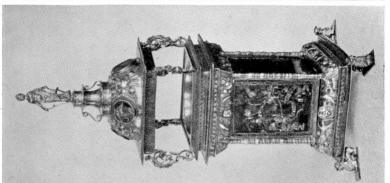

30

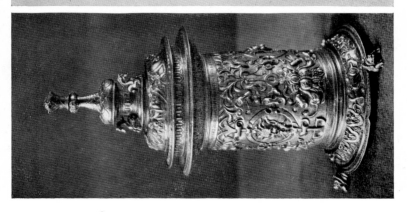

29

beautiful, whilst the mounts sometimes display the finest workmanship. German earthenware jugs form the majority of the surviving examples. They are of two sorts—the ordinary mottled brown Rhenish 'tiger-ware' and the grey Siegburg ware. Extant examples of the first half of the sixteenth century are rare but a finely mounted English earthenware jug of 1547 was presented to the Victoria and Albert Museum a few years ago. The same museum also possesses a representative collection of German jugs (P.B. I, 10, 11), as does also the British Museum. It is curious to note that the fashion for mounting these jugs seems to have been pursued with especial vigour at Exeter. Few examples can be dated later than 1600.

It is more easy to understand the motives which prompted the mounting of brightly coloured Turkish earthenware, since these combined rarity with beauty. The same may be said of the mounting of Chinese porcelain which became increasingly popular and of which several examples may be seen in the national collection (P.B. I, 18-19). The earliest example of Chinese porcelain mounted in England is the celadon bowl with gilt mounts in the gothic style, which is traditionally believed to have been given to New College, Oxford, by Archbishop Warham.

During the Middle Ages glass vessels had been rarities and had naturally been honoured with silver mounts as was the case of the cup mentioned in the 1338 inventory of the plate of Edward III. During the Renaissance the practice was continued, though Venetian glass was ceasing to be a rarity. Extant examples are, for obvious reasons, extremely rare and the British Museum is extremely fortunate in the

possession both of a tankard with silver mounts with the hall-mark for 1548 and another, of about 1570, with the arms of the great Lord Burleigh on the cover.

Whereas the 'hour-glass' is the only standard design of medieval salt which is known to us, the varieties in use during the Renaissance are better represented.

Firstly must be mentioned one type with a cylindrical body with spreading top and bottom (with or without feet). It has a domed top surmounted by a finial. The salt of 1562 presented to Corpus Christi College, Cambridge, in 1570, by Archbishop Parker (Plate VI, 29) is a particularly fine example of this variety. The Victoria and Albert Museum is very fortunate in the possession of two examples of this sort, one bearing the hall-mark for 1586 (P.B. I, 20) and the other that for 1614. The former is, like the last example, richly embossed with strapwork and arabesques. The second has a plain body decorated only by two bands of stamped Tudor roses. The cover is supported on four scroll-brackets attached to a ring which fits round the receptacle. The introduction of these detachable bracket fittings was due to the fact that a large part of the beauty of the salt was lost when it was in use and the cover removed. The present salt is remarkable in possessing a second receptacle and a second row of brackets which are clearly a later addition. The cover is surmounted by a pinnacle similar to those found on the steeple-cups of the period. Similar pinnacles are found on some Italian salts and perfume-burners of about this date. The most notable of all the cylindrical salts is, however, the 'Queen Elizabeth' salt at the Tower of London. It is hall-marked for 1572 and is particularly interesting as it is embossed with medallions containing figures of

Faith, Hope and Fortitude, copied from a set of eight engravings of the Virtues by Pieter Flötner (*d.* 1546).

The second type of great salt differs from the last in having a square instead of a cylindrical body. The Vyvyan Salt of 1592, at the Victoria and Albert Museum (Plate VI, 30), is undoubtedly the finest example. Its sides are filled with glass panels delicately painted on the inner side with designs adapted from Geoffrey Whitney's *Emblems and Other Devices, etc.,* published at Leyden in 1586. The cover, which is supported on the usual brackets, is decorated with medallions in the same technique of the heads of Julius Caesar, Antoninus, Cyrus and Alexander, whilst the whole is surmounted by a figure of Justice. Another example which may be mentioned is the salt of 1569 belonging to the Vintners' Company, which is embossed with figures representing Patience, Justice, Temperance and Venus which were also recognised by Mr. W. W. Watts as being derived from designs by Flötner. The first three figures belong to a set of the Virtues and the last to one of the planetary deities. The cover is surmounted by a female figure holding an escutcheon.

A much rarer variety is the pillared salt with base of varying form on which stand pillars or caryatids supporting the receptacle and its cover which follows the usual lines. The Goldsmiths' Company possesses a particularly fine example in which, in the space between the four pillars, is a statuette of Neptune encased in a crystal cylinder which gives him the appearance of standing in a column of water. It bears the hall-mark for 1576 and was given to the company by Simon Gibbon in 1632.

Bell-shaped salts enjoyed a period of popularity in the latter years of Queen Elizabeth and the early ones

of her successor. It is interesting to note that none appear in the 1574 inventory of royal plate, whilst there are five in the one of 1596. In reality they contain two salt-cellars fitting one on the top of the other. The upper one has a domed cover surmounted by a perforated knob like a pepper-caster. An excellent example of 1599 belongs to the Goldsmiths' Company (Plate VI, 31) whilst another of 1594 is at the Victoria and Albert Museum (P.B. I, 13). It is worth noting that it is the bell-shape, and not the idea of salts fitting together, which is peculiar to years round about 1600. In inventories of a considerably earlier date we repeatedly get references to groups of salts with only a single cover, whilst amongst the royal plate in 1520 had been 'a Doble salte oon couring another'.

The characteristic salt of the reign of Charles I with its three or four scroll brackets will be dealt with later on.

During the reign of Queen Elizabeth there appears to have been a distinct increase in the manufacture of small salts. Some of these are merely miniatures of the contemporary standing salts. The Victoria and Albert Museum possesses two miniature cylindrical salts of the years 1563 and 1566 respectively (P.B. I, 7a, 7c) and a miniature bell salt. Others are more original and are not equipped with covers. Some are circular and some triangular in shape, and few are as much as three inches in height.

Fancy salts still appear in considerable numbers in the royal inventories but seldom in those of subjects. Several clock salts appear in the last inventory of Henry VIII and some of them remained in use until consigned to the melting-pot by the Parliamentary Commissioners in 1649. Perhaps the most fascinating

of the royal salts is the one which is mentioned in the 1574 inventory:

> Item oon Saulte of silver and guilt, being an Arke of Noye containing therein a Chesse boarde wt XXXI men thereunto belonging, garnished wt course stones of divers sortes.

Another salt which appeals to our childish instincts, appears in the inventory of the goods of the Earl of Leicester taken after his death in 1588. It is described thus:

> A Salte ship-fashion, of the mother-of-perle, garnished with silver and divers workes of warlike ensignes and ornaments, with XVI pieces of ordinance, whereof ii on wheles, two anchers on the fore parte, and on the stearne the image of Dame Fortune, standing on a globe, with a flag in her hand.

We have already had occasion to mention the standing dish belonging to Arlington Church, Devon, as being one of the earliest examples of Renaissance work in this country. During the reign of Queen Elizabeth this type of vessel became extremely popular; we see no less than seventy-eight illustrated amongst the prizes of plate to be awarded in the State lottery of 1567. A very typical example of the standing dishes of this period, made in 1564, is in the Victoria and Albert Museum (P.B. I, 12) and has the centre of the dish filled with an embossed medallion of a helmeted head, from which radiate engraved arabesques. Indubitably the finest standing dish bearing an English mark is the one of 1567, till lately the property of St. Michael's Church, Southampton. Its bowl is beautifully embossed with the story of Isaac and Rebecca, but there can be no doubt of its thoroughly Teutonic appearance, which has led

Mr. E. Alfred Jones to include it amongst his very carefully selected list of pieces probably imported.

The need for ewers and basins did not in any way diminish during this period and the decorative possibilities of these objects were fully explored by the goldsmiths of the Renaissance. Three principal forms of ewers may be recognised.

The first of these is represented by the ewer and basin of 1545 presented by Archbishop Parker to Corpus Christi College, Cambridge, in 1570. The ewer has a round foot and a swelling octagonal body, the sides of which are alternately engraved with arabesques and left plain. The remaining two are occupied respectively by the angular handle and by a spout which is attached to the body for the whole of its length. The cover is decorated with spiral gadrooning which surrounds a medallion with the donor's arms. The centre of the basin is decorated in a similar way to the cover of the ewer, whilst the rim is engraved with arabesques. An equally beautiful ewer and basin of 1562 is the property of Winchester College. The ewer has, however, a taller foot, circular body and scroll handle. The basin carries in its centre an enamelled medallion of the arms of the college surrounded by an embossed ring of military trophies and the inscription MANERS MAKET MAN QVOTHE WYLLYAM WYKEHAM. The rim is very decoratively engraved with an inscription telling that the piece was re-made by the generosity of Ralph Henslow. The last example of this type of ewer and basin is the one of 1603 belonging to the Old Kirk, Edinburgh.

The second variety of ewer has a vase-shaped body, a narrow neck with spout and a scroll handle usually in

the form of a grotesque human demi-figure. A typical example made in 1583 by Robert Signell, is in the Victoria and Albert Museum (P.B. I, 14). It is richly chased and embossed with strapwork, fishes, masks and other motifs, whilst the handle is in the form of a demi-lion ending in a scroll. A ewer and basin of 1579 and 1581 respectively, belonging to the Duke of Rutland, is very exceptional, both in being set with agate and in the character of the arabesque ornamentation. There is a great deal to be said for the suggestion lately made by Miss Joan Evans that these pieces and the equally elaborate but more successful ewer and basin of 1617, belonging to the Corporation of Norwich and embossed with a triumph of Neptune and Amphitrite, are the work of French craftsmen. An immigration of Huguenots took place after the Massacre of St. Bartholomew and a number of French craftsmen were still working in London in the first quarter of the seventeenth century.

The third type of ewer and basin which appeared in the reign of James I is unrelated to the ones just mentioned. Both ewer and basin are, as a rule, ungilt and undecorated except for a heraldic achievement or inscription. The basin presents no remarkable features. The ewer resembles a straight-sided goblet with a scroll handle and curved spout. The introduction of a vessel so conspicuously lacking in aesthetic charm is typical of a number of artistic errors which were occasioned at the time when the inspiration of classical art was losing its popularity and artists were seeking originality at all cost. The dangers of novelty are not peculiar to our own age.

Amongst the unsuccessful attempts in this direction may be classed the small wine-tasters, cups and sweet-

meat dishes which began to appear in the reign of James I and became increasingly popular in that of his son. They are of thinnish silver and are often so clumsily embossed that the work might be supposed to have been done by a child with a blunt nail as in the case of the sweetmeat dish of 1633 at the Victoria and Albert Museum (P.B. II, 4). The engraved and pierced work used on this class of object is no better done. The tasters are in the form of shallow bowls, about 3 inches in diameter, with handles of wire. The cups are straight-sided and have short trumpet-shaped feet. The dishes have plain or scalloped edges.

The Renaissance wrought no startling change in the form of spoons, as it did in that of other types of plate. It can only be said that by about 1640 the bowls of spoons had become more oval and less fig-shaped than they had been a hundred years before. The process of this change was extremely gradual. Most of the varieties of knop invented during the Middle Ages continued to be made down to the end of the sixteenth century, after which a few types drop out.

The most characteristic knops of the Renaissance are the seal-top and the Apostle, both of which had appeared towards the close of the medieval period. The name seal-top does not appear in contemporary literature where they are described by various phrases emphasising the flat end of their knops. In the 1513 inventory of the Earl of Oxford's plate are two spoons with 'flat knoppes'. The earliest known example is of 1480 and is like most others produced down to the middle of the sixteenth century in having the hexagonal ends resting on a sort of gadrooned cushion (Plate IV, 19). The later variety of this knop has a circular end

resting on a baluster decorated with acanthus leaves
(Plate III, 12). The spoons still survive in considerable
numbers, no less than seventy-two, dating from 1552 to
1627, are in the possession of the Armourers' and
Brasiers' Company, as the result of a regulation passed
in 1561 compelling each brother to present a spoon
on his admission. Similar regulations were enforced by
other companies which have, however, been less success-
ful in retaining the proceeds.

The earliest mention of Apostle spoons yet recorded
is in a York will of 1494 where there is a bequest of
'XIII cocliaria argenti cum Apostolis super eorum
fines'. The earliest known examples bear the hall-mark
for 1490. The complete set of these spoons might num-
ber thirteen, that is, the Twelve Apostles and the
Master (Our Lord), but many sets consisted of twelve
pieces and omitted this last. Each apostle carries his
emblem and the Master an orb. Each figure wears a
halo which in the seventeenth century was apt to be-
come grotesquely large and to be surmounted by a dove
(Plate IV, 23). The list of Apostles is not uniform. St.
Paul with his sword is frequently intruded in place of
one of them. Complete sets of these spoons, by the same
maker and of the same year, are extremely rare and
fetch high prices. The rarity is partly explained by the
fact that during the sixteenth and seventeenth centuries
a silver spoon was a favourite form of christening spoon
as is shown in the passage in *Henry VIII* (Act v, Sc. 11)
where Cranmer tries to refuse to act as godfather to the
infant Elizabeth and the king retorts: 'Come, come, my
lord, you'd spare your spoons'—in actual fact the dis-
tinction cost the archbishop a standing cup of gold.
Apostle spoons were especially suitable as christening

69

presents as the godfather could present the child with
a spoon bearing the effigy of the saint whose name he
was to bear. Spoons with effigies of the Apostles with
popular Christian names are certainly more frequently
encountered. Many of the last Apostle spoons, made
in the second half of the seventeenth century, were
made probably either as christening presents or to
replace those from earlier sets which had been given
away.

Angels and saints (other than Apostles) appear on
spoons and were probably used in a similar manner.
We hear of spoons with a knop of St. Christopher and
St. Anthony, whilst an example of 1528 with that of
St. Nicholas fetched £690 at a sale in 1902. The Inn-
holders' Company possess twenty-three spoons with
figures of their patron St. Julian the Hospitaller, dating
from 1519 to 1685, the later ones being the result of a
regulation made in 1657 requiring the gift of a spoon
on admission.

The types of knops introduced during the late six-
teenth century and the first part of the seventeenth
century are generally less interesting than those of
longer standing. The most curious is that of a full-face
kneeling figure (Plate IV, 21) which has some super-
ficial resemblance to images of Oriental teachers and
deities. These have been christened Buddha, Krishna
or Vishnu spoons, it being held that they were inspired
by the essays at direct contact with India made by the
East India Company at this time. Considering how
common is the use of barbaric figures in Tudor and
Jacobean sculpture, it seems unnecessary to go so far
in search of the origin of this motif. All the examples
noted appear to be of provincial make.

70

The last type of spoon to be dealt with is the Puritan or stump-ended which made its appearance in the reign of Charles I. It is characterised by a stem of oblong section with a square end (Plate III, 13). Though it may have been derived from a simplification of the 'slipped in the stalk' variety which was still in use, it is more likely to have been introduced from abroad than to have been due to any puritanical effort to add simplicity to everything in daily life. French examples are known at as early a date as any of the English. Artistically there is nothing to be said in favour of the puritan spoon and we can have little regret for its disappearance in the reign of Charles II, together with all the other types of spoons inherited from the Middle Ages.

Spoons of a more personal character were made during the Renaissance as in earlier times. Edward Waring, of Wolverhampton, who died in 1625, bequeathed 'eleven silver spoons wth owles' which he had probably had made because he had a house at Owlbury, near Bishop's Castle. A spoon of 1600 at the Victoria and Albert Museum has a knop in the form of a bearded head which is probably derived from some family crest.

A set of spoons formerly belonging to the Tichborne family, if not the result of a private order, is certainly unique. It bears the hall-mark for 1592 and its knops represent twelve heroes, each identifiable from the name engraved on the stem. The list comprises—The Saviour, St. Peter, Joshua, David, Judas Maccabeus, Hector, Alexander the Great, Julius Caesar, King Arthur, Charlemagne, Guy of Warwick and Queen Elizabeth. The Saviour is an ordinary Master spoon and the St. Peter is such as is found in Apostle sets but without a halo. Queen Elizabeth carries her orb, but the other

figures are depicted in the curious species of 'artist's armour' used to represent warriors who could not be represented in the contemporary military costume.

It seems incredible to us that a period so renowned for its extravagance and luxury should have seen only at its close the introduction of table forks. Forks had, of course, been known throughout the Middle Ages and one of Anglo-Saxon date has already been mentioned. The rare silver forks which appear in inventories do not appear to have been intended for ordinary table use. The three amongst the plate taken with Piers Gaveston are qualified 'pur mangier poires', one in the 1399 inventory of royal plate weighed 15½ oz. and was probably a serving fork; another in the will of John Baret, of Bury, in 1463 is described as being for 'grene Gynger', as are also two combined spoons and forks in a 1513 inventory of the Earl of Oxford. The 'spoone and forcke of fair agatte' which Queen Elizabeth 'took from' Sir John Puckering when she honoured his house at Kew with a visit in 1595 may also have been intended for fruit or ginger. The existence of a whole set of spoons and forks in her 1574 inventory is more unusual as these objects are usually mentioned only in small numbers. It is probable that she had received them as a gift from abroad. That they had evidently received use is shown by their description: 'xii Spones of mother of perle, the steles of silver and guilt, and xii fforks of silver and guilt, thre of them broken'.

The use of table forks was a refinement which seems to have made a great impression on English visitors to Italy in about 1600. It is impossible to avoid giving in this connection a quotation from the eccentric Thomas Coryate, who took a five months' trip abroad in 1608,

during which he accumulated the materials for a highly amusing book which he entitled his *Crudities*:

'I observed a custom in all those Italian cities and towns through which I passed that is not used in any other country that I saw in my travels, neither do I think that any other nation of Christendom doth use it, but only Italy. The Italian, and also most strangers that are commorant in Italy, do always at their meals use a little fork when they cut their meat . . . their forks being for the most part of iron or steel, and some of silver, but those are used only by gentlemen. The reason for this their curiosity is because the Italian can not endure by any means to have his dish touched by fingers, seeing that all men's fingers are not alike clean. Hereupon I myself thought to imitate the Italian fashion by this fork cutting of meat, not only when I was in Italy, but also in Germany, and often-times in England since I came home.'

'Fynes Moryson, however, who had travelled very much more extensively than Coryate before venturing to publish his *Itinerary* in 1617, felt conscientious scruples about using his fork in England. He advises his traveller "Also I admonish him . . . so that he returning home, lay aside the spoone and forke of Italy, the affected gestures of France, and all strange apparrell . . . for we are not all borne reformers of the World." '

One of Ben Jonson's characters in his *Volpone* (printed 1607) when describing the acquirements necessary for one who would appear a true native of Venice, says: 'then must you learn the use, And handling of your silver forke at meales'. A few years later he recurred to the same subject in his *The Devil is an Ass* (printed 1616). The shady company promoter Meercraft, when threatened with arrest for debt by the goldsmith Gilt-

head and the smith Sledge, announces to them that he
has obtained for them a patent which will give them
respectively a monopoly of the manufacture of spoons
in the precious metals and in steel. He adds that he has
already come to terms with the linen drapers, as

> the laudable use of forks
> Brought into custom here, as they are in Italy,
> To the sparing of napkins,

might otherwise have been opposed by them. Though
the two creditors are gulled into accepting his ready
tale, it is clearly inferred that the dramatist himself had
few illusions about the financial prospects of a scheme
for introducing more hygienic feeding into the England
of his day. In this he was not far wrong, for in 1652
Peter Heylin in his *Cosmography* alludes to 'the use of
silver forks with us, by some of our spruce gallants
taken up of late' and we shall have occasion to show
later on that the use of forks was not general until some
time after the Restoration. Though it is probable that
the first table forks were made singly, or together with
a spoon, for the clients own use, yet as early as the
year 1629 we find the famous 'Belted Will' Howard,
of Naworth, purchasing ten silver forks for £3 : 13 : 6.

The Victoria and Albert Museum is fortunate in the
possession of what is generally supposed to be the oldest
English silver table fork. It is nearly 7 inches long and
has a flat, square-ended handle bearing the hall-mark
for 1632, and two prongs. It is engraved with the crests
of John Manners (afterwards Earl of Rutland) and of
his wife Frances, daughter of Lord Montagu of Bough-
ton. A few years since a puritan spoon, bearing the same
crests and marks, was found under a floor at Haddon
Hall, together with a combined fork and spoon. Several
later forks with puritan handles are also known.

PART II

THE MODERN PERIOD

CHAPTER I

HISTORY AND STYLES

THE reign of Charles II for a number of reasons was a landmark in the history of English silver. From the point of view of the ordinary collector the year 1660 acts as the dividing line between the collectable and the uncollectable—an economic reflection of the wholesale destruction of plate which had taken place during the Civil War period. This last was also responsible for the vast output of silversmiths' work in the years following the Restoration, since on the return of settled conditions, those whose fortunes had not been irretrievably shattered in the late troubles, began to replace the plate which had been lost in the cause of one side or the other.

Social conditions, however, had not remained unchanged during the fifteen years during which there had been a virtual intermission of silversmithing and consequently much of the new silver which now came into existence differed widely in use as well as appearance from the old. Articles which had still been in common use in the reign of Charles I had become obsolete, whilst wants which had been unfelt in the old days were creating fresh opportunities for the silversmith.

Of course a lot of overlapping occurred, a certain number of objects which we connect chiefly with the

77

reign of Charles II had been made for some years before his accession, others which fashion had condemned continued to be made in diminishing quantities, whilst at first the number of the pieces created to serve new needs was limited. When everything is considered, however, there can be no doubt that the year 1660 is by far the most satisfactory starting-point for the modern period of English silver.

During this period the character of the royal patronage of the goldsmiths' art shows a change. During the reigns of Charles II and William III the expenditure on plate for the sovereign's actual use continued to be large, though we must remember that most of the splendid pieces of plate that we see at the Tower and of the furniture at Windsor were gifts to the kings from their loyal subjects. Despite the recurrent financial crises from which the restored monarchy suffered, King Charles's mistresses were very well supplied with plate whilst Evelyn remarks that in 1673 he saw the toilet set of Queen Catherine of Braganza 'all of massie gold, presented to her by the King, valued at £4000'. The lengthy process of re-equipping the royal palaces with plate was continued by William III who naturally brought with him the tradition of opulent comfort current in Holland. The personal touch which can be traced in the patronage which many of the medieval, Tudor and Stuart sovereigns had extended to goldsmiths is lacking, however, from that of the kings of the House of Hanover before George IV. An interesting inventory survives of the plate in all the royal palaces in the year 1725. The quantity is very great but the preponderance of objects of everyday use to those intended primarily for display is larger than might be expected.

Several varieties of luxuries which were well known in the houses of the richer nobility are wanting from the royal collection, and their absence may be taken as symptomatic of the king's lack of interest in this as in other forms of art.

Much more considerable than the quantity of plate acquired annually for the sovereign's use was that which was produced at the charges of the State for other purposes. Charles II, like his predecessors Elizabeth and James I, made a lavish gift of plate to the Czar of Russia, part of which is still in existence. He also made a special grant of plate to Admiral Sir Edward Spragg for his services against Algiers in 1671. The old-established custom by which the king gave New Year's gifts to his principal subjects and officials also survived, until 1680 and Lady Fanshawe records the receipt in 1662 of fifteen ounces of gilt plate due to her husband as Secretary of the Latin Tongue, and the accounts of the period show that other minor officials were equally lucky. Foreign ambassadors who in the past had been presented with plate, seem from about this date to have been rewarded with a lesser show of delicacy and hard cash.

It is not necessary to trace before the reign of Charles II the history of a custom which was afterwards to become a source of much loss to the State. It was firmly established that ambassadors going on special missions to foreign countries, the principal secretaries of State, the Lord Chancellor, the Speaker of the House of Commons, and certain court officials, might have a loan from the Royal Jewel House of a varying quantity of plate with which to support the dignity of the sovereign whilst in his service. Up to the Revolution the idea that

79

plate issued for this purpose was in the nature of a loan which had to be returned, was clearly understood, but occasionally an ambassador who had overspent his allowance would offer to take his plate at cost price in payment or part payment for what was owed him. In this way in 1672 Sir George Downing took the plate which had been issued to him as ambassador to Holland, and received in cash the small balance still due to him. An arrangement like this was, of course, satisfactory to both parties as the Treasury was saved the trouble of finding ready money, whilst the ex-ambassador got the full value of his debt in the form of plate instead of having to wait an uncertain time for payment or selling the debt to a banker who took a commission. The Treasury seems to have taken considerable trouble in examining ambassadorial debts, and Lady Fanshawe, whose financial ability does not seem to have equalled her piety and literary charm, received short shrift when she attempted to retain on this score the eight thousand ounces of plate obtained by her husband who had died on a mission to Spain in 1666. It was only under very exceptional circumstances that the holder received a gift of his plate as did Henry Coventry, who received his in 1680 after serving Charles II for twenty years as a principal secretary of State.

The weakening of the power of the sovereign after the Revolution gave his ministers greater opportunities of enriching themselves at the public expense and free gifts of official plate became very much more easily obtainable. In 1701 the Lords of the Treasury record their disapproval of the gift to Lord Lexington of the plate issued to him on his appointment as a commissioner to negotiate the Peace of Ryswick, a mission

which he had never fulfilled. The case was all the more glaring as he had already drawn plate for a Spanish embassy on which he had never gone. The formality of obtaining a royal gift of plate was no longer always observed and in 1718 the Master of the Jewel House drew up a list of forty-three issues of official plate which had neither been granted away nor returned. The earliest issue on the list had been made in 1685 and the remainder are spread fairly evenly over the intervening years. It is shown that in all 5575 oz. of gilt plate and 68,514 oz. of white plate had been annexed by those to whom it had been entrusted. Lord Lexington is debited with still another issue of plate made on account of his embassy to Spain in 1712, and the remaining names on the list include those of many of the most important persons of the time.

An extension of the abuse is exposed in another minute of 1727. Those entitled to official plate had been wont to leave their orders at the Jewel House but the regulations did not sufficiently limit the cost, and in preparing the estimates too little allowance was made for 'fashion'. As a consequence the plate of an ambassador, which was estimated at £2500, frequently cost from £2900 to £3000. It was suggested that in the future the procedure should be the same as was already in use in the case of a lord chancellor who was allowed 4000 oz. of white plate which must not cost more than £1700. Some attention seems to have been given to this suggestion, but there were too many interested parties to permit the re-establishment of the principle that the plate, which had originally been drawn out to support the dignity of the sovereign, should not be retained to satisfy the social ambitions of a subject. By the close of

the eighteenth century the right to retain official plate was so generally recognised that a new ambassador was actually allowed to take a cash payment of £2300 in lieu of plate if he preferred. The end of this abuse came, in the case of ambassadors, in the year 1815 when the necessity of economising after the conclusion of the Napoleonic wars permitted Castlereagh to introduce the practice of equipping each embassy with plate which was handed on by each ambassador to his successor. It was not until 1839, however, that a similar regulation was made at the instigation of Hume, with regard to the plate issued to the Speakers of the House of Commons.

The history of the abuse of official plate, ignored in previous books on English silver, not only helps us to realise the lavish manner in which plate was produced during the eighteenth century but will also help to correct the erroneous idea that plate engraved with the royal arms and insignia was necessarily intended for the sovereign's personal use. In point of fact this is best regarded as the mark put by the Jewel Office on the plate which passed through its hands. A candlestick bearing the arms and initials of Queen Anne, which formed part of the official plate of Sir Thomas Hanmer, Bart., Speaker of the House of Commons from February to August 1714, is here illustrated (Plate XIX, 91).

The number of persons who had the opportunity of equipping themselves with plate in the manner which has just been described was, of course, relatively small and the maintenance of the age-long tradition of the ostentatious acquisition of plate was by no means confined to them. The period between the Restoration and the death of George IV was one of such extraordinary prosperity for the landed and mercantile classes that

the demand for plate seems hardly to have been affected by legislation, taxation or increases in the price of the metal.

We are now so accustomed to the modern attitude towards silver which has reduced its use to a minimum, that we are apt to forget how differently our ancestors felt about it. We need, however, go no further than the diary of Pepys to discover how important the acquisition of a new piece of plate appeared in his eyes and there can be no doubt that the same species of gratification which he obtained from his purchases was widely felt at this period.

Each individual aimed at possessing the amount of plate which befitted his station. The meticulous accounts of John Hervey (afterwards created Earl of Bristol) show that during the decade 1691–1700 his expenditure on plate totalled £2010 : 4 : 3 and amounted in the single year 1696 to £649 : 2 : 11. Though to us such bills would suggest extravagance in one who was not accounted exceptionally wealthy, they can easily be paralleled. Between 1721 and 1725 the Rt. Hon. George Treby bought plate to the value of £2025 : 4 : 3 from the great Huguenot silversmith Paul Lamerie. Messrs. Garrard's accounts show that in the latter part of the eighteenth century a handsome service of plate could be purchased for £2000 but that wealthy customers were sometimes prepared to pay from £3000 to £4000 for an exceptionally large one. The Duke of Newcastle paid £3900 for his service of plate in 1771 and other instances can be gleaned from the same source. Lord Strafford, a distinguished diplomat, when he prepared a private estimate of his resources at the time of his marriage in 1711, entered his plate and jewels as

83

being worth £12,000. The amounts spent on single items are sometimes astounding. The silver bed made by John Cooqus in 1674 for Nell Gwyn cost altogether £906 : 7 : 5. Wine cisterns were invariably expensive, but the one supplied in 1687 by Messrs. Child and Rogers to the Earl of Devonshire for £1223 : 12s. was exceptionally dear. When the same firm supplied in 1681 the one still at Belvoir the price was £616 : 10s. The one purchased by the Rt. Hon. Arthur Onslow in 1743 cost £568 : 18 : 8, and as he was destined five times to be elected Speaker of the House of Commons it may be supposed that his accumulation of plate must have grown to be enormous. Even the small cistern given by the Earl of Bristol to his son Lord Hervey in 1727 weighed 317 oz. and cost £82 : 11s.

Having considered the conditions which governed the manufacture of plate during the century and three-quarters with which we have to deal, we must now attempt to trace the various styles which succeeded one another. As a preliminary it may be remarked that the use of gilt plate by private persons became progressively rarer as time went on. A large proportion of ceremonial plate belonging to corporations continued to be gilt right down to the end of the eighteenth century and a certain proportion of many grants of official plate were also gilt.

Owing to the inevitable overlapping of styles it is not really easy to arrive at any chronological arrangement which is entirely satisfactory. The first period to be dealt with may be said to have ended about the time of the Revolution.

Probably at no time since the fourteenth century was the number of foreign goldsmiths at work in London

PLATE VII

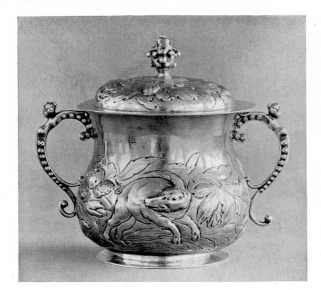

32

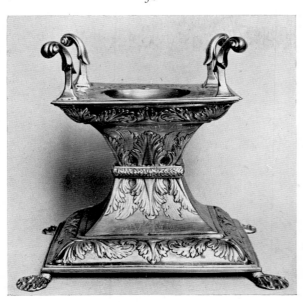

33

PLATE VII

32

CUP

Maker's mark, *AC in monogram.*
About 1660.
Height, 8⅜ in.
Goldsmiths' Company.

33

THE MOODY SALT

Maker's mark, *WH with a cherub's
head.*
Height, 7⅜ in.
Victoria and Albert Museum.

smaller than during the years from 1640 to 1660, owing to the slightness of the prospect of obtaining any profit in this country and to the lull in religious persecution abroad. Within a very short time of the restoration of the monarchy we begin to read once more of complaints about foreign craftsmen and particularly of Dutchmen. There can be no doubt that English silversmiths' work in the second half of the seventeenth century was deeply affected by Dutch art, but as this influence is already traceable during the lean years of the Commonwealth, it is clear that it can not be more than partially explained either by the immigration of Dutch workers or the return of royalist exiles from Holland.

Matted ornament, for instance, is found on Dutch and German silver from the early years of the seventeenth century. It appears to have reached England about the period of the Civil War and continued popular until the Revolution.

The use of heavily embossed floral ornament with which are combined birds and animals (Plate VII, 32, and P.B. II, 7, 9), which was extensively used during the reign of Charles II, reached this country from the Netherlands during the Commonwealth.

There can be equally little doubt of the Dutch origin of the embossed acanthus leaf decoration which is the most characteristic of all the forms of ornament used during the reign of Charles II (Plate VII, 33, and P.B. II, 15).

A very distinctive and fortunately much rarer type of embossed decoration shows the influence of the tradition of four great Dutch silversmiths, Adam and Christian van Vianen, of Utrecht, and the two Jan Lutmas,

of Amsterdam, who, also, were father and son. These
had evolved in the first half of the century a curious
species of design derived from fish forms. Christian van
Vianen seems to have spent most of the years 1637–44
in this country in the service of Charles I. He was again
in England between 1662 and 1666 and is still entitled
'his Majesty's silversmith', but he was perhaps not very
actively employed as in 1665 he stated that he had been
for the last three years in failing health, in a petition for
the final settlement of a debt due to him for altar plate
supplied for St. George's Chapel, Windsor, in the reign
of Charles I. His style had been further popularised by
a book of engraved designs published about 1650. The
best known of the pieces in this style are the wine-
fountain presented to Charles II for his coronation by
the Borough of Plymouth and now at the Tower, and a
standing cup of 1666 belonging to the Grocers' Com-
pany.

A rare technique of rather uncertain origin is shown
on a cup and cover of 1669 at the Victoria and Albert
Museum (P.B. II, 10), and the standing cup presented
to the Clothworkers' Company by Pepys in 1667. In
both cases the vessel is made of silver-gilt and is com-
pletely encased in a covering of silver pierced with a rich
design of birds, beasts and flowers in the Dutch style.

During the reign of Charles II the influence of the
Far East begins to affect the decoration of English
silver. Not much care was taken in the imitation of
Chinese art, and the standard of the execution of these
'chinoiserie' designs was usually low. The designs were
sometimes embossed but more generally engraved
(Plate VIII, 34) with fantastic scenes and bird and
plant forms.

As might be expected Dutch art did not cease to affect English silversmiths' work during the reign of William and Mary, but its importance as an influence gradually diminished. Two causes seem to have contributed towards this process.

The first of these was the ever increasing number of Huguenot silversmiths who began to seek refuge in this and every other Protestant country from the religious persecution which had broken out once more in France. The first appear to have arrived in 1682 when the admission of two to membership of the Goldsmiths' Company awoke an almost instantaneous storm of protest from the native craftsmen. The years of the heaviest immigration were, however, between the Revocation of the Edict of Nantes in 1685 and the accession of Queen Anne. The number of these immigrants was so considerable that it was inevitable that they should leave some mark on English silversmiths' work. Actually their intellectual vigour dominated English silver from 1700 to 1760.

It is necessary, however, to obtain some idea of the limits of the Huguenot influence. That it contributed to the overthrow of the Dutch hegemony can not be doubted, but the extent to which it contributed to the growth of the Queen Anne style is much more problematical. The prevailing fashion for silver in France in the latter part of the seventeenth century differed from that in Holland only in the form of its ornateness. Plain work was not unknown, however, and was produced chiefly by the provincial craftsmen from whom the Huguenot silversmiths who migrated to England were largely recruited. What does appear to be certain is that very few of the shapes used during the Queen Anne

period were introduced from abroad and in this respect the influence of the Huguenots resembled that of their Dutch predecessors and differed from the Germanic supremacy of the sixteenth century.

The second cause of the overthrow of Dutch influence, and probably the more powerful, was a change in the canons of public taste. We have already dealt with the rise of a similar movement in favour of simplicity in the early years of the seventeenth century and the period of its greatest extension in the days of the Commonwealth. The production of plate virtually without applied decoration had never, as a matter of fact, really ceased during the reign of Charles II, so that the simplicity of the Queen Anne style may be fairly claimed to be largely, if not entirely, an indigenous growth. Some of the devices used with such effect by the Queen Anne silversmiths had first made their appearance on the plainer work of the time of Charles II and it was encouragement chiefly which was needed to spur the craftsmen to greater efforts. The moment of arrival of the second period of simple silversmiths' work was more fortunate than that of the first, for it came at a time of increasing national prosperity instead of one of gradual economic deterioration. There was no lack of opportunities for the craftsman to increase his skill and no urgent cry for economy.

It is very necessary to realise that the use of the Queen Anne style was not confined to the actual reign of that sovereign. It was already well developed several years before her accession and lasted throughout the reign of her successor, only disappearing about the year 1730. Though we associate chiefly plain and undecorated silver with the early years of the eighteenth century

it was not until the reign of George I that the taste for simplicity obtained anything like general acceptance. From a little before 1688 till about 1715 there had been used a very characteristic type of embossed work which is sometimes referred to as the 'William and Mary' style. Owing to the inextricable manner in which the simpler and more ornate work are mixed up, we propose to treat the embossed work as a variety of the Queen Anne style which will therefore be regarded as obtaining from 1688 to 1730.

The forms of embossed decoration most constantly applied were vertical fluting and alternate fluting and gadrooning, either vertical or diagonal, accompanied usually with little stamped acorns, trefoils, etc. (Plate IX, 36). A scrolled cartouche with ragged bottom and with stamped scale-work was also very widely used. Borders are usually roped or gadrooned. It has been suggested that the gradual elimination of the embossed work in favour of the simpler cast work was a result of the adoption in 1697 of the finer 'Britannia standard' which, it is urged, was found to be too soft for embossing. As, however, a very large number of embossed pieces are found after the introduction of the purer alloy, it is obvious that the skill of the craftsmen was superior to any defects in the material.

Since the attraction of Queen Anne silver is derived principally from its beauty of outline, skilfully enhanced by mouldings and faceting, there is little enough to tell of characteristic forms of decoration. First of all must be mentioned 'cut-card work' which had been sparingly used from early in the reign of Charles II but which now became exceedingly popular. This ornament consists of designs cut in thin sheet metal and applied to

the body of the piece, usually with very attractive results as in the case of the two-handled cup belonging to All Souls College, Oxford, which is here illustrated (Plate VIII, 35).

Although the general appearance of simplicity is shared also by the larger pieces produced at this time, it will be found that in point of fact these often bear a considerable amount of cast ornament as beautifully finished as the best work of the periods when elaboration was fashionable. An examination of makers' marks on the more ornamented pieces leads to the conclusion that they were largely the work of the Huguenot craftsmen who successfully combined the simplicity fashionable in this country with something of the richness customary across the Channel. The English craftsmen could not afford to ignore the work of the foreigners who received the patronage of many of the most important clients, so that they also were forced to give greater attention to detail and finish. Some of the native craftsmen seem rather to have resented this change, as is shown in a passage in a petition against the foreigners addressed to the authorities of the Goldsmiths' Company in 1711:

'That by the admission of the necessitous strangers whose desperate fortunes obliged them to worke at miserable rates, the representing members have been forced to bestow much more time and labour in working up their plate than hath been the practice in former times, when prices of workmanship were much greater.'

Though there can be no doubt that it was the Huguenot craftsmen who led back their English contemporaries to more elaborate designs, the pace which they set was a very gentle one.

PLATE VIII

34

CUP

Maker's mark, *AR*.
Hall-mark for 1684.
Height, 4 in.
Museum of Fine Arts, Boston.

35

CUP

Gilt.
Maker's mark, *DG separated by a
sword supporting a crown.*
About 1690.
Height, 5⅝ in.
All Souls College, Oxford.

PLATE VIII

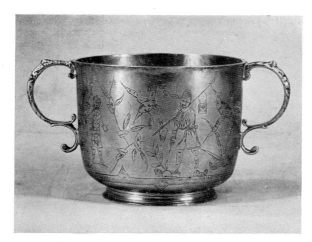

34

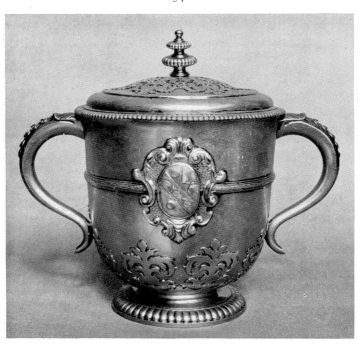

35

It was not till about 1730 that the shapes which we associate with the Queen Anne period began to disappear to be replaced by others, some of which were to remain in current use for the next thirty-five years. Just as the years 1688–1700 must be regarded as the initiation of the Queen Anne period so the decade 1730–40 is of the Rococo. A considerable proportion of the work of these years succeeds in combining the forms of the new period with something of the simplicity of its predecessor, but there is a very marked tendency towards richer effects and the general effect shows the influence of the work produced in France a little earlier during the Regency (1715–23). A very successful use was made of applied stamped work (Plate IX, 37), whilst engraving, which in late years had been practically confined to heraldic motifs, now began to play a more important rôle. The standard of craftsmanship of the engravers who executed the arabesques of the early years of George II was extremely high and affords a striking contrast to the puerile designs and slovenly workmanship which had obtained when engraving had last been extensively used in the reign of Charles II.

The period of the popularity of the rich and orderly arabesques was unfortunately short as, in about 1740, we see it becoming definitely superseded by the importation of a new form of ornament which aimed at a combination of richness with irregularity. The chief part in the origin of the Rococo style is generally attributed to the inventive faculties of Juste-Aurèle Meissonier, an architect, who in 1725 was received as a master into the Paris gild of goldsmiths as a result of a royal *lettre de cachet*, a very exceptional means of entry only known to have been used on one other occasion.

Plate from his designs soon became the rage all over France. The monumental style then fashionable in that country was objectionable to him and he set himself to supersede it with one chiefly characterised by the use of unsymmetrical forms, broken lines and the lavish use of scroll ornament. Amongst the first to use the new style in this country was Paul Lamerie whose work in the late seventeen-thirties was artistically several years ahead of most of his contemporaries. It is well to note that although Lamerie was early to imitate the new French style, he belonged to the second generation of Huguenot immigrants and had learnt his skill in Pierre Platel's shop in London. We should also remember, of course, that although colloquially the 'Lamerie style' is synonymous with the Rococo, this great craftsman actually worked in all the styles which succeeded each other during his long career from 1712 to 1751, and that the height of the Rococo fashion did not arrive till several years after his death.

According to modern opinion the shortcoming of the Rococo style lies in its sacrifice of shape to ornament, but the importance accorded to the latter raised the general level of workmanship to a height which has seldom been rivalled and helps to explain the reverence with which this period was regarded during the Victorian age. The finest execution is displayed in the cast and chased work, but the most characteristic feature of the period is the inordinate popularity of embossing. Engraving plays an important but a secondary part in many designs but the possibilities of pierced work were better exploited than ever before. The commoner features of Rococo design have already been mentioned, but to these must be added a few more. Amongst these

must be added the liberal use of floral motifs (Plate X, 38) and a return to 'chinoiserie' (Plate X, 39). The Oriental character of these last must not be stressed but it may be noted that whilst seventeenth-century 'chinoiserie' designs had usually been engraved, during the present period they were mostly embossed. It should be remembered, however, that although the Rococo period is chiefly memorable for its love of ornament, a certain proportion of the output was made up of comparatively plain pieces.

The end of the Rococo period came rather suddenly in about 1770. The style which succeeded it was the result of the accurate study of classical art which had been stimulated by the excavations at Herculaneum (begun in 1738) and Pompeii (begun in 1755). The discoveries here and elsewhere all contributed to show how inadequate had been the conceptions of classical art formed at the time of the Renaissance and accepted ever since. As a consequence of the interest that had been awakened throughout Europe, rich English travellers had begun to buy and ship home all sorts of sculptural remains collected for them by dealers, whilst at the same time began to appear illustrated books on Greek and Roman art, which made it possible for designers in England to become acquainted with new forms and styles of decoration.

Amongst those who did most to popularise the adaptation of classical designs for modern needs were the brothers Adam. Their influence on English silversmithing was chiefly indirect and exercised through their architectural work and Robert's books on archaeological subjects. In a lesser degree it was also direct, as Robert also designed plate for some of the clients whose

houses he had built. A number of pieces from his designs still survive and drawings for others are preserved at the Soane Museum.

Whilst it is legitimate to refer to this as the Adam period, it must be realised that the introduction of accurately copied classical forms and ornament into English silversmiths' work can not be attributed solely to the members of this talented family.

The Adam style, though frankly derivative, can be justly considered as purely English as any that was developed in this country during the eighteenth century. English designers made their own adaptation from the common stock of illustrations of classical remains which were open to all the silversmiths of Europe to use, and English work of the last thirty years of the century is related to that of contemporary France, Holland and Germany, only through the source from which all, in varying degrees, drew their inspiration. The international bond formed by the Huguenots now appears to have broken and from this date we can only trace a single strain in English silversmithing.

Whilst it is sometimes remarked that fashions in ornament go in cycles with alternating periods of simplicity and elaboration, it must be realised that the simplicity which we admire in the Adam style is due to the proper balancing of the claims of form and ornament and not to the virtual suppression of the latter as in the Queen Anne period.

Of the skill with which the Adam silversmiths borrowed the shapes and ornament of the ancient world, we shall have to speak at greater length when treating of the history of the various types of objects. The classic urn (Plate XI, 40), it was discovered, could be adapted

PLATE IX

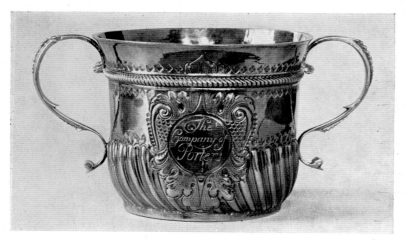

36

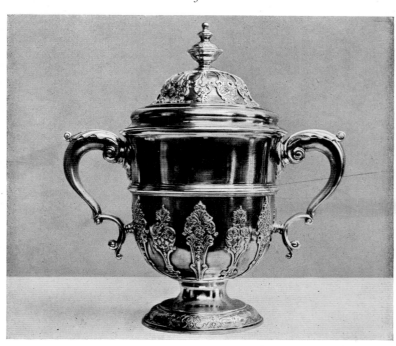

37

PLATE IX

36

CUP

Maker's mark of John Sutton.
Hall-mark for 1705.
Height, 4½ in.
Victoria and Albert Museum.

37

CUP

Maker's mark of Edward Vincent.
Hall-mark for 1736.
Height, 12⅜ in.
Victoria and Albert Museum.

for almost any purpose and even when it became necessary to invent shapes a classical flavour could be imparted to them by means of their decoration. Floral swags and draped linen suspended between oval shields, rams' and lions' heads, and various species of acanthus leaf formed the principal decorative motifs.

Free use was made of all the usual techniques but it may be noted that engraving ceases to be applied as profusely as during the Rococo period. The type of engraving most favoured was the 'bright-cut' (Plate XIV, 57) which now appears and which soon became a speciality of the Birmingham silversmiths.

The Adam period ended with the eighteenth century. The first thirty years of the nineteenth century were marked by the competition of two types of decoration, one of which was original and the other derived from the classic.

The derivative designs were invariably used for monumental pieces but were also used for objects of quite minor importance. The source of their inspiration appears to have been not so much the Pompeian work which had been so freely used during the Adam period, as the later and more massive periods of Roman art. That this change was not entirely the result of unconscious development is shown in the preface to the architect Charles Heathcote Tatham's book of *Designs for Ornamental Plate*, published in 1806, in which the writer remarks 'instead of Massiveness, the principal character of good Plate, light and insignificant forms have prevailed, to the utter exclusion of all good Ornament whatever'.

If modern opinion is apt to compare to its disadvantage the designs of the early nineteenth century with those of the close of the preceding one, it cannot be

denied that many of them do succeed in their attempt at
giving an impression of solid grandeur which is largely
due to the marvellous finish given to the strictly classical
ornament with which they are decorated. It is always
well when criticising the designs of this period and of
the preceding one to remember that the designers
derived their knowledge of classical art almost entirely
from works in stone, bronze or earthenware. The great
hoards of Roman plate which are now so familiar to
us, were not found till later—that of Bernay in 1830,
Hildesheim in 1868, Chaourse in 1883 and Boscoreale
in 1895. Though the event was to prove that the silver-
smiths' work of the Roman period was a less valuable
source of inspiration than might have been anticipated,
it is well to realise that the silversmiths with whom we
are dealing were always faced with the difficult problem
of adapting for silver designs which had been intended
for less precious materials. It is often difficult to decide
whether a design which is good in one material will be
equally good in another, so we must not be too severe
on the designers of this age, who went further afield in
their search for inspiration and who often fared worse
than their predecessors of the Adam period, who cared
less for archæological exactitude. Most of Tatham's
designs, some of which were actually executed, would
probably have been quite successful if carried out in
bronze or ormolu.

The great designer of plate in the early years of the
nineteenth century was John Flaxman (1755–1826),
and a number of pieces from his designs, executed
either by Paul Storr or by the royal goldsmiths Rundell,
Bridge and Rundell, are preserved at Windsor Castle.
They present an extremely unequal appearance. It is

impossible to deny the beauty of the cup decorated with a scene illustrating the First Idyll of Theocritus, executed by Paul Storr in 1812. On the other hand the design for the famous Achilles Shield of 1821 is quite unsuitable for execution in silver, whilst that of the four wine-coolers of 1827 are inappropriate for any material. The pair of wine-coolers of 1810 at the Victoria and Albert Museum (Plate XII, 42) are very much more successful. A candlestick of 1819, also in the national collection (Plate XII, 43), is an example of the best work of a comparatively unknown firm.

However we may regard the designs of Flaxman and of his contemporary Thomas Stothard (1755–1834), there can be no doubt that they were greatly admired both at the time and during the remainder of the first half of the nineteenth century. There was, of course, nothing new in calling in to design plate well-known artists with no practical knowledge of silversmithing, but the results have at all periods tended to be disappointing. The dictators of taste at the beginning of the nineteenth century seem to have decided that the sphere of the silversmith should be strictly limited to the execution of designs and they seem to have got what they desired. It is recorded that in 1827 a member of the firm of Rundell, Bridge and Rundell noticed the younger Pugin, aged fifteen, copying the engravings of Dürer and Silvestre at the British Museum and was so struck with his artistic capacity that he at once engaged him to prepare designs for plate. The arrangement lasted for only a short time, but it seems to show how far the idea of reforming the silversmiths' craft from without was carried. Unfortunately the designers were not all Flaxmans, Stothards or even Pugins.

PLATE X

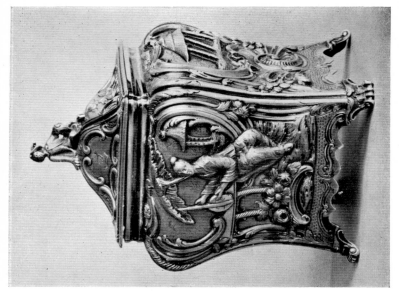

39

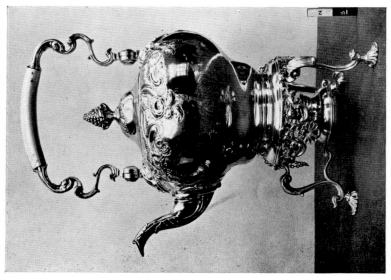

38

PLATE X

39

TEA-CADDY

Maker's mark of Pierre Gillois.
Hall-mark for 1766.
Height, 5⅝ in.
Victoria and Albert Museum.

38

TEA-KETTLE, with stand and lamp

Maker's mark of William Grundy.
Hall-mark for 1753.
Height, 13⅞ in.
Victoria and Albert Museum.

The original designs of this period were used almost entirely for such objects as teapots, coffee-pots, cruet-stands, salt-cellars and other objects too insignificant to attract the attention of the reforming academicians and architects. Though they tend to display the fashionable massiveness they are usually thoroughly serviceable and occasionally we come across a piece which would reflect credit on any age. To modern taste the minor works of some of the great silversmiths like Paul Storr are often more satisfying than their larger ones executed to the designs of fashionable artists. The weakness of the designers of these minor pieces lay in a tendency towards an over-profusion of ornament which becomes increasingly noticeable as time goes on. The decoration of the earlier pieces is frequently confined to simple ribbed or beaded borders, but latterly the prevailing taste was for naturalistic floral motifs.

There can be no doubt that in 1830, when we close our study, the prospects of silversmithing in this country were gloomy. The inventive capacity of the silversmith was being efficiently crushed. All that remained for the future was the development of three evils —the designs of a professional designer with no knowledge of the limitations of the silversmiths' art, the direct imitation of the forms and ornament of the past, and, perhaps worst of all, the combination of the ornament of the past with the shapes of the day.

THE DINNER SERVICE

THE revolution which took place in the table manners of our ancestors during the middle of the seventeenth century can be traced in almost every part of the dinner service, but nothing is perhaps more significant than the dethronement of the salt from its place of honour.

We left the history of the salt-cellar early in the reign of Charles I at a point when a design, which was destined to remain in fashion for rather over half a century, had begun to appear. It is less impressive than its predecessors, a fact which may be regarded as symptomatic of the decline of the prestige of its species. Most examples are almost free of applied decoration and are about 7 inches high. They are generally circular, square or octagonal and they have a waist which gives them an appearance slightly reminiscent of the late medieval hour-glass variety. The Moody Salt of 1664 at the Victoria and Albert Museum is typical (Plate VIII, 33) though rather more ornate than most examples. Round the cavity at the top are three or four scrolled brackets which form the most characteristic feature of the group. The purpose of these scrolls is generally supposed to have been to support a covering napkin when not in use. On 27 April 1662 Pepys went to see the splendid gilt salt, with four eagles in the place of the customary

scrolls, which the town of Portsmouth was about to present to Catherine of Braganza on her arrival in this country. Another use is suggested by his remarks:

'Visited the Mayor Mr Timbrell, our anchor-smith, who showed us the present they have for the Queen, which is a Salt-Sellar of silver, the walls of Christall, with four eagles and four greyhounds standing up at the top to bear up a dish; which indeed is one of the neatest pieces of plate I ever saw.'

The salt in question, which fully justifies the favourable criticism, in 1693 came into the possession of the Goldsmiths' Company as a gift from Thomas Seymour who in return was excused from serving as touchwarden.

Amongst the other elaborate salts of this type are the eleven gilt St. George salt-cellars which form part of the royal plate at the Tower and were made for the coronation of Charles II. They differ somewhat in form but all are richly embossed and some are fitted with a detachable domed cover, surmounted by a figure of St. George, with scroll supports similar to those commonly used at the beginning of the century.

The series of salts with scroll branches seems to end in 1686, though the feature recurs on the curious example of 1730 belonging to the City of London, which has a bowl-shaped body on three dolphin feet.

The survival of the tradition of salts of fancy design is shown in the castle salt presented by the City of Exeter for the coronation of Charles II, and a curious salt made in about 1698 in the form of the first Eddystone Lighthouse, in private possession.

The disappearance of the large salt was a direct result of the increasing popularity of the small one. A considerable range of simple designs were in use during the

Charles II and Queen Anne periods. They are for the most part low and in shape circular, quatrefoil or polygonal. A gadrooned example of about 1690 (Plate XIII, 44), recently acquired by the national collection, is rather more elaborate. Those made between 1700 and 1730 are usually merely faceted or moulded (Plate XIII, 46, 47). Another variety (Plate XIII, 45), which is considerably larger than the ones of which we have been just speaking, is found in the early part of the Queen Anne period.

From about 1720 to 1740, a type having a circular bowl and a round foot was much in evidence (Plate XIII, 48). The more elaborate examples are attractively decorated with applied leafwork on the lower part of the bowl. During the middle of the century the prevailing type consisted of a circular bowl on three or four feet. Many are nearly plain, but most of the finer examples are embossed with floral swags and have lion masks above the feet (Plate XIII, 49). Some are pierced with rococo or chinoiserie designs and are fitted with glass liners. During the Adam period the use of pierced designs with blue-glass liners became general. The most popular designs comprised respectively a circular bowl on a spreading base (Plate XIII, 51) and an oval bowl on four feet (Plate XIII, 50, 52). The decoration is generally classical in inspiration but free floral arabesques are also found. Amongst the designs which did not involve pierced work was one with a boat-shaped bowl, with or without handles, on an oval base.

The early nineteenth century produced no characteristic designs of its own, but adapted to the taste of the time many of the patterns in use in earlier times. The original designs which we do encounter, both good and

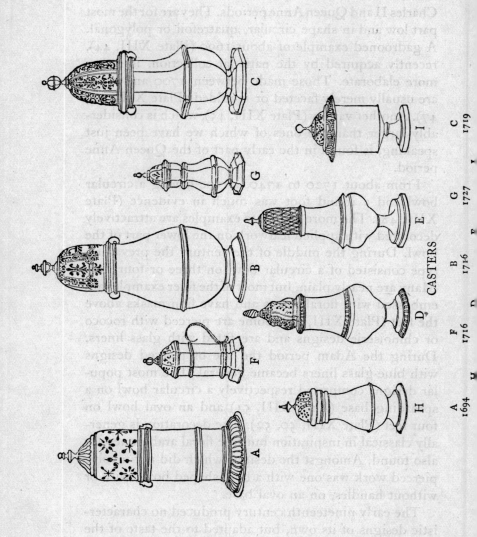

CASTERS

bad, seem never to have had a wide vogue. Some of the
more elaborate are reminiscent of the Italian bronzes of
the Renaissance.

Whilst the reign of Charles II was remarkable for a
decline in the importance given to salt, it added to that
of sugar and pepper. Sugar had been in use in this
country since the Middle Ages, but although it had
been a luxury it is not until we reach the middle of the
seventeenth century that we come across references to
receptacles for it. We then come across both casters and
sugar-boxes. It seems not improbable that we should
recognise by the latter name the oval caskets, on four
feet, with a hasped lid (P.B. II, 19), which appear about
this time and the use of which has hitherto been de-
scribed usually as spice-boxes.

Whilst the use of pepper in this country can claim
also to go back to the Middle Ages, receptacles for it
can only be traced back as far as the Renaissance. The
Victoria and Albert Museum possesses a small vase-
shaped caster of the year 1563 (P.B. I, 78) and casters
in the covers of bell salts have already been noted.

Since the middle of the seventeenth century casters
have been made in all sizes. The larger varieties will be
treated first. At first these were usually made in sets of
three, one large (sometimes 9 inches high) and two
smaller. Up to the year 1700 the standard pattern was
cylindrical with a gadrooned, roped or moulded base
and a pierced domed cover surmounted by a knob and
attached by a bayonet joint (p. 106, Fig. A).

The cylindrical body was occasionally used as late as
the third quarter of the eighteenth century, but after
1700 the normal caster is vase-shaped and fitted with a
moulded foot. A pear-shaped body, rounded or poly-

PLATE XI

41

SUGAR-BASKET, with blue-glass liner
Maker's mark of Burrage Davenport.
Hall-mark for 1774.
Height, 5⅜ in.
Victoria and Albert Museum.

40

CUP
Maker's mark of L. Courtauld and G. Cowles
Hall-mark for 1771.
Height, 14$\frac{11}{16}$ in.
Victoria and Albert Museum.

PLATE XI

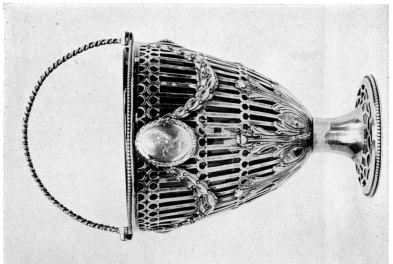

gonal, was at first usual (p. 106, Fig. B), but towards the end of the Queen Anne period the form is rather altered by the giving of a more acute curve to the part of the body above the moulding which marks the greatest diameter (p. 106, Fig. C). The piercing of the cover, which had been frequently very clumsily done during the Charles II period, now becomes extremely elaborate and beautiful. The designs are usually arabesques, but are sometimes floral. Though both the examples illustrated show the bayonet joint, a simple pull-off cover had become quite usual.

During the Rococo period the bottom part of the body tends to sag and to lose its rounded appearance and the domed cover its sing le curve (p. 106, Fig. D). At the same time a gener al decline in size is noticeable, the largest casters of the latter half of the century being usually no larger than the medium sized ones of the beginning. The casters of the end of the eighteenth century are for the most part very disappointing. The vitality which is displayed in most works of the Adam period, is singularly lacking in them and the piercing is most elementary and uninteresting (p. 106, Fig. E). The same may be said of most of the examples of the early nineteenth century.

The small casters of the latter part of the seventeenth and first quarter of the eighteenth centuries are made both with cylindrical and octagonal bodies and low domed covers with or without a handle (p. 106, Fig. F). Vase-shaped casters on the same lines were also popular (p. 106, Fig. G). At the close of the Queen Anne period there was introduced a pear-shaped caster with a low domed cover (p. 106, Fig. H). The covers of George II examples usually have a knob.

During the Adam period small casters were frequently made with pierced-work bodies fitted with blue-glass liners. A thistle-shaped caster appeared at the end of the eighteenth and continued popular during the first quarter of the nineteenth century (p. 106, Fig. I).

Large casters are frequently referred to as dredgers and small ones as muffineers. The latter term appears to be considerably younger than most of the objects to which it is applied.

During the period with which we are now dealing the history of the caster becomes intimately connected with that of cruets; through the invention of the cruet frame. Silver or silver-mounted cruets seem to have been in use in this country during the Middle Ages. It would be difficult to say how far they go back as it is necessary not to confuse them with the sacramental vessels of the same name. It is seldom possible to distinguish in a will or inventory silver table cruets from those for ecclesiastical use, as the former were certainly not in use in small houses whilst cruets mentioned in large houses may always have belonged to the chapel. It is therefore very necessary to examine the context of any supposed reference to domestic cruets and to weigh carefully the probabilities in every case. It will be found that not even all those given in Jackson will pass a rigid scrutiny.

The cruets used in Post-Restoration times have usually been made of glass with silver mounts. Their interest from the point of view of the silver collector is small, so that we had best proceed to study their more interesting stands.

It does not seem improbable that the use of cruet-frames may have originated rather before 1700, but, doubtless owing to the difficulty of replacing the fragile

contents, large numbers have been allowed to perish, and at present the series of surviving pieces seems to begin in the latter part of the Queen Anne period. The shape of the frame was largely conditioned by the number of vessels it was intended to contain. Some have no more than two cruets in an openwork frame with a lateral handle, but a more normal complement included three silver casters as well. For this case the stand was usually given three feet and had an open framework following the shapes of the vessels and a central handle. It is to this pattern that the name of 'Warwick' frame has been given. During the third quarter of the century the frames usually have pierced work sides. The shape does not always conform to that of the contents, some examples resembling an enlarged coaster with central handle. A popular design during the Adam period consisted in a boat-shaped stand with handles at the ends. In the early years of the nineteenth century an oblong stand with rounded angles, bulging side and central handle was much used.

Towards the close of the eighteenth century cruets were often supplied with little labels, like those used at the same period for decanters. It seems remarkable that no difficulty seems ever to have been experienced in distinguishing the contents of the casters.

In a bill for plate supplied in 1670 by the celebrated banker-silversmith Alderman Backwell for the use of Prince Rupert, occurs what appears to be the earliest known reference to a silver mustard-pot. The cleaning of another is charged up in the well-known bill for Nell Gwyn's plate, which is four years later in date. Although there is plenty of evidence for the use of mustard-pots during the latter part of the seventeenth century, few

PLATE XII

43

CANDLESTICK

Maker's mark of John Angell.
Hall-mark for 1819.
Height, 15⅞ in.
Victoria and Albert Museum.

42

WINE-COOLER

Gilt.
Designed by John Flaxman, R.A.
Maker's mark of Paul Storr.
Hall-mark for 1810.
Height, 9½ in.
Victoria and Albert Museum.

PLATE XII

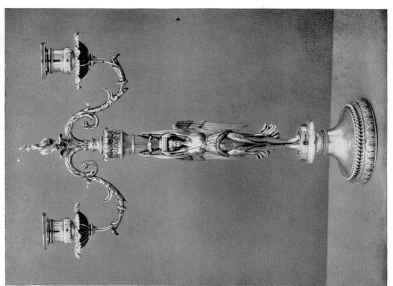

43

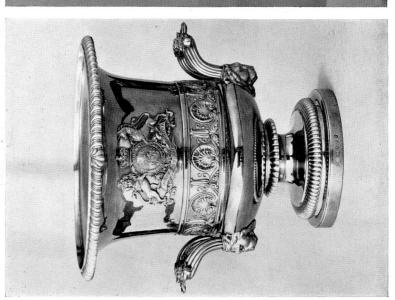

42

examples seem to have survived earlier than the middle
of the succeeding one. An example of the year 1724,
probably the work of Paul Lamerie, is barrel-shaped
and has a scroll handle and a domed lid with acorn knob
and the familiar aperture for a spoon. Another, in the
Farrer Collection, bears the mark of Edward Wakelin
and may be judged to have been made very soon after
he entered his mark in 1747. It is vase-shaped and has a
harp-shaped handle and domed lid. What was ulti-
mately to become the normal shapes for mustard-pots
had already appeared before the middle of the century.
These have cylindrical, oval or long-octagonal bodies,
scroll handles, domed lids and sometimes feet. A large
proportion have pierced sides and blue-glass liners.

Bread-baskets of Elizabethan date are known but
examples are very rare before the Queen Anne period.
Those actually made during that sovereign's reign
are usually circular with a spreading pierced-work
side fitted with a pair of handles. A certain number of
the examples of the middle of the century are shaped
like a giant cockle-shell but the majority preserve the
basket design and many are actually made in imitation
of basket-work. In the second quarter of the century
a swing handle replaced the pair of fixed ones. The
decoration is almost entirely by means of piercing, with
the exception of the strengthening band of cast-work.
The most attractive examples belong to the Rococo
period, the pierced designs of which often resemble the
openwork designs on tea-cloths. Those made towards
the close of the century are also mainly pierced and
show the prevailing classicism in floral swags and
little embossed medallions. Miniature bread-baskets
were made to contain sweetmeats and were also used

to furnish épergnes. Such baskets, of course, are fitted with bases instead of feet.

The elaborate épergnes of the eighteenth century took on the dinner table the place of honour which had been relinquished by the great salt. They were designed to save (*épargner*) the trouble of passing things at table, but the word, despite its French appearance, is in reality Anglo-Gallic and probably could not be found before 1700. The magnificence of a large épergne may be better appreciated if we remember that most of the objects we have described in this chapter and others besides, might form its fittings. Amongst the royal plate at the Jewel Office in Whitehall, in 1725, was a gilt 'Aparn containing one Table Basket and Cover, one foote, four Salt Boxes, 4 small Salts, four Branches, 6 Casters, 4 Sauceboats' weighing together 783 oz. The number of utensils forming the complement of an épergne varied as much as did the design. One of the earliest examples (of which there is an electrotype reproduction at the Victoria and Albert Museum) was formerly in the possession of Count Bobrinsky. It was made by Paul Lamerie in 1734 and is fitted with eight waiters, six casters, four candle-brackets and two cruet-frames, besides the central body. It was not possible to use the whole equipment at the same time, but the unwanted parts could be taken off and replaced by others. If any of the branches were dispensed with, their sockets could be filled with ornamental knobs. An épergne made by Paul Lamerie in 1743, now at the Victoria and Albert Museum, is typical of the more modest examples of the period. It was made as a wedding present to Sir Roger Newdegate and consists merely of an ornamental centre-piece with four detachable branches with waiters. In

other examples the centrepiece is crowned not by a waiter but by a bread-basket, whilst sweetmeat baskets hung from branches. Other épergnes of the Rococo period were made in the Chinese style. A fine example of 1745, by George Wickes, is at Windsor Castle. The épergnes of the Adam period are more remarkable for their flimsy appearance than for their classical veneer.

In place of an épergne fitted with numerous detachable parts, centrepieces of more solid construction were introduced before the middle of the eighteenth century. A magnificent example, made by Nicholas Sprimont in 1747, was formerly in the Ashburnham Collection. It is surmounted by a large covered fruit-bowl supported by two goats which are seated in the midst of a large salver. The tradition of this piece is carried on by another of 1780 in the possession of the Duke of Rutland. On the top Neptune reclines on an oval vase supported on four dolphins, which rest on a large and elaborately chased salver with feet in the form of sea-horses. The monumental centrepieces naturally found favour in the nineteenth century, which gloried in massive effects, but though we may allow a tempered admiration for some of those produced within our period, a general condemnation is not too hard for those of later date.

It is curious to note that in the year 1663 the officials of the Goldsmiths' Company took an unprecedented step in attempting to prescribe the shape of an object. Complaints had been made that some of the spoons which were then being made, were inconveniently short in the stem and narrow in the bowl. The Company now ordered that a pattern spoon should be provided for the assayer's office and that all spoons of $2\frac{1}{2}$ to 3 oz. weight brought for assay, which did not conform to it, should

be returned to the makers. It is difficult to say whether this ordinance had any result, as it does not seem to have been intended to affect the ordinary table-spoon (which weighs from 1 oz. to 2 oz.) and larger varieties are extremely uncommon.

The Restoration ushered in a century of continuous change in the form of spoons. Puritan spoons still continued to be made for some years after 1660, but were then superseded by a new variety which, after passing through numerous gradations of change, finally disappeared in the reign of George I. Two features have to be noticed about these new spoons. The bowl has become elliptical and its junction with the stem is reinforced at the back by a 'rat-tail' (Plate XIV, 53-4). The end of the stem is flattened out and rounded, but a couple of notches are cut in it so that the name 'trifid' has been applied to it. The minor varieties of the trifid spoon are countless, but in the course of time the cleavage of the notches increased, so that by the reign of Queen Anne the end has become wavy and resembles a rather weak triple cusp (Plate IV, 24). The most handsome trifid spoons are delicately engraved and sometimes gilt, but the ordinary method of ornamenting them was by stamping the back of the bowl and the end of the stem with floral scrolls. After about 1700 the decoration seldom consists in anything more elaborate than a little beading on the rat-tail. At about this date the stem begins to become more rounded.

Before describing the successors of the wavy-ended spoons which continued to be made into the reign of George I, a few words may be spared for a small but very curious group of spoons which lie half-way between the 'rat-tail' and the 'Puritan'. The bowls are of the 'rat-

PLATE XIII

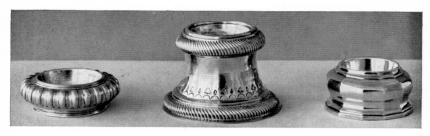

44 45 46

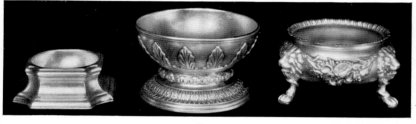

47 48 49

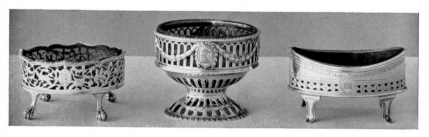

50 51 52

PLATE XIII

SALT-CELLARS

44

Gilt.
No marks.
About 1690.
Height, 1⅛ in.
Victoria and Albert Museum.

45

Maker's mark, *ET with two pellets.*
Hall-mark for 1695.
Height, 2½ in.
Victoria and Albert Museum.

46

Maker's mark of Matthew Cooper.
Hall-mark for 1707.
Height, 1⅔ in.
Victoria and Albert Museum.

47

Maker's mark of Edward Wood.
Hall-mark for 1728.
Height, 1⅛ in.
Mrs. Oman.

48

Maker's mark of Louis Cuny.
Hall-mark for 1728.
Height, 2 1/12 in.
Victoria and Albert Museum.

49

Maker's mark of D. Hennell.
Hall-mark for 1743.
Height, 2 in.
G. C. Bower, Esq.

50

With blue-glass liner.
Maker's mark of D. and R. Hennell.
Hall-mark for 1770.
Height, 1⅞ in.
Victoria and Albert Museum.

51

With blue-glass liner.
Maker's mark of R. Hennell.
Hall-mark for 1775.
Height, 2⅝ in.
Victoria and Albert Museum.

52

With blue-glass liner.
Maker's mark of John Wren.
Hall-mark for 1799.
Height, 2⅛ in.
Victoria and Albert Museum.

tail' type, but the stem is flat and ends in a roundel. On the front of the stem is engraved LIVE TO DIE with a skull on the roundel, and on the back is DIE TO LIVE with the arms of Strickland borne on a lozenge. Three spoons of this type are known, all bearing the York hall-mark, one made by John Plummer in 1661 and the other two by Thomas Mangy in 1670 and 1677 respectively. It has been claimed that these spoons were made, like the American 'coffin-spoons', for giving away to friends and relatives at the funeral in place of mourning rings. Though it is readily understandable that these somewhat grim objects might readily be consigned to the melting-pot after they had passed into the possession of persons unacquainted with the deceased, it is curious that the evidence for this supposed custom should so far be confined to spoons connected with one family.

Other varieties of trifid spoons are of political interest. Some which bear the Leeds mark and seem to date in the latter part of the reign of Charles II, bear on the end of the stem a little cast medallion of the head of Charles I. Others of about the same date are stamped with a little head of the reigning king, and with a mark which is generally attributed to Bridgwater.

In about 1710 began to appear an alternative form of 'rat-tail' spoon to that with the wavy end. Its end is rounded and curved upwards, the earlier examples having quite a marked ridge running down the middle. This type of end remained the standard pattern until about 1775, as the changes which took place in the middle of the century affected only the bowl. The only other form of end used during this period which need be noted is the 'Onslow' pattern, called after Arthur Onslow,

Speaker of the House of Commons. It is not common and has a ribbed end curved downwards.

The next change to be noted affected the bowl, which became increasingly egg-shaped, whilst the 'rat-tail' disappeared early in the reign of George II, though spoons retaining this feature were still occasionally made, even in London, as late as 1773. The junction of the bowl with the stem was now merely reinforced with a single or double drop (Plate XIV, 56). From about 1740 until about 1775, the back of the bowl was usually decorated with a stamped ornament (Plate XIV, 55).

The spoons of the Adam period are of the 'Old English' pattern and are both more attractive and more usable than any other type produced since 1660. The rounded ends are curved down and the varieties consist only in the form of their decoration. Of these the most familiar are the 'bright-cut' (Plate XIV, 57), 'feathered edge' (Plate IV, 25), 'beaded edge' and 'threaded edge'.

In the early nineteenth century appeared the familiar 'fiddle' pattern spoon, with its more ornate derivatives, the 'thread and shell' and the 'king' pattern which are too well known to require description.

Tea-spoons, strainer-spoons and caddy-spoons are dealt with elsewhere and the other varieties of spoon will not delay us long, since they are closely related to those which have just been described.

Ladles made much before 1750 are rare, though it is quite clear that they had been in use for a considerable time before that date. Most examples have circular bowls and a curved stem of the same type as the contemporary table-spoon.

Salt spoons are not known to have been made before the close of the seventeenth century. Many early ex-

amples resemble miniature table-spoons but the familiar ladle shape appeared at a comparatively early date. A variety having a shovel-shaped bowl was in use from about 1740 till the close of the eighteenth century. During the Rococo period and the early nineteenth century a number of eccentric types were devised which do not require description.

A mustard spoon is mentioned in an advertisement of 1678, but extant examples only date from well into the eighteenth century and are usually formed like ladles.

Marrow-scoops were widely used during the eighteenth century. Some examples have scoops at both ends, but others combine an ordinary spoon with a scoop which serves as the stem.

When dealing with the silver of the early Stuart period some mention was made of the first appearances of the silver table fork (p. 72). Though English writers might note the spread of the use of this utensil, to foreigners who visited this country even after 1660, the fork was conspicuous by its absence, although it had by this time won its way into general use in polite society abroad. Samuel Sorbière, who visited England in 1663, remarks that the English (to whom he took a strong dislike) 'scarce ever make use of forks or ewers, for they wash their hands by dipping them in a basin of water'. Count Magalotti, who accompanied the heir of the Grand Duke of Tuscany in his visit to England six years later, is still more precise (if more involved):

'There is a great want of neatness and gentility which is practiced in Italy; for on the English table, there are no forks nor vessels to supply water for the hands, which are washed in a basin full of water, that serves for all the

company or perhaps at the conclusion of dinner, they dip the end of the napkin into the beaker which is set before each of the guests, filled with water, and with this they clean their teeth and wash their hands.'

Only at the close of the century do the number of forks in inventories begin to approximate to that of the spoons.

The connection between the two implements remained very close, as the shape of the handle of the fork merely followed that of the spoon. The number of the prongs varied without any apparent reason. Three-pronged forks were in general use until the second half of the eighteenth century, when they were gradually superseded by those with four prongs, although these last had been well known since the end of the seventeenth century. Two-pronged forks were popular until about 1700 and were still being made at York in 1784, and at Newcastle in 1801.

In addition to forks made entirely of silver, there is another variety which enjoyed a long period of popularity during the eighteenth century. These have steel prongs and handles of thinly stamped silver, filled with resinous composition. They have usually two or three prongs and a rounded handle. A common variety has the end of the handle curved like a pistol butt. These forks were used in conjunction with knives with similar handles, and blades usually with a curved back and rounded end.

Most of the other forms of silver knives which are ordinarily encountered on the modern dinner table cannot trace their history much before the late eighteenth or early nineteenth century. The fish-slice, however, goes back to the middle of the eighteenth century, a particularly fine one of 1741, made by Paul Lamerie, is

in the Farrer Collection. It has a rounded blade pierced with fishes. The more ordinary of the early examples have a blade, either resembling a pointed leaf or a builder's trowel, elaborately pierced and engraved. The curved end resembles that of the contemporary spoon.

The general adoption of forks spelt the ultimate ruin of the ewer and basin. The prevailing design for ewers during the Charles II period, resembled a straight-sided goblet with the rim bent into a scarcely perceptible spout, and was fitted with a harp-shaped handle. The later examples, made about 1700, have a short cast spout added to the lip, which decidedly improves their appearance. The basins are virtually plain.

Shortly before 1700 appeared what was destined to be the last standard pattern. The body resembled an inverted helmet and had either a harp-shaped handle or a curved one bent over the body. The basin was usually circular but sometimes oval. The helmet ewers of the Queen Anne period are, without exception, magnificent examples of the proper combination of a good shape with a rich but restrained ornament. The same can be said of some of the later ones, such as the ewer and basin of 1739 made by David Willaume at Clare College, Cambridge, but as a rule the ewers and basins of the Rococo period give an impression of over-decoration, even when not positively grotesque. The ewer and basin of 1741 made by Paul Lamerie for the Goldsmiths' Company, are doubtless superb from the technical aspect, but regarded as works of art can only be described as uninspired. The ewer and basin had by now become no more than a sideboard ornament, and their manufacture virtually ceased in the third quarter of the eighteenth century, although the wealthy were

still prepared to expend vast sums for other varieties of plate of no greater utility.

The earliest known sauce-boats belong to the year 1698, but neither literary evidence nor the number of extant examples suggest that they were at all common before the accession of George I. The earliest variety has an oval body with a shaped rim, a spout at each end and a handle on either side (p. 127, Fig. A). They normally stand on a moulded base but some are fitted with four feet. This pattern was ousted in the middle of the eighteenth century by a boat with a pouring lip at one end and a handle at the other, a design which had appeared about the middle of the reign of George I. Two varieties exist of this type, as of the last, one being equipped with a base (p. 127, Fig. B) and the other with feet (p. 127, Fig. C). The scroll handle is sometimes attached at both ends to the body, and at others is curved over the body. The sauce-boat was made the subject of countless experiments during the Rococo period. Whilst some designs are a play of spirited curves (p. 127, Fig. D) others are purely fantastic and unshapely. The later examples of the scroll-handle type are usually made of rather flimsy metal, though English examples are less often embossed than the contemporary Irish.

In the middle of the eighteenth century there began to appear a covered sauce-boat having no pouring lip and resembling a miniature soup-tureen. During the Adam period these vessels are shaped as urns (p. 127, Fig. E), whilst at the beginning of the nineteenth century they conform to the fashionable rounded oblong form with bulging side (p. 127, Fig. F).

The word tureen is said to derive its existence from

PLATE XIV

SPOONS

53

RAT-TAIL
Trifid end.
Maker's mark, *T. D.*
Taunton mark.
About 1680.
Length, $7\frac{11}{16}$ in.

54

RAT-TAIL
Trifid-end.
Maker's mark, *TZ.*
Hall-mark for 1696.
Length, $7\frac{3}{4}$ in.

55

SHELL-BACK
Maker's mark of Peter Bennett.
Hall-mark for 1739.
Length, $8\frac{3}{8}$ in.

56

DOUBLE-DROP
Maker's mark of Thomas Jackson.
Hall-mark for 1743.
Length, $7\frac{3}{8}$ in.

57

OLD ENGLISH
Bright-cut.
Maker's mark, *IL.*
Hall-mark for 1780.
Length, $8\frac{1}{4}$ in.

Victoria and Albert Museum.

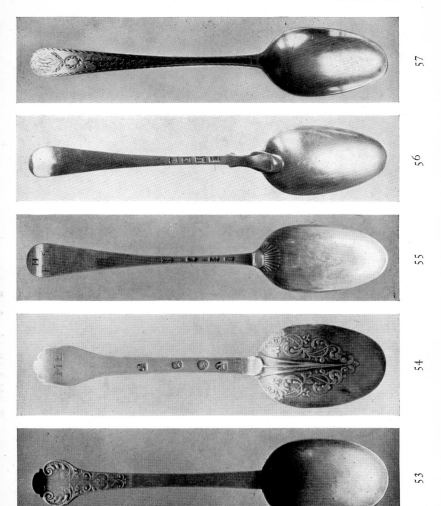

PLATE XIV

the story that Marshal Turenne on one occasion used his helmet to hold soup. A tureen of the year 1703, the work of Anthony Nelme, appears in the catalogue of the loan exhibition at South Kensington Museum in 1863. Little need be said of these sumptuous vessels. Their decorations naturally changed with the times, but the form of body was usually oval and supported on four feet or a spreading base.

The Argyle was an ingenious vessel for keeping gravy hot and is supposed to have been introduced by John, 4th Duke of Argyll (*d.* 1770). It was heated either by an interior lining filled with hot water or by a hot iron fitting into a socket like a tea-urn. It was extensively used during the last quarter of the eighteenth century and the early years of the following one. Its shape was something between that of a teapot and that of a coffee-pot. The handle and spout were usually put at right angles to each other.

Silver plates and dishes can trace their history back to an early period and huge quantities appear in some of the inventories of the latter part of the Middle Ages and of the Renaissance. The survival of so few examples made prior to the seventeenth century need not be regretted too much, as it is improbable that any large proportion ever had any appreciable artistic interest. A few sets of finely engraved fruit-plates form an exception. A set of 1573 showing Old Testament scenes was bought for the Victoria and Albert Museum in 1946. Sets of 1567 and 1569 depict Hercules and the Prodigal Son.

The plates of the seventeenth century have not always as much ornamentation as a moulded border. Waved and gadrooned borders add but slightly to the interest of those of the eighteenth and nineteenth centuries.

During the period with which we are dealing a number of methods were used to avoid the evil results of standing the hot meat dishes directly on the table. The usual plan was, of course, to stand the dish on a plate to match. In an anonymous inventory of plate dated 15 January 1697, found at the Public Record Office amongst the papers relating to the Dutch Treaty of that year, are mentioned '2 Rings', whilst an advertisement in the *London Gazette* of 24 June of the same year refers to '2 Rings for a Table'. Though it would be rash to depend much on such vague phrases it is not impossible that they may refer to dish-rings, as an example of the year 1704 by the silver-smith Andrew Raven is in a private collection. Though these objects seem to have fallen completely into oblivion in this country, they were afterwards extensively manufactured in Ireland during the latter part of the century. Dish-crosses appear rather before the middle of the eighteenth century in order to serve the same purpose. The feet and supports are made to slide along the rods of the cross so as to be able to carry different sizes of dishes. They are often fitted with spirit lamps and are generally extremely finely finished considering the very subordinate rôle which they were intended to play.

It seems unnecessary to do more than mention the silver skillets for broths and caudles, produced chiefly during the Charles II and Queen Anne periods. They are fortunately rare, as they are completely lacking in artistic interest. We propose to accord equally summary treatment to the entrée dishes, and dish covers of the eighteenth century, as these are not usually of interest to the collector although of rather greater artistic importance.

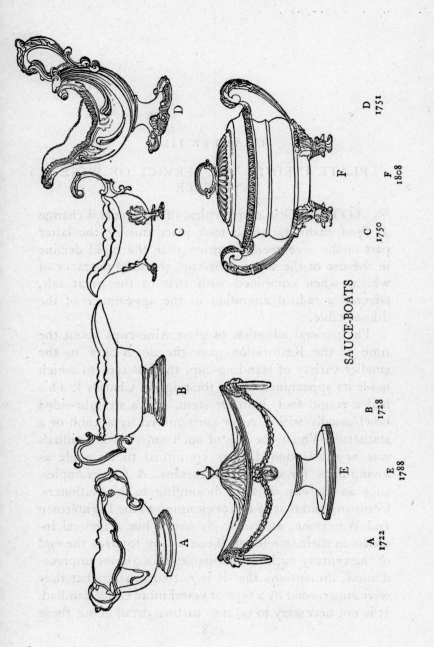

SAUCE-BOATS

A
1722

B
1728

C
1750

D
1751

E
1788

F
1808

CHAPTER III

PLATE USED IN THE SERVICE OF WINE AND BEER

NOTHING is more typical of the general change of manners which took place during the latter part of the seventeenth century than the rapid decline in the use of the silver wine-cup, the disappearance of which, when combined with that of the great salt, effected a radical alteration in the appearance of the dinner-table.

The general adoption of glass wine-cups about the time of the Restoration gave the death-blow to the smaller variety of standing-cup, the last type of which made its appearance late in the reign of Charles I. This had a round foot, baluster stem, and a straight-sided bowl usually with a cover surmounted by a knob or a statuette. Whilst the use of such cups by individuals was now abandoned, they continued to be made as loving-cups for convivial occasions. A few examples, such as the cup of 1677 belonging to the Stationers' Company and that of 1695 belonging to the Lightermen and Watermen, are relatively small, but a general increase in their size led to the attaining towards the end of the century such unreasonable (though not unprecedented) dimensions that it is not surprising that they were superseded by a type of vessel more easily handled. It is not necessary to go into further detail about these

cups which display all the forms of ornament in use during this period, but special mention may be made of that presented by Samuel Pepys in 1677 to the Cloth-workers' Company which is the finest example of the peculiar pierced openwork technique already described (on p. 87). Equally worthy of mention is the unique cup in the form of the Royal Oak, having a cover surmounted by a crown, presented by Charles II to the Barbour Surgeons' Company in 1676, in commemoration of his memorable escape.

It is now necessary to turn to the smaller varieties of drinking-vessels which, although tracing their origin back to the first part of the century, reached their fullest development later on. These have been divided arbitrarily into two classes, caudle or posset cups and porringers, but as the lines on which this division has been made is entirely without validity it will not be used here, where we shall speak only of two-handled cups. It is, of course, pretty certain that the vessels in question are those which are referred to in wills and inventories by the names given above, but we have so far discovered no means of appropriating the correct name to each object, and it may even be doubted whether our ancestors had very definite views on their proper nomenclature. It seems equally improbable that the use of these cups was confined in the least strictly to these peculiar and, to modern taste, unappetising contents or to the homely porridge. Caudle, it may be mentioned, was a warm drink composed of thin gruel mixed with sweetened and spiced wine or ale, whilst posset contained hot milk curdled with ale or wine and flavoured with sugar and spices. Caudle and posset cups and porringers all appear in sixteenth-century inventories,

but no examples have survived and the earliest examples of the two-handled cups with which we have to deal belong to the succeeding century. They were produced according to several distinct designs, some of which remained unaltered but most of which changed in appearance as time went on.

Amongst those which remained unaltered were the 'College Cups', a variety which invariably commands a high price in the auction room not because of its beauty or rarity but because all the surviving examples except four were originally made for Oxford colleges and only a few, which have been lost by neglectful or improvident bursars, are ever seen in the market. This type of cup has a low foot, pear-shaped body and two ring-handles attached to the neck. It has been suggested that it is derived from a type of two-handled covered pot of which there is an example of 1533 at Corpus Christi College, Oxford, and two of the years 1555 and 1570 (probably replacing others of earlier date) at the Cambridge College of the same name. This would appear to be a little far-fetched but there seems no reason to doubt that this type of cup probably pre-existed the earliest surviving example by a number of years as is suggested by the entry in 1595 in the plate book of Brasenose College, Oxford, of 'towe silver potts wt eares'. The earliest example, of 1616, was presented by the great collector Earl of Arundel to Greenwich Hospital and is preserved by the Mercers' Company. Whilst a number of these cups, which were made well into the eighteenth century, still remain at Oxford, there is none at Cambridge, where they were certainly used before the Civil War.

Another variety, which made its appearance in the middle of the seventeenth century and which was

extremely popular during the reign of Charles II, re-
sembled the last in having a bulbous body contracting
into a neck, but has two scroll-handles usually formed
as caryatids. The example belonging to the Gold-
smiths' Company of about 1660 (Plate VII, 32) shows
a very usual type of cover surmounted by a grotesque
knob in the Dutch style. Others, such as the example of
1660 at the Victoria and Albert Museum (P.B. II, 7),
have the knob replaced by a flat button so that the cover
can be stood upside down. A simpler variety of cover
with a moulded knob is shown by that belonging to the
cup of 1673 in the same collection (P.B. II, 11) presented
by Charles II to Archbishop Sterne, great-grandfather
of the author of *Tristram Shandy*. It is well to remember
that not all the cups of this sort are as impressive as those
which have been mentioned. Many are considerably
smaller, without covers, and meanly decorated.

The type of two-handled cup which was destined at
the beginning of the eighteenth century to take over the
functions of the tall loving-cup had begun to appear
some fifty years earlier. It was made both with and
without a cover and had a deep bowl with side either
vertical or only slightly sloping outwards. The two
handles were usually of the scroll and caryatid types
characteristic of the period. A good example of the year
1684 has lately been bequeathed to the Boston Museum
of Fine Arts (Plate VIII, 34), whilst three excellent
examples of the years 1656, 1676 and 1683 are in
the national collection (P.B. II, 6, 15, 17). These cups
vary very much both in size and artistic finish. The
smallest would certainly not contain more than a small
draught for one person, whilst others have bowls as
much as $7\frac{1}{2}$ inches deep and $9\frac{1}{2}$ inches in diameter.

Some of the earlier examples of both this type of cup and the one described just before it were originally equipped with salvers, but most of these have got dissociated in the course of time. Thomas Blount in his *Glossographia* (2nd edn., 1661) describes the salver as follows:

'Salver . . . is a new fashioned peece of wrought plate, broad and flat, with a foot underneath, and is used in giving Beer, or other liquid thing to save the Carpit or Cloathes from drops.'

The national collection possesses a very fine early salver of 1664 richly embossed with flowers and beasts (P.B. II, 9). The salvers of the end of the century and the beginning of the eighteenth are plain except for a roped, gadrooned or simply moulded border. During the first quarter of the century the circular salver on spreading foot was replaced by small square or circular waiters on three or four feet which were miniature editions of the current 'tea tables'.

Towards the end of the seventeenth century there grew up alongside the variety of two-handled cup, which has just been described, a cup of more substantial construction and imposing appearance. The production of the lighter cups, however, did not cease; an excellent example of the year 1705 is illustrated (Plate IX, 36) as well as one of the year 1777, which has been entirely spoilt by decoration added in the nineteenth century (Plate XXI, 101). The proportions of this last, as also of most of the later examples of this type of cup, are decidedly poor.

The gilt cup of about 1690, presented to All Souls College, Oxford, by George Clarke, is a splendid example of the more massive variety of cup which

began to appear about this time (Plate VIII, 35). Harp-shaped handles were used as alternatives to the scrolled ones shown in the illustration, and as the first quarter of the eighteenth century proceeded these cups gradually grew in size and their proportions altered by an increase in the height of the foot and the dome of the cover. This increase in size and importance was doubtless a result of their adoption as loving cups. The fine cup made in 1736 by Edward Vincent (Plate IX, 37) differs from the later examples of the Queen Anne period only in its wealth of applied ornament. Towards the middle of the century, however, the outline of the bowl was altered, by allowing the bottom to sag, as was done in many other varieties of vessel produced during the Rococo period. The silversmiths of the Adam period found in the two-handled cup a perfect opportunity for reproducing classic forms. The example of 1771 by L. Courtauld and G. Cowles (Plate XI, 40) is amongst the earliest and finest cups in the form of a funerary urn which remained the stock source of inspiration for designers until the close of our period.

Though the general adoption of wine-glasses put an end to the manufacture of most of the smaller varieties of silver wine-cups the manufacture of wine-tasters still continued. These served two purposes, both of which can be traced back to the Middle Ages. The cup of assay or essay cup was used on ceremonial occasions at the tables of great personages by whoever was deputed to taste the wine to detect poison. Seven such cups, one with a salver, appear in the 1725 inventory of royal plate, but we have no indication either of their appearance nor of those of earlier periods, though their weight was usually slight. The second purpose of the wine-

taster was to allow the vintner to sample the wine which he was proposing to buy. For this purpose it was necessary to have a small bowl which was also shallow so as to show the colour of the wine. The vintner's silver taster was already a well-known feature in late medieval times. One appears in the 1383 inventory of the goods of a Norwich taverner, while in 1477 a statute which dealt with the enforcement of the embargo on the export of plate, made a special exception in the favour of the merchant who took 'un taster ou shewer pur vine' overseas when going to replenish his stock.

The earliest-known wine-tasters are the shallow rudely embossed two-handled bowls which have already been mentioned (p. 67) but which continued into the reign of Charles II. Recently Mr. E. Alfred Jones has suggested that there should be included in this category a species of vessel produced in small quantities in the seventeenth and eighteenth centuries and known in collecting circles in America as a 'porringer' and in England as a 'bleeding bowl'. There seems to be no doubt that this vessel, which consists of a bowl of varying size with a single flat pierced handle, was actually used in America as a porringer, whilst it is equally certain in England some pewter vessels of similar form were marked inside with a scale in ounces supposedly for cupping, but the writer has never encountered a silver example so engraved. Whilst it may be admitted that the smaller examples are somewhat reminiscent of a well-known French type of taster and might well have been used for this purpose, some other explanation must be found for the existence of larger and commoner ones which, if used as tasters, would have proved both extravagant and unserviceable, as if filled to anything like

their capacity, the colour of the wine would be quite indistinguishable. It would seem on the whole wiser to suppose that these English bowls were used like those in America as porringers, as is rather suggested by a passage in an advertisement of lost plate in the *London Gazette* for 20 October 1679, where are mentioned '3 Porringers (one with the ear off)'.

Another variety of wine-taster was also in use from the second quarter of the seventeenth century. This was in the form of a bowl with a sloping side and a domed bottom admirably suited for showing the wine. Examples are usually quite plain except for an inscription.

Further confirmation of this is afforded by examples of silver skillets having an inverted one-eared porringer to serve as the cover.

Mention may be made here of several minor varieties of drinking-vessels, some of which may have been used for wine and the rest probably for spirits. Puzzle-cups, which had to be drained without spilling the contents, were hardly ever made in this country before the reign of George IV, though numerous forgeries exist. An example of Charles II date belonging to the Vintners' Company is in the form of a milkmaid holding a small swivelled drinking-cup above her head, whilst a second cup is formed by her skirts. Another of similar form, by the silversmith Jonah Clifton, was presented in 1727 to the Guild of the Trinity House, Hull, and bears a quaint anti-Jacobite inscription. Countless varieties of small cups, with or without a handle, are found during the eighteenth century and were probably used for brandy. During the reign of George III there appeared several varieties of goblets which may have been used either for

wine or beer. Some have an eggcup-shaped bowl and a round, square or octagonal base, whilst others produced towards the close of the reign have a thistle-shaped bowl. Amongst the miscellaneous drinking-vessels of this period may be mentioned the stirrup-cups in the form of a fox's head, which appeared at the beginning of the last quarter of the eighteenth century and were very popular at the beginning of the succeeding one.

If the silversmith lost opportunities for showing his skill with the general adoption of wine-glasses he gained a new outlet for his skill in the making of a wine-glass-cooler—an excellent example of the extent to which the cult of luxury was carried in the latter half of the seventeenth century. These took the form of large bowls with notched borders, and are found both with and without handles. They were known as Monteiths, as is shown in a well-known passage by the Oxford diarist Anthony Wood:

'This yeare (1683) in the summer time came up a vessel or bason notched at the brims to let drinking glasses hang there by the foot so that the body or drinking place might hang in the water to cool them. Such a bason was called a "Monteigh" from a fantastical Scot called "Monsieur Monteigh" who, at that time or a little before, wore the bottome of his cloake or coate so notched.'

The earliest example of this type of vessel which has survived is a particularly fine one of 1685 belonging to the Drapers' Company. It will be noticed that the first monteiths neither had detachable rims nor were used as punch-bowls. These points can be further verified by the definition in Kersey's *English Dictionary* (1706), 'Monteth, a scallop'd bason to cool Glasses in'.

The brewing of punch appears to have been introduced into this country during the second quarter of the seventeenth century by Englishmen returning from the Indies. Unlike tea and coffee it was stigmatised neither as a medicine nor as having anti-social tendencies and its popularity spread rapidly during the Commonwealth and reign of Charles II. Punch, it would appear, had long been brewed in bowls but the earliest references to silver punch-bowls are only of about the same date as those to monteiths. At an early date it was discovered that the same vessel could be made to serve as punch-bowl and glass-cooler by fitting it with a detachable notched brim. Monteiths with detachable rims were made in large quantities from about 1690 to 1710, but their manufacture had virtually ceased by 1720. If after this date there was less insistence on cool glasses, there was no decline in the demand for hot punch. Later punch-bowls are therefore without the detachable rim and are decorated in accordance with the prevailing style of the time.

Complementary to the punch-bowl was the silver saucepan and the ladle. The former requires no description. A large range of designs were used for punch-ladles. A minority are silver throughout, the majority having wooden or whalebone handles. The commonest type has a circular bowl with or without a pouring lip. A great many have been hammered out of Spanish dollars or crown pieces in such a way that the marginal design or inscription still appears on the lip of the ladle. The setting of a coin at the bottom of the bowl was also a common trick. Other designs get right away from the circular bowl and have a shaped one or one in the form of a shell.

Lemon-strainers were another necessary accompaniment to the punch-bowl. They show little variation and have a pierced circular bowl and two flat handles with shaped edges and sometimes pierced. Whilst speaking of lemon-strainers it is curious to note that orange-strainers appear to have been not unpopular at a rather earlier date. One weighing 4 oz. and formerly belonging to the Duke of Buckingham appears in the royal inventory of 1520; six appear in that of 1574.

If it was desirable to keep wine-glasses cool, it was still more necessary to keep the wine itself cool. We have already had occasion to mention silver wine-cisterns (p. 84) as being the most costly of all the pieces of plate made during this period. Base-metal cisterns filled with water had certainly been used in this country in the earlier part of the seventeenth century for keeping wine-bottles cool at banquets. It was not, however, until after the Restoration that we come across silver ones. In 1672 Charles II provided his mistress Renée de Querouaille with one weighing 1000 oz. and the earliest surviving example of two years later is in the possession of the Earl of Rosebery. They are always oval in form and supported on a substantial base. All the styles in use between the time of their appearance and of their disuse at the close of the eighteenth century are found represented. In the early part of the eighteenth century almost every large house contained one, though it is curious to note that there were none in the royal palaces in 1725, although four are known to have been purchased for William III in 1689. Though some are comparatively modest in size and weight (say 2 ft. wide by 15 in. high and weighing 280 oz.), others are simply immense. One, in the possession of the Duke of Buccleuch,

which was made in 1702 by Benjamin Pyne is 3 ft. 2 in. high and weighs 2056 oz. Amongst the plate made for the great Duke of Marlborough, in the possession of Lord Spencer, is one made in 1701 by Philip Rolles which is 3 ft. 10½ in. wide by 17½ in. high. Greatest of all, however, is a cistern made in 1734 by Charles Kandler, from the design of George Virtue, which is 5½ ft. wide by 3½ ft. high and weighs 8000 oz. It is not known for whom it was originally commissioned but it was bought by the Empress Catherine II of Russia. It is a fantastic affair supported on four chained leopards and it is more profitable to refer the reader to the electro-type copy in the Victoria and Albert Museum than to attempt to give any further description of its compli-cated design.

A small vase-shaped type of wine-cooler capable of holding a single bottle was introduced at the end of the seventeenth century and continued to be made to the end of the Queen Anne period. A fine example of the year 1698 belongs to the Duke of Devonshire. It again became popular at the end of the eighteenth century when the larger cisterns were going out of fashion, and continued in use until the end of our period. A pair of gilt wine-coolers made by Paul Storr in 1810 from a design by Flaxman are in the Victoria and Albert Museum. The arms of William IV which appear in the illustration (Plate XII, 42) were added later.

Silver wine-fountains were known in the Middle Ages but they were by no means common. A small one 'all gilt with 1 columbyne floure in the bottom' appears amongst the plate of Sir John Fastolf in 1459. Several appear in the royal inventories of the sixteenth century of which we may quote the description of one which

belonged to Queen Elizabeth in 1574: 'oone Fountaine of silver and guilt having vi pillars and a pipe, standing upon the toppe a woman holding a cluster of grapes in her hands'. The well-known silver-gilt fountain made by Sir Robert Vyner as a present from the borough of Plymouth to Charles II on the occasion of his coronation is in keeping with the traditions of the past and hardly more than a handsome table ornament. It is heavily embossed in the Dutch style and is surmounted by a female figure grasping two serpents, standing upon a column surrounded by figures of Neptune and sea-nymphs and supported on a spreading foot above which spreads a tray with four basons.

The fountains made during the first thirty-five years of the eighteenth century are in an entirely different style, quite usable and extremely handsome. They are urn-shaped with a tap at the front and two or four handles. Many examples are very richly decorated according to the standards of a period noted for its simplicity.

The use of silver wine-bottles was already of long standing at the time of the Restoration, but the only examples of earlier date are in Russia and Germany (or were before the War). These range in date from 1579 to 1619 and have bulbous bodies, long necks and curb-chain handles. The prevailing pattern in the Charles II and Queen Anne periods was the pilgrim bottle, a flask with two flattened sides, a long neck and a curb-chain handle. This design was not new. Pilgrim bottles form a conspicuous part of the Leigh Cup of 1499 belonging to the Mercers' Company and the 'two flatt Flagons, gilt, with scutcheons' amongst the plate of Henry Fitzroy, Duke of Richmond (d. 1536) were also probably of this type. The national collection is

fortunate in the possession of a superb example of this type of vessel made by the Huguenot Pierre Platel between 1702 and 1714 for General Charles Churchill, brother of the Duke of Marlborough, into whose hands it afterwards passed.

A certain feeling of bathos is unavoidable when we turn from these dignified pieces to the minor vessels used in the service of wine. The Farrer Collection contains a fine bowl-shaped bottle-stand made by Augustin Courtauld in 1741, but the ordinary varieties of coasters and decanter-stands made their appearance during the Adam period. The commonest type has a turned wood bottom and a solid or pierced silver side. Stands to hold two decanters are rather later in date. One presented to All Souls College, Oxford, in 1810, is in the form of an admiral's barge, being the gift of a judge of the Court of Admiralty. Other double decanter-stands are equipped with wheels.

The use of small labels, pierced or engraved with the name of a wine and fitted with a chain to go round the neck of a bottle, became popular in the reign of George III and the writer has heard of an example of definitely earlier date. The names on the labels will often puzzle those who have not studied the habits of our ancestors. It is not surprising that these neat little objects should lately have begun to attract the attention of the collector. The varieties of these little 'bottle tickets' are almost innumerable. A few examples appear to have been made to order. One of the year 1808, in the collection of Major H. C. Dent, is shaped like an officer's gorget and belonged to the mess of the Royal Scots; another of the following year, in the national collection, is cast with the crest of the Earl of Wilton.

The earliest funnel for decanting wine known to the writer is the example of 1651 belonging to Earl Fitzwilliam. These utensils were made extensively in later years but are devoid of artistic interest.

It is now time to turn to the vessels used for beer-drinking. The history of the tankard was left in the middle of the reign of Charles I when there began to appear a new type which was destined to remain in fashion until the Restoration. It approximates much more closely to its successors than to its predecessors both in its form and ornament, or lack of ornament, as it is only occasionally that we encounter an example which has as much as a matted surface. It has a wide cylindrical body with a spreading base, a flat lid with a pointed rim and a scroll handle. The example of 1653 belonging to the Carpenters' Company (Plate XV, 58) is entirely characteristic. Another variety in use during the same period is even plainer, having neither the spreading base nor the slight dome to the flat lid.

The typical tankard of the Charles II period has a rather more tapering body and a moulded base. The lid resembles that in use in the type of which the Carpenters' Company's tankard is an example. A tankard of the year 1673 (Plate XV, 59) shows all the normal features. The body of the tankard is usually left plain, but some are engraved with chinoiserie scenes (P.B. II, 13) whilst others have a band of embossed acanthus ornament at the bottom.

The normal tankard of the Queen Anne period differs from that of the reign of Charles II only in having a domed lid as is shown in the example of 1702 here illustrated (Plate XV, 61). Some are decorated with the

characteristic fluting and gadrooning, but the majority have a plain body with perhaps a single moulding rather below the middle. The form of the handle shows little variation but occasionally the scroll is curved back after its upper junction with the body. Amongst the attractive features found on some of these tankards are a row of diminishing beads just below the thumb-piece, and cut-card decoration at the junctions of the handle with the body. A large variety of thumb-pieces were in use, of which the two plumes type shown above was the commonest. A lion couchant thumb-piece is not uncommon.

A considerable range of tankards differing from those which have been described were also made during the Charles II and Queen Anne periods. The use of tankards on feet was not uncommon. An example of 1669, belonging to Balliol College, Oxford, which is supported on three lion-couchant feet is rather exceptional in having a handle in the form of a dolphin and a porcupine thumb-piece. An example of the year 1713 belonging to the Ironmongers' Company is also supported on three lion-couchant feet, but has a rounded bottom and a lid with a central knob, a feature occasionally found on tankards with the ordinary moulded base.

A rare variety of footed tankard which appeared rather before the Restoration and is found only with Hull, Newcastle and York marks, is derived from Denmark. It has a low domed lid and a cylindrical body supported on three feet in the form of pomegranates attached by leaf-work, as is shown in a York example of 1673 (Plate XV, 60) in the Boston Museum of Fine Arts. A Newcastle example of this type made as late as 1774 is known. This tankard and a small proportion of

PLATE XV

TANKARDS

58

Gilt.
Maker's mark, *HG*.
Hall-mark for 1653.
Height, 6⅛ in.
Carpenters' Company.

59

Maker's mark, *OS with a trefoil and three pellets.*
Hall-mark for 1673.
Height, 6½ in.
Victoria and Albert Museum.

60

Maker's mark of John Thompson.
York hall-mark for 1673.
Height, 7⅜ in.
Museum of Fine Arts, Boston.

61

Maker's mark of John Sutton.
Hall-mark for 1702.
Height, 6⅛ in.
Victoria and Albert Museum.

62

Maker's mark of W. Shaw and W. Priest.
Hall-mark for 1756.
Height, 6¼ in.
Victoria and Albert Museum.

63

Maker's mark of J. Langlands and J. Robertson.
Newcastle hall-mark for 1780.
Height, 7 in.
Laing Art Gallery and Museum, Newcastle.

PLATE XV

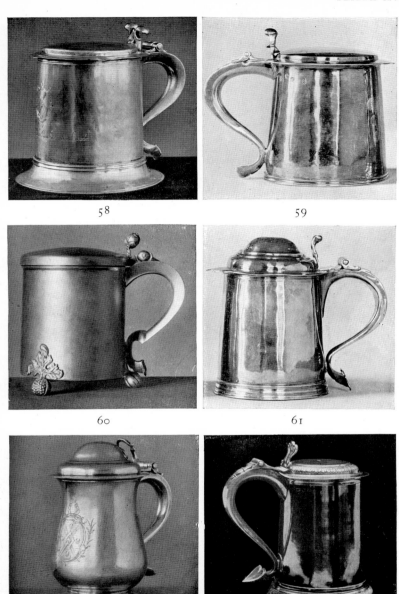

58

59

60

61

62

63

the tankards of other types made in the second half of the seventeenth century, are fitted on the inside with a row of pegs which served to measure out the beer so that none should have more than his fair share.

Whilst the custom of 'taking down a peg' is well attested, the idea that the slot in the under side of the handle of many seventeenth- and eighteenth-century tankards (and communion flagons) was used as a whistle to summon attendants when the vessel was empty, must be refuted. The slot was in reality a vent to allow the hot air to escape when the handle was being soldered to the body.

In about 1730 began to appear tankards of a type which was to remain the standard pattern throughout the remainder of the eighteenth century. It retained the domed lid of the preceding type but replaced the latter's cylindrical body by a bulging one. A typical example is afforded by a tankard of the year 1756 (Plate XV, 62).

Other varieties continued to be used during the reign of this pattern. A type peculiar to Newcastle has an unusually tall cylindrical body, a flat-topped lid and a base usually gadrooned. The example illustrated (Plate XV, 63) is of the year 1780. Another uncommon variety of the end of the eighteenth century has a flat lid and tapering cylindrical body with ribbed bands resembling the metal hoops used to reinforce wooden tankards.

Most of the shapes used for tankards between the second half of the seventeenth century and the date which closes our study were also used for beer mugs. Besides these there are found a number of vessels of varying sizes and shapes. During the latter part of the seventeenth century a mug with a round body and a

straight neck, resembling the earthenware vessels of the time, was much in use.

Another characteristic vessel for beer was the tumbler which had a heavy rounded bottom which enabled it to right itself after a knock. Pepys gives a casual reference to them in 1664, but it is not really known when or where they originated. French examples are known.

Beakers similar in form and decoration to those mentioned in a previous section (p. 57) continued to be made in the reign of Charles II. Others embossed with a band of acanthus ornament were added to these. A variety practically confined to two Oxford Colleges, is equipped with a couple of cast scroll handles. Relatively few beakers were made during the eighteenth century, but these have usually a nicely moulded base and spreading lip. Beakers shaped and engraved as beer barrels are not uncommon from the second half of the eighteenth century.

PLATE USED IN THE SERVICE OF TEA, CHOCOLATE AND COFFEE

NOT least amongst the reasons which suggest the choice of the reign of Charles II as the starting-point of the modern period of English silver is the fact that the three non-alcoholic drinks, which have since played so great a part in the nation's life, began at that time to take root in this country. As early as the reign of Charles I, English merchants in the Far East had begun to drink tea, but, though its refreshing nature appears to have been acknowledged, the general verdict classed it as medicine. As such it appears in an advertisement of the year 1658: 'That excellent and by all Physicians approved China Drink called by the Chinese Tcha, by other nations Tay, *alias* Tee, is sold at the Sultaness Head, a coffee-house in Sweeting's Rents, by the Royal Exchange, London'.

On 28 September 1660 Pepys records: 'I did send for a cup of Tee (a china drink) which I never had drank before', but unfortunately he passes no verdict on this experiment. Although tea was obtainable at coffee-houses, it seems to have escaped the opprobrium with which its rival was connected. Whilst the sudden popularity of coffee was a subject commented on by diarists, tea only receives casual mention. In 1664 the East India Company presented the King with 2 lb. 2 oz.

of tea worth 40s. a lb., but when, encouraged by the growing demand for the drink, they imported 4713 lb. in the year 1678 they had difficulty in disposing of it. Despite these unpromising beginnings the popularity of tea grew, so that by the end of the seventeenth century it passed from the category of medicine into that of a pleasant luxury.

The earliest tea-pot, which is of the year 1670, is in the Victoria and Albert Museum and shows no sign of any foreign influence. The body is a tapering cylinder with a straight spout and a leather-covered handle at right angles to each other. The lid is conical and the total height is 13½ inches. From its form alone it might be supposed to be a coffee-pot but this is negatived by the inscription. . . . 'This silver tea-Pott was presented to yᵉ Comᵗᵗᵉ of yᵉ East India Cumpany by yᵉ Honoᵘᵉ George Lord Berkeley of Berkeley Castle A member of that Honourable & worthy Society and A true Hearty Lover of them 1670.'

The later vessels of similar form are probably rightly regarded as coffee-pots.

Tea-pots with the characteristic squat form began to appear in the last quarter of the seventeenth century. Their designs are derived from porcelain wine-pots and hot-water-pots which were imported from China. Whilst tea was made in China by pouring hot water out of the pot on to the leaves in the cup, it seems always to have been usual in this country to infuse the tea in the pot.

A typical example of the use of a Chinese shape is given by a small gilt pot made by Richard Hoare in the collection of Mr. L. A. Crichton (Plate XVI, 64). An almost identical example bearing the mark of

PLATE XVI

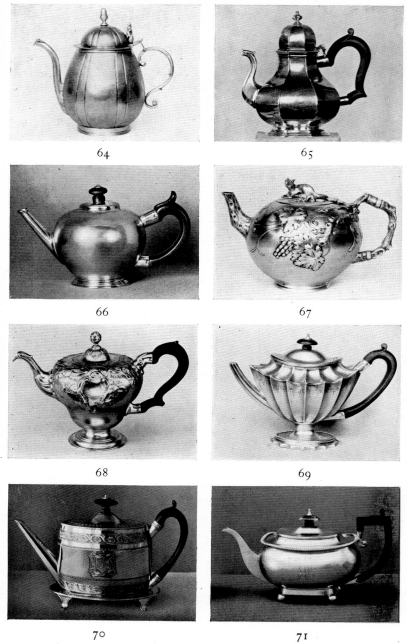

64

65

66

67

68

69

70

71

PLATE XVI

TEA-POTS

64

Gilt.
Maker's mark of Sir Richard Hoare.
About 1690.
Height, 5½ in.
Victoria and Albert Museum.

65

Maker's mark of J. Lamb and T
Tearle.
Hall-mark for 1718.
Height, 6⅝ in.
Victoria and Albert Museum.

66

Maker's mark of James Smith.
Hall-mark for 1723.
Height, 4½ in.
Victoria and Albert Museum.

67

Maker's mark of John Wirgman.
Hall-mark for 1748.
Height, 4½ in.
Victoria and Albert Museum.

68

Maker's mark of R. Gurney and T.
Cook.
Hall-mark for 1753.
Height, 6¼ in.
L. A. Crichton, Esq.

69

Maker's mark of William Plummer.
Hall-mark for 1788.
Height, 7 in.
Mrs. C. B. Allan, O.B.E.

70

Maker's mark of Henry Chawner.
Hall-mark for 1791.
Height (with stand), 6¾ in.
Victoria and Albert Museum

71

Maker's mark, *S.H.*
Hall-mark for 1812.
Height, 6¼ in.
Victoria and Albert Museum.

Benjamin Pyne is in the collection of Mr. A. T. Carter, K.C., and both must be dated shortly before the adoption of the Britannia Standard in 1697. Tea-pots made during the reigns of Queen Anne and George I owe their high value not so much to their rarity as to their beauty. A pear-shaped body with a domed lid was usual, the outline being either rounded or polygonal as in the example of the year 1718 here illustrated (Plate XVI, 65). The handle, as in the case of the early coffee- and chocolate-pots, was sometimes set at right angles to the spout. Many of these tea-pots were equipped with stands with oil-lamps. The globular tea-pot on a tall foot, which enjoyed a prolonged popularity in Scotland, does not seem to have been adopted south of the Tweed, where, however, a type which had a rounded body sloping into the moulded base was made with slight variations, into the last quarter of the century. The attractive example illustrated is of the year 1723 (Plate XVI, 66). An unusual example of the year 1748 (Plate XVI, 67) has a crabstock spout and handle and is embossed with grapes. It has a cover surmounted by a squirrel. The design is clearly borrowed through the contemporary Staffordshire ware from the Chinese. In about the year 1730 appeared an inverted pear-shaped pot which was extensively used during the remainder of the Rococo period (Plate XVI, 68).

The Adam period was extremely prolific in designs for tea-pots. In comparatively few, however, can we trace any borrowing of classical motifs as in the curious urn-shaped example of the year 1789 here illustrated (Plate XVI, 69). The typical tea-pot of the period had a circular, oval or octagonal drum-shaped body, usually with a straight spout. Many examples are equipped with

a small stand, as it was found that the large expanse of the bottom was more than usually liable to damage a highly polished tea tray or table. Though both the tea-pot and stand illustrated (Plate XVI, 70) were made by Henry Chawner in 1791, it is not at all infrequent to find tea-pots fitted with stands by different makers and a few years later in date, due presumably to the pur-chaser not having realised originally the peculiar incon-venience of this pattern.

In the most characteristic of the designs which appeared in the early nineteenth century this fault was remedied by giving the tea-pot four feet. This pattern is shown very favourably in an example of the year 1812 (Plate XVI, 71). Many of those made even before the close of our period, were plastered with inappropriate ornament.

Probably owing to the high price of tea the size of tea-pots remained small until quite late in the eight-eenth century. The tea-pot had, consequently, fre-quently to be refilled. The earliest reference to a tea-kettle which has been discovered is of the year 1687, but there appear to be no surviving examples earlier than the reign of Queen Anne. These are found both round and octagonal and are larger and squatter editions of the contemporary tea-pots, but fitted with a swing handle with a holder, usually of ebony. They are equipped with a tripod stand fitted with a spirit lamp. At the close of the Queen Anne period appeared a flattened globular kettle, a shape which continued popu-lar up to the middle of the century. They are decorated in most of the styles used during the Rococo period and some are extremely rich. A fine example of between 1730 and 1740 in a private collection has the body

embossed with a triumph of Neptune and Amphitrite, with a spout formed by a demi-figure blowing a conch, whilst the tripod is formed by three mermen. Like some other examples of this period it is fitted with a triangular stand. A variant of the same shape has the body of the kettle formed like a melon. The latest of the common varieties of tea-kettle appeared in the middle of the century and was made for some ten or fifteen years. It has a pear-shaped body like many of the contemporary tea-pots and coffee-pots. An excellent example of the year 1753 bearing the mark of William Grundy is in the Victoria and Albert Museum (Plate X, 38). The tea-kettles of the late eighteenth and early nineteenth centuries are not sufficiently uniform or common to warrant description.

Occasionally the tea-kettle was supplied with a tall tripod to stand directly on the floor. The example by Simon Pantin of the year 1724, belonging to the Earl of Strathmore, is $25\frac{1}{2}$ inches high and has an octagonal table-top. In the one belonging to the Duke of Northumberland, made by John Corporon in the following year, the stem of the tripod ends in a lamp and a triple support for the kettle.

When the tea-kettle fell into disfavour in about 1760 it was succeeded by the tea-urn fitted with a tap at the bottom of the body and standing on a base with four feet. In these the water was kept hot by means of a hot iron which fitted into a sheath in the middle of the vessel. The body of the urn varied with the successive styles. The earlier examples are frequently pear-shaped, but with the advent of the Adam style the classical vase inevitably became the standard model. The same source of inspiration guided the designs of the examples of

early nineteenth-century date though they tended to imitate the more squat forms of vase.

It was very natural that the making of silver tea-cups should have followed closely upon the adoption of tea-drinking as an ordinary habit. The tea-cups of the late seventeenth century are circular and usually without handles (though some have two) and are equipped with saucers. They were, of course, objects of luxury and, as such, were usually decorated with a more than ordinary care. A not very long period of trial was enough to prove that the material was unsuited to this use, as the cup, even when equipped with a handle, became much too hot to hold, more especially as it was not yet customary to dilute the tea with milk. Most examples date before the year 1700, though the Victoria and Albert Museum possesses a small hexagonal cup with a saucer to match of about the year 1710 which may have been used for tea. It is pretty clear that the manufacture of silver tea-cups must virtually have ceased quite early in the eighteenth century and that imported porcelain cups were used down to the opening of the Bow and Chelsea factories in 1744 and 1745. There are no tea-cups in the 1725 inventory of the plate of George I, though four tea-pots (which he may have inherited from the tea-drinking Queen Anne) were preserved in the Jewel Office in Whitehall.

The earliest reference to a tea-spoon that has been discovered occurs in the *London Gazette* for September 1685, where the theft of 'six little wrought silver spoons one tea pot . . .' is noted. In the following year 'three small gilt tea spoons' are mentioned. There seem to have been no early references to coffee-spoons, so that it must be presumed that the same spoons were used for

tea and coffee. The majority of tea-spoons of all periods are merely reduced copies of the contemporary table-spoons, but a few varieties not found in larger sizes must be mentioned. At the end of the seventeenth and the beginning of the eighteenth centuries there was in use an attractive type of spoon with the usual waved end and rat-tail but with a twisted stem. Many of the designs stamped on the back of the bowls of the spoons of the middle of the eighteenth century do not seem to be known in the larger varieties. Some have political allusions such as the bird standing on the top of a cage with the motto of John Wilkes, 'I love liberty'. It has been suggested that the spoons with acorn-shaped bowls may have been made for members of the Jacobite Oak Society of London.

From the end of the seventeenth century till late in the eighteenth there was made a spoon usually about the size of a tea-spoon but with a pierced bowl and a circular stem ending in a spike. The piercing of the bowls of earlier examples consists merely of circular holes, but later examples have extremely attractive designs. The purpose for which these spoons were made has remained somewhat of a mystery. The idea that they were used for eating mulberries or picking out lemon pips from punch lacks all documentary proof. It can only be said that 'strainer' spoons are usually referred to in advertisements in conjunction with tea-spoons, so that it may be supposed that they formed part of the tea equipage.

The earliest tea-caddy known to the writer only belongs to the first decade of the eighteenth century, but the use of these objects spread rapidly. The word caddy derives from the Malay *kati*, a weight equivalent

to $1\frac{1}{5}$ lb., and as tea was sold by the *kati* the name became by transference that of the case in which it was bought. As a matter of fact, it is doubtful whether the use of the word caddy in this sense dates before the end of the eighteenth century. Canister was certainly the name used previously and is found as early as 1711 when 'a silver canister for tea' is mentioned in an advertisement in the *London Gazette*.

Although the price of tea gradually declined during the eighteenth century it long remained usual to keep the current supply under lock and key. Early tea-caddies were made in sets of two or three (for different sorts of tea) and kept in a locked case, usually made of wood covered with shagreen, tortoiseshell or mother-of-pearl, and mounted with silver. In later times when it ceased to be necessary to keep so strict a control over tea many of these cases perished, as they had ceased to be decorative owing to the hard wear to which they had been subjected. Many cases included a sugar-basin with the caddies. The most luxurious cases were covered with silver, but these appear always to have been rare.

The fact that early tea-caddies were intended to fit into cases had great influence on the designs selected. The commonest type during the Queen Anne period is extremely simple, being usually oval, oblong or long octagonal, having a flat top with a hole covered by a domed cap. As it was difficult to fill them through the hole, most examples have a sliding top or bottom. In some examples, even before 1720, a bulge appears in the middle of the body, which may be regarded as the first step towards the vase shape afterwards so popular.

The type of box-shaped caddy which was most popular in the middle of the century, has curved sides

PLATE XVII

MILK-JUGS

72

Maker's mark, *PC*.
About 1730.
Height, 4⅛ in.
C. D. Rotch, Esq.

73

Maker's mark of S. Laundry.
Hall-mark for 1730.
Height, 2⅞ in.
C. D. Rotch, Esq.

74

Hall-mark for 1738.
Height, 4⅝ in.
G. C. Bower, Esq.

75

Maker's mark of Henry
Cony.
Hall-mark for 1756.
Height, 4½ in.
G. C. Bower, Esq.

76

Maker's mark, *HC*.
Hall-mark for 1765.
Height, 3⅞ in.
*Victoria and Albert
Museum.*

77

Gilt.
Maker's mark of Robert
Hennell.
Hall-mark for 1785.
Height, 7⅛ in.
*Victoria and Albert
Museum.*

78

Maker's mark, *IB*.
Hall-mark for 1796.
Height, 5⅞ in.
*Victoria and Albert
Museum.*

79

Maker's mark, *IB*.
Hall-mark for 1807.
Height, 3⅝ in.
*Victoria and Albert
Museum.*

PLATE XVII

72

73

74

75

76

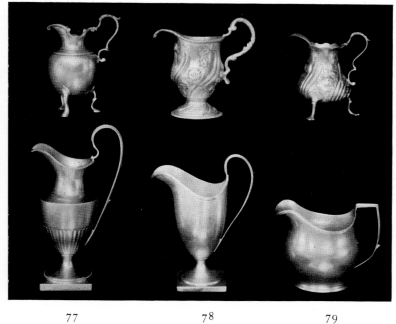

77

78

79

bulging towards the top and a concave lid surmounted by a knob. An example illustrated (Plate X, 39) is of the year 1766 and the work of the Huguenot Pierre Gillois. It is elaborately decorated with rococo chinoiserie which was considered especially appropriate for tea services.

Definitely vase-shaped caddies appear in the second quarter of the century and it became quite customary for these to be made like casters in sets of one large and two small. During the Adam period this type of caddy was changed into a classical urn, usually with very happy results.

Shortly after the middle of the century there appeared a cylindrical caddy with a hinged cover, resembling very much the outline of the modern thermos flask. It was made in sets like its predecessors but unlike them is fitted with a lock.

A little later a completely new type of caddy made its appearance. It is usually oval or long octagonal in shape with a straight side and flat lid. It is much larger than that which preceded it. It is divided into three inside, so that it replaced the three separate caddies. As it was not intended to be kept in a case it was fitted with a lock. Though it might have been expected that the greater convenience of this type would cause it to supersede the earlier ones, these last maintained their popularity into the nineteenth century.

Some of the vase-shaped tea-caddies of the middle of the eighteenth century are accompanied by small ladles with shell-shaped bowls which must be regarded as the earliest form of caddy-spoons. The miniature caddy-spoons came into use in the Adam period and soon obtained an immense popularity which lasted well into

the nineteenth century. The collection of over two hundred examples in the Victoria and Albert Museum is by no means exhaustive of this type of object. The aim of the designers seems mainly to have been to get away as far as possible from the shape of the conventional spoon. Some are in the form of jockeys' caps, others of eagle feathers, shells, or vine leaves. The care expended on the making of these spoons varies greatly, some being extremely shoddy productions.

It may be doubted whether sugar was commonly taken with tea before the eighteenth century, but a small bowl with a domed cover and turned knob in the collection of Mr. A. Assheton Bennet bears the hall-mark 1691 and is closely related to the covered bowls of the reign of Queen Anne, which are generally supposed to have been used for sugar. Some of these have polygonal bowls and covers whilst another variety has the ordinary circular bowl with a slightly domed cover which is fitted on the top with a ring, giving it the appearance of an inverted saucer. There has been some dispute as to the purpose for which this latter type was made. All that can be said with certainty is that the shape was borrowed from the Chinese tea-cup.

The bowls of the Rococo period tend to be somewhat more vase-shaped. They are usually richly embossed and have some sort of finial, often in the form of a flower, on the top of the cover. The Adam period is marked by completely vase-shaped covered sugar-bowls often with pierced work with a glass liner. About the same time appeared also sugar-baskets, sometimes with a vase-shaped body and glass liner like the example by Burrage Davenport in 1774 (Plate XI, 41), but also with boat-shaped forms. A variety with an oblong bowl

with bulging sides and a handle at each end was made to match the popular type of tea-pot and milk-jug in use at the beginning of the nineteenth century.

Owing to the fact that early sugar-tongs are seldom fully hall-marked it is difficult to decide how far their use can be traced into the first half of the eighteenth century. The earliest were formed like scissors and had attractively scrolled stems with loop handles and flat shell-shaped fingers to hold the sugar. This pattern continued in use until the early years of the Adam period. A curious variety is in the form of a stork, the stems being pivoted at the bird's head and the sugar being picked up in its beak. The present pattern of sugar-tongs with a spring back and two arms ending in spoon-shaped fingers cannot be traced back before the last years of George II. At first the arms were usually pierced, but towards the end of the century they were made solid and usually decorated with bright-cut engraving. Nineteenth-century examples are usually plainer and have commonly nothing more than a threaded edge.

Although nowadays the use of milk- and cream-jugs is not confined to the meals at which tea is served, these vessels seem, originally, to have come into existence as part of the tea service. As the price of tea remained high for a considerable time after its introduction, it is not surprising that it was usual to drink it plain, in the Oriental fashion, instead of losing some of its flavour by mixing it with milk. There are, therefore, no milk-jugs contemporary with the first tea-pots, and although the earliest examples made their appearance quite at the beginning of the eighteenth century, they do not seem to have been regarded as the essential part of the equip-

ment of the tea-table till much later. This point can be verified by reference to the meticulously accurate paintings of Hogarth, such as the family group in the Cook Collection at Richmond, or in one of the earlier scenes of the 'Marriage à la mode', in both of which are shown tea-sets without milk-jugs. An early reference to the practice of drinking milk with tea occurs in Matthew Prior's 'To a Young Gentleman in Love', written about 1720, where the passage occurs:

> He kissed her on his bended knee;
> Then drank a quart of milk and tea.

Whilst some of the designs of the earliest tea-pots, coffee-pots and chocolate-pots display considerable originality, those of the first milk-jugs are largely traditional. The earliest example known to the writer is of 1708 and was in the Dunn Gardner Collection. In form it resembled the example of 1730 here illustrated (Plate XVII, 73) and it will be seen that its shape has been borrowed from the contemporary stoneware beer-jug. Modifications of the helmet shape used for rose-water ewers began to appear at an early date and remained popular until the end of the century. An early example of about 1730 (Plate XVII, 72) and a late one of 1796 (Plate XVII, 78) are illustrated. When filled with milk the centre of gravity of these later examples is much too high so that they are easily upset. The helmet-shaped milk-jug on three feet which became so popular in Ireland in the latter part of the eighteenth century was occasionally made in England during the second quarter. The last variety of the helmet-shaped jug appears in about 1800 and has a flat bottom without any foot (Plate XVII, 79).

The jug with a round foot and pear-shaped body (a shape also used for rosewater ewers), appeared rather before 1740 and remained popular until almost the end of the century (Plate XVII, 75). Though occasionally found undecorated, the majority of examples are embossed in the rococo style, particularly with floral and landscape subjects. It is remarkable that even the later examples are usually decorated in an entirely rococo style although made well into the Adam period.

The jug with a bulbous body on three feet, of which an example of the year 1738 is shown (Plate XVII, 74), had a comparatively short reign, being supplanted by one in which the greatest diameter was nearer the bottom, as is shown in the example of 1765 (Plate XVII, 76). The embossed rococo decoration was still used on this type of jug up to its disappearance at the end of the century. Whilst the majority of the jugs of this and of the preceding types are embossed and have a rather flimsy appearance, it must be remembered that other examples were cast and do not suffer from this failing. A splendid ewer-shaped jug of another type of about 1750 is typical of the more substantial work of the period.

Milk-jugs of the purest Adam style were also produced. The gilt example of the year 1785 here shown (Plate XVII, 77) is particularly fine. About 1800 there began to appear low jugs with a bulging body on four ball feet to match the tea-pots and sugar-basins of similar design.

Another school of design which appeared rather before 1740, produced cream-jugs modelled on the contemporary sauce-boats. These have a low body narrowing to a spout at one end, an open scroll handle at the

other, and three feet. The silver pap-boat which has a body of similar shape to these and is nowadays of small market value, is not uncommonly converted into a cream-jug by the addition of feet and a handle.

Besides the common varieties of jugs already mentioned were used a large range of designs of different degrees of rarity. Amongst the best known of these is the jug in the form of a cow with a fly as the handle of the lid in the middle of the back. These are nearly all the work of John Schuppe who entered his mark in 1753 and continued to turn them out for the following twenty years. They are quite outside the tradition of English silversmiths' work and it is tempting to think that Schuppe, like the makers of the common modern Dutch fakes, was Dutch. An unusual jug with the mark of the younger David Willaume and the hall-mark for 1753, is at the Victoria and Albert Museum and may mark some sort of association between the two silversmiths.

The more dubious 'goat and bee' jug reproduces in silver a design used by the silversmith and potter Nicholas Sprimont for his Chelsea porcelain. This has a swelling body decorated on each side with a goat wallowing in a morass, and has a bee in front. Most of the examples encountered appear to be forgeries of some fifty years ago.

From early in the eighteenth century the tea equipage was stood on a 'tea-table' or what is now known as a tea-tray or salver. They vary greatly both in shape and size, and are usually supported on four feet. The earlier examples have a simple moulded edge, but those of the Rococo period usually have a shaped border often enriched with the most elaborate cast and applied ornament. Their beauty is not confined to their borders, for

on them was lavished the very finest decorative engraving.

Ordinarily the tea-tray occupied only a small portion of a wooden table covered with a cloth, but in the middle of the eighteenth century a wooden stand was sometimes made with a top of the same size as the large silver tray with sockets to receive its feet. In the inventory of Dunham Massey taken by the Earl of Warrington in 1752 there occurs in the account of the Tea-Room Gallery '2 Mahogany stands to set the silver Tea and Coffee Tables on', and it is satisfactory to be able to note that in this case both the 'tables' and 'stands' remain associated. When it is remembered that the 'table' was sometimes intended to form an integral part of a piece of furniture, the resemblance of its border to that of the contemporary woodwork is seen in its proper relation.

During the Adam period, in addition to the ordinary circular tea-tray, there was used an oval tray with a vertical rim (usually pierced) with holes at the ends to act as handles. The bottom of the tray was sometimes made of silver and at others of papier mâché.

Coffee and chocolate began to make their appearance on the English market at very much the same time as tea. The earliest known establishment for selling coffee is recorded by Anthony Wood to have been set up by a Syrian, by name Cirques Jobson, at Oxford in 1651. Coffee-houses sprang up like mushrooms during the next few years and their power of attracting customers from their proper occupations soon became a matter of remark. Sometimes a comic note was touched, such as in 'The Maiden's Complaint against Coffee' which was published in 1663 and was met by 'The Coffee-man's

grenado discharged upon the Maiden's Complaint against Coffee'. In 1674 Anthony Wood complains of the manner in which undergraduates wasted their time in coffee-houses, just as his successors at Oxford inveigh against 'elevenses'. 'The decay of study of learning are coffee-houses, to which most scholars retire and spend much of the day in hearing and speaking of news, in speaking vily of superiors.' Even during the Commonwealth coffee-houses had become centres of anti-Governmental intrigue and this characteristic did not disappear with the Restoration. In 1675 Charles II issued a proclamation suppressing coffee-houses, but the effect of this was purely transitory. By the close of the century the coffee-pot had become generally recognised as being worthy of the distinction of the use of silver.

The great period of the consumption of chocolate appears to have been during the last quarter of the seventeenth and the first of the eighteenth centuries, when it seems to have been regarded as being more genteel than coffee whilst escaping being stigmatised as a medicine like tea. In later times, however, it would never seem to have rivalled the popularity either of tea or coffee.

It would appear from illustrations of the signs of the first coffee-houses and from the copper tokens issued by their keepers, that the first vessels used in this country as coffee-pots were the ewers with bulbous body, narrow neck and long curved spout used by the Turks, from whom the supply of coffee was obtained, for rosewater. There is no evidence that such vessels were ever reproduced in silver, and the earliest silver coffee-pots show no extraneous influence. The earliest example (Plate

PLATE XVIII

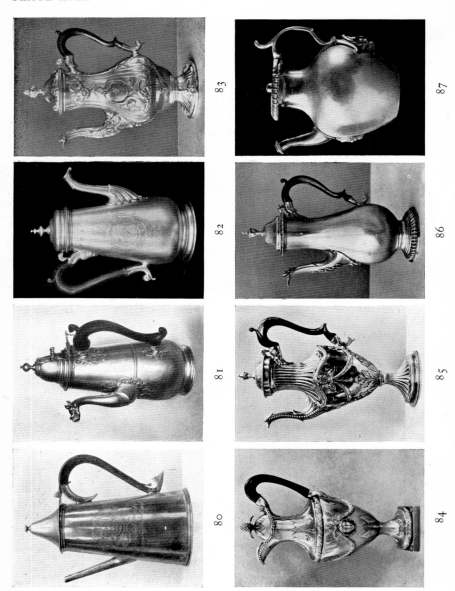

83

87

82

86

81

85

80

84

PLATE XVIII

80

COFFEE-POT

Maker's mark of George Garthorne (?).
Hall-mark for 1681.
Height, 9⅝ in.
Victoria and Albert Museum.

81

CHOCOLATE-POT

Maker's mark of William Fawdery.
London hall-mark for 1704.
Height, 10 in.
Victoria and Albert Museum.

82

COFFEE-POT

Hall-mark for 1748.
Height, 9¾ in.
Private possession.

83

COFFEE-POT

Maker's mark, *DW WH.*
Hall-mark for 1764.
Height, 12 in.
Victoria and Albert Museum.

84

JUG

Maker's mark of George Natter.
Hall-mark for 1773.
Height, 12½ in.
G. D. Rotch, Esq.

85

COFFEE-POT

Maker's mark of George Woodward (?).
Hall-mark for 1776.
Height, 13⅝ in.
Victoria and Albert Museum.

86

COFFEE-POT

Maker's mark of Charles Bateman.
Hall-mark for 1783.
Height, 12¼ in.
Victoria and Albert Museum.

87

JUG

Maker's mark of Paul Storr.
Hall-mark for 1810.
Height, 7½ in.
Charles Oman, Esq.

XVIII, 80), which is in the Victoria and Albert Museum, is of the year 1681 and resembles the earliest tea-pot of eleven years earlier in almost every respect except that the handle is set opposite the spout. In the next earliest example, which is eight years later in date, and which is the property of His Majesty the King, the handle is set at right angles to the spout as it is also in a number of other coffee-pots and chocolate-pots of the early eighteenth century. Chocolate-pots can only be distinguished from coffee-pots by the presence of a small cover in the lid through which the molionet (or stick) was inserted to stir up the contents. An exceedingly fine example of the year 1704 is in the collection of Mr. C. D. Rotch (Plate XVIII, 81). The spout had already become slightly curved before the year 1700, but shortly after that date it received the elegant form shown in the illustration, though the dragon-head is an unusual elaboration. The very distinct foot of this piece is also rare. During the latter part of the Queen Anne period the popular octagonal form was used as an alternative to the ordinary tapering cylinder. After the close of the Queen Anne period the tapering cylinder form of coffee-pot and chocolate-pot was modified, usually by curving the lower part of the body into the base, and at the same time the lid became flatter and more deeply moulded as is seen in the example of the year 1748 (Plate XVIII, 82). In the middle of the Rococo period the lower part of the body became more bulging (Plate XVIII, 83), a change paralleled on the contemporary standing cups, kettles and tea-pots. The popular design of the Adam period was naturally based on an urn, a form which adapted for this purpose with remarkable success (Plate XVIII, 85). A plainer form

produced during the Adam period has a graceful bulbous body as is seen in the late example of the year 1783, which is illustrated (Plate XVIII, 86).

Throughout the eighteenth century we encounter tall-jugs, generally following the lines of the contemporary coffee-pots, but with either a short spout applied to the lip or with a curved pouring lip. The purpose of these jugs is open to dispute. A few obviously belonged to shaving-sets but the remainder are called variously chocolate, hot-milk and hot-water jugs. A typical Adam example of the year 1773 is here illustrated (Plate XVIII, 84). Another example (Plate XVIII, 87) of 1810 is typical of the plainer and simpler work of Paul Storr.

An advertisement in the *Whitehall Evening Post* for 3-5 June 1747 mentions 'Chocolate Cup frames', which were presumably the same species of article as the 'Six chocolate frames' weighing 44 oz. mentioned in the 1725 inventory of royal plate. It would be interesting to know what these objects were like.

LIGHTING APPLIANCES

CANDLESTICKS made in the precious metals for the service of the church can be traced back to the latter part of the tenth century and by the fourteenth century silver candlesticks for domestic use were beginning to be familiar objects in the houses of the wealthy. Unfortunately no candlestick which has survived can be dated much before 1600 and the descriptions given in wills and inventories give us little information as to the appearance of those in use in earlier times. Occasionally we come across records of ones which must have been extremely rich, such as the pair pledged for £466 : 13 : 4 by Henry VI to his uncle Cardinal Beaufort in 1439, which were of gold set with four sapphires, four rubies, four emeralds and twenty-four pearls.

We know, at any rate, that both sockets and prickets were used, sometimes on the same candlestick. A 'nose of a kandelstyk' which appears as a separate item in a list of royal plate in 1438 and a seizure of base 'nossells' by the officials of the Goldsmiths' Company in 1633 seem to suggest that detachable nozzles may have been in use at a considerably earlier date than the surviving examples would lead us to suppose. One of the candlesticks in the 1532 inventory of the plate of Henry VIII was equipped with a steel, a chain and snuffers engraved

with H and K, and a rose and pomegranate. The advertisement of the State lottery of 1567 illustrates two candlesticks amongst the prizes of plate. They both have sockets, short stems, wide grease-pans and spreading bases.

The few candlesticks of Pre-Restoration date which have survived present considerable variety. The earliest, which has changed hands several times of recent years, is of crystal and silver-gilt and dates rather before 1600. It is curious rather than beautiful and has two sockets attached to a crystal cross-beam supported on a stem decorated with figures of eagles and satyrs.

The other examples are less pretentious. A pair of the year 1618, in the Swaythling Collection, have solid sockets and grease-pans, but stems and triangular base of wire. Each is supported on three feet resembling pepper-pots. Doubtless the 'paire of wyer silver candlesticks' in the Fairfax inventory of 1624 were of this sort.

A set of four pricket candlesticks of 1637, in private possession, stand half-way between those in the lottery advertisement of 1567 and those belonging to one of the commonest late seventeenth-century types. They have straight stems, wide grease-pans and domed bases.

The use of pricket candlesticks for domestic purposes had probably become rare by the beginning of the seventeenth century and does not seem to have survived the Restoration. The candlesticks of the latter part of the seventeenth century are usually divided into three parts, a socketed stem and a base divided by a grease-pan. The importance of the last feature varies. Sometimes even in late examples of the reign of Queen Anne, such as the pair of 1709 in the recent Dunn

Gardner sale, it is readily recognisable, but for the most part it is little more than a memory and we can only say that the stem and base are separated by some meaningless mouldings. Such is the case in the examples of the years 1682 and 1698 (Plate XIX, 88, 89) which belong to the commonest type of candlestick in use at this period. This is of embossed work and has the stem in the form of a column, usually fluted but occasionally of the clustered gothic type, and a variously shaped base which is sometimes domed but usually flattish. A much less common type has a socket in the form of a clustered column, a vase-shaped knop with below it four cast scrolls, a well-developed grease-pan and a flattish base. Cast candlesticks with the stem in the form of a human figure are also found towards the end of the century.

The typical candlestick of the Queen Anne period is of cast work. It made its appearance rather before 1700 and lasted till about 1730. There are countless minor varieties of these extremely beautiful objects and it is only possible to allude to some of their more salient features. The stem and base are moulded and all trace of the intervening grease-pan has disappeared, as also of the fixed nozzle which had previously surmounted the socket. The examples illustrated (Plate XIX, 90, 91, 92) well display the most characteristic features of this group.

During the short interval between the Queen Anne and Rococo periods the form of the candlestick remained much the same but the decoration becomes more elaborate. An extremely attractive example of 1738 with a stepped base with grotesque masks is illustrated (Plate XIX, 93).

English rococo candlesticks seldom approach the

shapelessness of their French contemporaries. A pre-
ference for twisted designs is noticeable but a more
moderate use is made of the ornament characteristic
of the period than might have been expected. The
three candlesticks which are depicted (Plate XX,
94, 95, 96) give a very good idea of the prevailing
fashions. A rarer type, also popular at this time, has the
stem in the form of a human figure or demi-figure with
arm or arms raised to support the candle-socket resting
on its head. The use of detachable nozzles became
general about now.

The Rococo period appears to have come to a pre-
mature end with regard to candlesticks in about 1760
when a general classicisation of design and a change
of technique took place. The candlesticks made after
this date are of thin stamped metal and are loaded to
give them strength, a method which would have been
repugnant to the goldsmiths of the Middle Ages and
Renaissance. The column design which had been so
popular up to the Queen Anne period returned to use.
Both fluted and wreathed columns are used and have
the socket contained in a capital of the Corinthian
order (Plate XX, 97). A variety has a clustered column
with a capital formed of stiff acanthus or palm leaves,
not closely copied from any classical model (Plate XX,
98). Another design, which appeared slightly later than
the above when the Adam style was in general use, has
the stem in the form of a pedestal on which stands a vase
which serves as the candle-socket (Plate XX, 99, 100).
All the above types are found mounted on square bases,
usually decorated with floral swags, but triangular and
circular ones were also used.

Candlesticks derived from the above types continued

171

PLATE XIX

CANDLESTICKS

88

Maker's mark of Richard Morrell (?).
Hall-mark for 1682.
Height, 7⅛ in.
Victoria and Albert Museum.

89

Maker's mark of Alexander Roode.
Hall-mark for 1698.
Height, 7⅞ in.
Cora, Lady Strafford.

90

Maker's mark of Joseph Bird.
Hall-mark for 1710.
Height, 6⅝ in.
Victoria and Albert Museum.

91

Maker's mark of Louis Metayer.
Hall-mark for 1714.
Height, 9 in.
Private possession.

92

Maker's mark of David Tanqueray.
Hall-mark for 1720.
Height, 7 in.
Victoria and Albert Museum.

93

Maker's mark of Louis Dupont.
Hall-mark for 1738.
Height, 8⅞ in.
G. C. Bower, Esq.

PLATE XIX

88 89 90

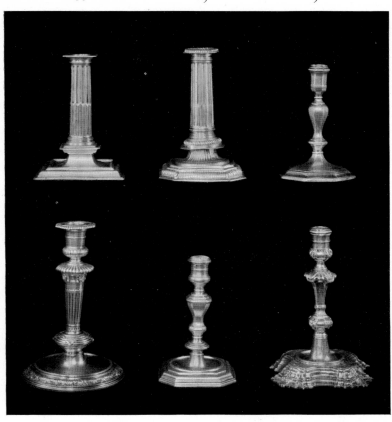

91 92 93

to be made into the nineteenth century. The taste of the period required more elaborate decoration, whilst the demand for massiveness led to a partial return to cast work.

Branch candlesticks were well known during the Middle Ages and we have already had occasion to mention one specimen of the Renaissance period. Their later development requires only a few words as in their stems and bases they follow for the most part the designs in use for ordinary candlesticks. During the Queen Anne period the prevailing pattern had three curved branches radiating from the central stem which was surmounted by a moulded finial. The use of twisted branches was not uncommon during the Rococo period and the central finial was frequently replaced by a socket. These devices were all used, perhaps with greater success, during the Adam period. Those of the early part of the nineteenth century seem, for the most part, to reflect the worst tendencies of the period. Those not taken from ordinary trade designs are usually better, as for instance the pair of little two-branched candlesticks of 1819, at the Victoria and Albert Museum, with stems in the form of classical victories and, appropriately enough, the work of John Angell (Plate XII, 43). A still more sculptural branch candlestick at Windsor by Paul Storr can equally be excluded from the general condemnation. The Garden of the Hesperides, made in 1809 from Flaxman's design, is certainly a masterpiece in its way. It is unfortunate that the architect designers attempted time and again to make branch candlesticks in the form of classical tripods with the most disastrous results.

The 'hond candilstikke' mentioned in the inventory

of royal plate in 1438 may be considered as the ancestor of the numerous chamber candlesticks which have come down to us from the eighteenth century. Examples before 1700 are rare. One, of 1688, at Exeter College, Oxford, has a socket standing in a circular pan fitted with a flat handle and resembles closely the contemporary brass examples. Another, of 1711, at the Victoria and Albert Museum, has an extinguisher attached to the socket, a circular pan and a flat pear-shaped handle. At a later date the handle becomes a scroll whilst the pan receives an ornamental border similar to that of the contemporary waiters.

Silver sconces or wall-candlesticks fitted usually with a reflector-plate, appear to have been used in this country from the time of Henry VIII. George Cavendish, in his account of the reception given by Wolsey to the French ambassador at Hampton Court in 1527, mentions 'the plates that hung on the walls to give light in the chamber were of silver and gilt, with lights burning in them'. More references to their use can be found in the Tudor inventories of royal plate, whilst in the inventory taken in August 1649 of the former plate of Charles I are recorded '4 large hanging wall candlesticks' weighing 37 lb. 11 oz., and a single 'wall candlestick'. It would appear, notwithstanding, that these objects were rare before the time of Charles II.

From 1660 to 1700 wall-sconces were extremely popular and their present rarity is due to the wholesale destruction which was partly the result of their somewhat flimsy construction. In 1725 the royal palaces still contained 209, of which 71 were at St. James's, 24 at Kensington, 20 at Hampton Court, 90 at Windsor and 4 in the Jewel Office. It is unlikely that many, if any, of

these were of recent manufacture. One made by the Huguenot Peter Archambo for the second Earl of Warrington in 1734 still exists, but most of the other examples which survive date before about 1705.

Three principal types may be recognised of which the simplest is represented by an example of 1665 in the collection of Captain N. R. Colville. This has a single socket attached to an oblong back-plate with rounded top, engraved with a chinoiserie design and embossed with flowers. Another uncommon design has an enriched truss or console in place of a back-plate, and a scroll branch with socket. The standard pattern, however, consists of a richly embossed back-plate with one or two branches with sockets. The back-plate is usually in the form of a cartouche, with a border decorated with cherubs or floral swags. The centre is sometimes left plain, at others it is engraved or embossed with the owner's arms or initials. The richest, however, are embossed with biblical or mythological scenes and are referred to as 'picture sconces' in inventories. Another variant has in the centre of the back-plate a human arm which clasps in its hand the branch with the candle-socket. A type of sconce which was once popular but is now rare had the back-plate formed by a silver-framed mirror.

In contrast to wall-sconces, silver chandeliers (or branches as they were usually described) never really became popular. In the 1550 inventory of the plate formerly belonging to Henry VIII there is the twice-repeated item of 'tenne hangynge Candlestickes gilt wt xxx sockettes and xxx prikes and gilt cheynes', and one set of these was in use in Elizabeth's reign. An example made in England in 1630, which formerly

hung in the Cathedral of the Assumption, Moscow, probably did not differ from those made for domestic use but unfortunately perished during the Napoleonic invasion. The surviving examples date between the Restoration and the middle of the eighteenth century and are chiefly to be found in the houses of the most important families of that period. Their relative scarcity, even during the period when they were still being made, may be judged by the fact that in 1725 the royal palaces only contained five, two each being at St. James's and Hampton Court and one at Windsor. Of these only one survives, the magnificent twelve-branched example made by George Garthorne for William III, which still hangs at Hampton Court. The most notable of the other chandeliers which have come down to our times are the two with sixteen branches made by Paul Lamerie in 1734 which are at the Kremlin, and the latest of all, made in 1752, which belongs to the Fishmongers' Company and has the seventeen branches grouped round the central body decorated appropriately with seaweed and dolphins.

Tapers were in much more general use before the introduction of the gummed envelope rendered the sealing of letters unnecessary. Despite their attractive appearance, taper-sticks only require a passing mention as their development since their appearance in the late seventeenth century has followed exactly those of the candlestick and chamber-candlestick.

The use of wound tapers requires a few more words. In 1930 there appeared in the sale-room a silver taper-stand or wax-jack with an indistinct hall-mark of about 1680. It belongs to a late seventeenth-century type well known in brass but not hitherto encountered in silver.

PLATE XX

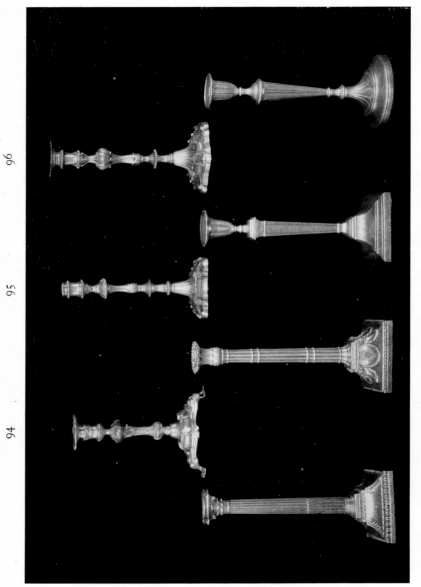

PLATE XX

CANDLESTICKS

95

Maker's mark of Hyatt and Semore.
Hall-mark for 1759.
Height, 10½ in.
Victoria and Albert Museum.

96

Maker's mark of Ebenezer Coker (?).
Hall-mark for 1767.
Height, 6⅛ in.
Victoria and Albert Museum.

100

Maker's mark of John Green.
Sheffield hall-mark for 1795.
Height, 12 in.
Victoria and Albert Museum.

99

Maker's mark of John Parsons.
Sheffield hall-mark for 1791.
Height, 12⅛ in.
Victoria and Albert Museum.

98

Maker's mark of Samuel Roberts.
Sheffield hall-mark for 1773.
Height, 12¾ in.
Victoria and Albert Museum.

94

Maker's mark of John Cafe.
Hall-mark for 1744.
Height, 9¼ in.
G. C. Bower, Esq.

97

Maker's mark, IC.
Hall-mark for 1768.
Height, 12⅛ in.
Victoria and Albert Museum.

The taper is wound on to a horizontal reel with embossed guards, whilst its end is held in a scissor-like pan with handles in the form of birds. The reel itself is held between two uprights on scroll feet, and with cross-bars, one of which supports the taper-pan.

Numerous other appliances for holding wound tapers were in use from the seventeenth until the early nineteenth century. Some have a foot supporting a rod round which is coiled the taper, the end of which is held in a pan similar to the one just described. Others use the principle of the horizontal roller, but have a sort of candle-socket through which the taper is passed. Commonest of all is the taper-box, which is found as early as 1698 and consists of a cylindrical box with handle resembling a mustard-pot, with a hole in the centre of the lid.

Snuffers formed a very necessary part of the equipment of every house before the invention, in the nineteenth century, of candlewicks which could be entirely consumed by the flame. Amongst the plate belonging to All Souls College, Oxford, in 1448, are mentioned two low candlesticks and four movable 'snoffeffers'. The earliest surviving silver snuffers are in the British Museum. In them the box is divided into two equal parts, one of which bears an enamelled medallion of the arms of Henry VIII and the other one with those of Christopher Bainbridge, Archbishop of York. The arms of the latter are ensigned by the cardinal's hat which the Archbishop received in 1512, an honour which he only enjoyed until 1514 when he was poisoned in Rome by his chaplain. The handles of the snuffers are formed by open loops ending in tiny squirrels, a motif selected from the owner's arms.

Next in date comes the example at the Victoria and Albert Museum, which is of no less historic interest. Its construction is similar except that the loops of the handles are closed. The box bears the arms and initials of Edward VI, whilst the stems of the handles are inscribed: GOD SAVE KYNGE EDWARDE WYTHE ALL HIS NOBLE COVNCEL.

Snuffers of the Post-Restoration period have on one blade the box and on the other a pressing plate which fits inside it. The snuffers of the late seventeenth and first three quarters of the eighteenth century are rarely decorated except by heraldic engraving. Those of the late eighteenth and early nineteenth century tend to be more ornate and to be decorated with beading or engraving. Many of this period stand on three short feet. Whilst silver snuffers show little development, those in which the blades are of steel and the handles only of silver follow the course of mechanical improvement followed by the steel snuffers after about 1750. The devices for avoiding the danger of dropping pieces of charred wick are often extremely elaborate and ingenious.

From the Restoration snuffers were frequently equipped with pans. Some of the pans are shaped to the form of the snuffers and have a handle at the larger end, but the more usual design has a lateral handle and an oblong pan with a moulded border. The border of the oblong pan was variously shaped in the eighteenth century. In about 1720 scroll-handles replaced ones which had been either flattened pear-shaped or composed of a ring and a handle.

During the later years of the seventeenth and the early ones of the eighteenth century the snuffer-stand

formed an attractive alternative to the snuffer pan. These had an upright receptacle for the snuffers, fitted with a scroll-handle, and stood on a foot resembling that of the contemporary candlestick.

The ordinary implements for putting out candles were extinguishers and douters. The former are almost always conical and are found hooked on to chamber candlesticks and snuffer-stands. Douters which resemble scissors with flat plates at the end of the blades for pressing the wick, were also made in silver from the end of the seventeenth century. They are much rarer than snuffers and must not be confounded with the early scissor-shaped sugar-tongs which have only slightly hollowed ends.

MISCELLANEOUS PLATE ABOUT THE HOUSE

DURING the Middle Ages very little plate was used for purposes unconnected with eating, drinking and lighting. The Renaissance enlarged the range of miscellaneous silver in domestic use but the quantity still remained relatively insignificant. The Charles II and Queen Anne periods saw a vast increase both of the range and quantity of the objects produced but a decline in the fashion for the indiscriminate use of plate occurred well before the middle of the eighteenth century.

The use of silver furniture has already been instanced as characteristic of the extravagant fashions which came in with the Restoration. Very little had been produced in this line previously. A silver-plated weaving-stool appears on the list for the trousseau of Princess Mary, which was prepared in 1508 when it was planned that she should be the bride of the future Charles V. In 1520 Henry VIII already possessed a silver-gilt mounting-block which, having a framework of iron, did not succumb to his increasing corpulence but was still in use in the latter days of Elizabeth. The Virgin Queen herself had had a silver-plated cradle set with gems, the work of Cornelis Hayes, one of her father's most favoured goldsmiths. Amongst the plate consigned to be melted by Charles I in 1626 were 'four gilt pommells

for a chaire' and 'five gilt cupps for a feild bed', the latter
being probably the plume-holders which surmounted
the tester. A 'folding table covered all over w^{th} silver plate
ingraven' was amongst the royal plate which the Parlia-
mentary Commissioners attempted to recover in 1649.

Though the bed made for Nell Gwyn in 1674 was
the work of John Cooqus, a foreigner, some at least of
the craftsmen who produced the surviving examples of
the silver furniture in use at this time were Englishmen.

When recording a visit on 4 October 1683 to the
apartments of the King's mistress Renée de Querouaille,
Duchess of Portsmouth, Evelyn remarks on the richness
of the furnishing which included 'great vases of wrought
plate, tables, stands, chimney furniture, sconces, branches,
braseras &c. all of massive silver and out of number'.

The Royal Collection at Windsor still possesses the
wrecks of three splendid sets of tables, stands and
mirrors. Two of these were presents from the City of
London to Charles II and William III and the third had
been made for 'the Queen Dowager', a title which must
refer either to Catherine of Braganza or Henrietta
Maria, most probably to the latter. The following is the
description of them in the inventory of 1725:

	ozs.	dwt.	grs.
One large silver table, 2 Stands and a large glass with a silv^r frame	7306	0	0
One other large table, 2 Stands a large Glass w^{th} a silver frame	3712	0	0
One other Table, two Stands and a glass with a Silver frame for-merly Queen Dowagers, the weight not known being only covered with silver			

Only two of the tables remain. The first in the list is the one made by Andrew Moore for William III. It is almost entirely of solid silver, only the minimum of wood and iron being used in its construction. Its legs are four female caryatids, whilst the top is magnificently engraved with the royal arms by an artist who used a monogram R H as his signature. The second table is the one made for Charles II whose device of the two C's appears on the richly embossed top. It is, like most of the silver furniture, of wood plated with silver. Traditions of the former existence of a third table had lingered at Windsor, but it was not until the discovery by the author of the above document that its original destination was known.

The pair of candlestick-stands which remain evidently belong to the set made for Charles II. They stand 40 inches high and have circular tops with the two C's, a baluster stem and three scroll feet. They are richly embossed with acanthus ornament and floral swags.

Of the mirrors, King William's is the most sumptuous. It is $7\frac{1}{2}$ feet high and consists of a frame embossed with fruit and surmounted by the royal arms and supporters. King Charles's is 6 feet 11 inches high and is most attractively decorated with *putti*, floral swags and with the two C's at the top. The Queen Dowager's mirror is only 4 feet high and is more simply decorated with acanthus and laurel leaves.

The silver furniture at Windsor is closely rivalled by magnificent pieces of the same period at Knole Park where can also be seen a table of a less costly type, made of ebony mounted with silver. Another example of this last variety is at Ham House which is also credited in

an inventory of 1679 with two silver-mounted fire-screens.

Very little silver furniture was made after the accession of Queen Anne. The Duke of Portland possesses a table made between 1709 and 1718 for Edward Harley, second Earl of Oxford, whose arms with seventy-two quarterings are engraved on the top. It is otherwise virtually undecorated, as is also the one made by Augustin Courtauld in 1742, in the Russian Imperial Collection. In strong contrast to it is the throne and foot-stool made in 1713 by Nicholas Clausen for the Czar, which is as elaborate, in a different style, as the Charles II pieces.

The use of silver-mounted andirons or fire-dogs goes back to the reign of Henry VIII. Several are mentioned in his inventories and one pair which belonged to him is preserved at Knole. These are rather elaborate pieces of ironwork but the silver decoration is confined to a crowned medallion on each. One of these bears King Henry's arms and initials and the other the Boleyn falcon with H and A for Henry and Anne.

The manufacture of silver-mounted andirons became widespread after the Restoration but ceased early in the first quarter of the eighteenth century, rather before the custom of burning coal in large houses rendered them obsolete. The royal inventory of 1725 shows that there were then five pairs at St. James's, nine at Kensington and seven at Windsor. Their use was by no means confined to the houses of the very rich. The accounts of John Hervey (later Earl of Bristol) show that he possessed at least six pairs at his house at Ickworth, so that it would seem that there was not so much

exaggeration as might be expected in Evelyn's lines in the *Mundus Muliebris* (1690):

> The Chimney Furniture of Plate,
> (For Iron's now quite out of date:).

The andirons of the Charles II and Queen Anne periods differ from their predecessors in having the whole of the upright of silver instead of iron with a few silver mounts. Their appearance is derived from that of the brass andirons of the Low Countries but they are much more elaborately finished as befitted the use of the more precious metal. They are usually surmounted by a vase which often acts as the pedestal for a statuette, whilst the lower portion has a scrolled outline and stands on two eet. The earlier examples are usually richly decorated in the same style as the contemporary tables and chairs which they were intended to match. Those of later date display a much greater sobriety, as is shown in the superb pair made by Louis Metayer in 1715 for the Earl of Mountrath, which was sold recently from the collection of Lord Hillingdon.

The use of silver fire-irons follows closely that of andirons but very few examples now survive. The Earl of Dysart, however, possesses some at Ham House, as well as one of the two surviving silver bellows. This last is of Charles II date, as is also its fellow at Windsor which is of combined silver and marquetry. Of the other treasures with which the Duke of Lauderdale endowed Ham House and which figure in the inventory of 1679, there is a silver 'hearth rod' or, as we should term it, a fender, of pierced and embossed work, and a silver-mounted fire-pan.

The tradition of the use of plate primarily for ostenta-

tion found further expression in the reign of Charles II in the manufacture of various types of flasks, covered vases and exaggeratedly tall beakers. A fine set consisting of a gilt vase and two flasks of 1675 were acquired by the Victoria and Albert Museum (P.B. II, 14) from the Ashburnham Collection. The fashion waned during the early part of the eighteenth century though many of the two-handled cups of the Rococo and Adam periods may be regarded as reviving the tradition. In this category must certainly be included the gigantic two-handled vases made in the late eighteenth and early nineteenth century, though these might equally well have been treated with the other sorts of centre-pieces for the dinner-table. The Victoria and Albert Museum possesses a fine example of this class in one of a group of covered vases made by the firm of Digby Scott and Benjamin Smith from a design by Flaxman, for presentation by Lloyd's Patriotic Fund to the admirals and the captains of ships who had fought at Trafalgar. It stands 17 inches high and is decorated on one side with a figure of Britannia Triumphant and on the other with a warrior overcoming a three-headed serpent. On the cover is a British lion.

Perfume-burners of silver can be traced back to at least the reign of Henry VIII when 'A fumytorie for fumigations white wt a cover poyz. XXVI oz. di.' is mentioned together with others in the 1520 inventory of his plate. It may be doubted whether any sort of perfume-burners or perfuming-pans were ever to be found except in the houses of the very wealthy, even in the time of Charles II. A cassolet (as it was now christened, to Evelyn's disgust) of the year 1677, was sold in 1944 by the Duke of Rutland, whilst an unmarked

example of the same period belongs to the Duke of Devonshire. Both are splendid examples of pierced work.

A certain number of silver clocks have been made in this country from time to time since the second half of the sixteenth century. The Victoria and Albert Museum has been fortunate in acquiring a small lantern clock with an attractively engraved dial bearing the name of the clockmaker David Bouquet (*d.* 1665). In the collection of Lord Mostyn is a clock in a silver-mounted ebony case which was bequeathed by William III to the Earl of Leicester. Its movement was the work of the celebrated Thomas Tompion who received £1500 for it. The Earl of Ilchester owns a clock dated 1740, on which is represented figure of Minerva seated beside a cockle-shell and reclining against a flamboyantly rococo framework which contains the dial.

Two inkstands (or standishes as they were almost invariably called until about a century ago) are mentioned in the 1520 inventory of the plate of Henry VIII. One was Spanish work, but the other 'Standysshe with a lyon theruppon' was probably English made. A little inkstand of 1630, belonging to Sir John Noble, appears to be the only survivor of those made before the Civil War. It is only 5½ inches high but contains receptacles for two pens, an inkpot and a pounce-box and a box for sealing wafers.

The inkstands of the second half of the seventeenth century follow a number of different designs. Some were made in the form of a tray to which were attached the various utensils (except the pounce-box containing the sand used instead of blotting-paper, which had to be movable and fitted into a socket). A flat pen-box had

by now joined the requisites. Another design housed all the utensils in an oblong box with a double lid with a common hinge dividing the whole into two compartments, one of which was the pen-box. Yet another style which continued well into the first quarter of the eighteenth century, was in the form of an oblong box with hinged lid covering the inkpot, pounce-box and wafer-box, and a drawer underneath for pens.

In the reign of Queen Anne the fitted-tray type was rearranged in a manner which was to last for the better part of the century, with varying changes in the decoration. The tray was fitted with three sockets, two of which were occupied by the ink-pot and pounce-box. The third might be used for a hand-bell, taper-stick or a wafer-box. The pen-box had by now disappeared. The pens could be stood in sockets round the top of the ink-pot or laid in a trough in the tray, but occasionally a drawer was provided underneath the tray. The equipment of the inkstands of the late eighteenth and early nineteenth century differed little from these except that silver-mounted cut-glass bottles were frequently used.

Though the inventories of the Renaissance show that ladies already possessed a number of silver toilet utensils, the manufacture of whole sets does not seem to have begun before the Restoration. In 1690 John Evelyn was inspired to write a poem entitled *Mundus Muliebris: or the ladies dressing-room unlock'd and her toilette spread*, with the following lines:

> A new Scene to us next presents,
> The Dressing-Room and Implements,
> Of Toilet Plate Gilt, and Emboss'd,
> And several other things of Cost;

The Table Miroir, one Glue Pot,
One for Pomatum, and whatnot?
Of Washes Unguents and Cosmeticks,
A pair of Silver Candlesticks:
Snuffers and Snuff-dish, Boxes more,
For Powders, Patches, Waters Store,
In silver Flasks, or Bottles, Cups
Cover'd or open to wash chaps.

Though this is a fairly good inventory of a toilet set, it is by no means complete. We miss, for instance, the pair of oblong comb-boxes, the pair of salvers, the two sorts of brushes, the pincushion, besides the hand-bell and the little ewer which often appear. The manufacture of silver toilet sets continued just into the second half of the eighteenth century though most examples are of the Queen Anne and Charles II periods. When they had ceased to be appreciated they were generally broken up and dispersed so that there now survive very few sets which approach completeness. Amongst these are the Earl of Stamford's set of twenty-four pieces made in 1728 by Isaac Liger, and a set of twenty-eight made in 1724 by Paul Lamerie in the Farrer Collection. The decoration of the first is cast in a style reminiscent of the embossed work of the Charles II period which seems still to have found favour at Dunham Massey, but most other sets merely reflect the current fashion. The Victoria and Albert Museum has a set of a dozen pieces made in 1683 for the Calverley family. It is particularly finely embossed and chased with acanthus ornament and classical deities (P.B. II, 14).

By comparison the equipment for the masculine toilet seems almost Spartan. The first reference to a silver shaving-basin known to the writer is in the Paston Papers in an inventory of plate drawn up sometime after

1479—'j holowe barbore bason bought of Colet'. The confiscated shaving-basin of the Duke of Buckingham and that of the King himself appear in the royal inventory of 1520. Both were round and weighed respectively 63½ oz. and 76½ oz. Extant examples only date from the end of the seventeenth century. They are oval and have a crescent-shaped piece cut from one side of the rim.

No details, except the weights, are given of the two jugs which accompanied the basins in King Henry's inventory. The forms in use during the Queen Anne period varied somewhat. Some have a flattened pear-shaped body and a lid with curved thumb-piece, others a more bulbous body and a spout with a hinged lid.

The soap-box of this same period remained standardised. It was globular and stood on a round foot, the lid being sometimes pierced and engraved.

From the 1550 inventory of the royal plate we learn that Henry VIII had a handsome silver warming-pan to heat his bed, having the royal arms on the end of the handle. Several silver warming-pans occur in the inventories of Elizabeth's plate but the first reference to one in a subject's possession is in a complaint made to the Goldsmiths' Company in 1600. One appears amongst the plate of Elizabeth Wortley at the time of her marriage to the Earl of Sussex in 1633. By the reign of Charles II such luxuries were to be found even in the homes of some of the more prosperous of the middle class and on New Year's Day 1669 Pepys received 'a noble silver warming-pan' as a gift from Captain Beckford. It is distinctly surprising that only three silver warming-pans should now be known to exist. One of these, engraved with the arms of Long,

co. Norfolk, bears the hall-mark for 1662 and is now in the United States. Earl Beauchamp has the second which is hall-marked 1690, whilst the third, made by Seth Lofthouse in 1715, is at Buckingham Palace.

Sir Thomas More, writing in 1515, tells us that the Utopians used chamber-pots of gold and silver, from which it may be inferred that he did not envisage that in England the precious metals would ever be put to so base a use. A reference in John Marston's *Scourge of Villanie* proves that silver chamber-pots were in use at the end of Elizabeth's reign. The earliest surviving example bears the York hall-mark for 1671 and was made for use at the Mansion House, York, under the bequest of Marmaduke Rawdon who is better remembered for his *Life* with its fascinating account of the Canary Islands. These pieces are frequently found engraved with their owner's arms but the use of silver for this purpose was never widespread.

The records of Hoare's Bank show that Pepys delivered to his goldsmith Robert Cooper on the 18th June, 1685, a silver 'spitting-pot' weighing 14 oz. 12 dwt. Two days later he brought in another for alteration. A 'spitting bason' occurs amongst the plate at Kensington Palace in 1725, but no example is known to survive.

Similarly silver mortars with pestles are recorded amongst the belongings of Sir Thomas Fairfax in 1627 and of 'Belted Will Howard' of Naworth in 1629, but no example is yet known.

PLATE XXI

PIECES DECORATED IN THE 19TH CENTURY

101
CUP
Maker's mark, _J. L._
Hall-mark for 1778.
Height, 5½ in.

102
TANKARD
Maker's mark, _TN._
Hall-mark for 1749.
Height, 7 in.

Victoria and Albert Museum.

PLATE XXI

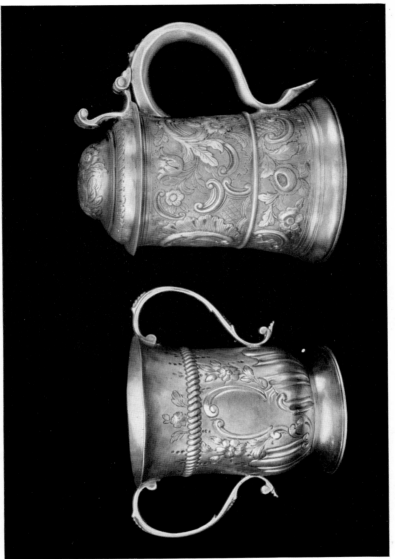

HALL-MARKING, FALSIFICATION, HERALDIC
ENGRAVING

A PROPER understanding of the development and the usages regarding hall-marking is indispensable for the collector. Although he had best refer straight to Jackson's monumental work whenever he encounters a serious difficulty, it is hoped that the following remarks will help him to make the best of the more portable lists of marks suitable for everyday use.

No reference will be made to the regulations regarding the alloys and marking of gold, since the surviving examples of gold plate in this country are so few that they may safely be overlooked in a handbook of the dimensions of this. It is perhaps well to warn the reader that the 'gold' cups, salts, etc., sometimes encountered in ancient wills and inventories must not be too readily believed to have been made of the more precious metal, as it is often quite clear that silver-gilt is all that is intended. Gold plate has, of course, been made from the Middle Ages down to the present time, but always in very small quantities. In the immense hoards of plate in the possession of Sir John Fastolf in 1459 and of John de Vere, Earl of Oxford, in 1513 there was only 121 and 168 oz. of gold respectively, as opposed to some 1100 lb. of silver. The amount of gold plate in the Tudor royal inventories is large, but the amount of

silver and silver-gilt is immense. No domestic gold plate appears in the long royal inventory of 1725.

From at least the thirteenth century the purity of silver plate exposed for sale has been a matter of concern for the authorities of the State. The regulations which have grown up have always been primarily intended to secure the original purchaser from the wiles of the dishonest silversmith who used too much alloy. They also had the desirable effect of making it possible to ascertain readily the value of any piece, so that the owner who was forced to sell his plate was not absolutely at the mercy of the silversmith to whom he was selling it. This point, however, appears always to have been considered of much less importance than the other.

The surviving examples of Post-Conquest domestic plate made prior to the introduction of hall-marking are practically confined to the few spoons which have already been described. More than one of these are of markedly impure metal, so that it may well be supposed that there was a good case for governmental intervention. This came in the form of an ordinance in the Close Rolls for 1238, which deals with the manufacturing of plate in London and orders that the standard purity for silver plate should be the same as that for the English coinage, *i.e.* that every pound (troy) should contain 11 oz. 2 dwt. of pure silver and 18 dwt. of alloy. This standard is usually referred to as the 'sterling standard', the name being derived from the sterlings or silver pence which formed the sole currency at this time. The sterling standard was so well known that it was ordered to be used by the goldsmiths of Paris when Etienne Boileau, provost of that city, codified their regulations in 1260.

The standard of purity for plate and for the silver coinage has only been varied thrice, viz.:

1. From 1697 to 1720 when the standard for plate was raised.
2. From 1542 to 1560 ⎱ when the standard for coin
3. From 1920 onwards ⎰ was lowered.

The enforcement of the regulations of 1238 was entrusted to six goldsmiths of good reputation, chosen by the authorities of the City of London. Though these ordinances refer only to London, we hear in 1276 of the imprisonment, pending trial, of a certain Reymund de Barbane, merchant of Bordeaux, in whose possession a plate of impure metal had been found at Bristol. It would appear, therefore, that a national standard was already supposed to exist.

In the year 1300 a statute was passed by which the practice of hall-marking was introduced. The enforcement was this time deputed to the wardens of the London goldsmiths who were ordered to mark with a leopard's head all plate before it left the goldsmith's hands. In the first charter of the Goldsmiths' Company, granted in the year 1327, it is stipulated that in every town where goldsmiths worked, one or two should be deputed to come to London concerning 'the punch with the leopard's head for marking their works as was formerly ordained'. This appears to be an unjustified amplification of the 1300 statute which, whilst it imposed on the provincial goldsmiths the obligation to use the sterling standard, merely ordered them to come to London concerning the gold. It is unlikely, at any rate, that the clause in the charter had any practical effect.

The full-face leopard's head still remains on London

plate though it was temporarily superseded during the period 1697–1720 and does not appear on pieces made at the higher standard since then. Up to 1478 the leopard's head is represented uncrowned and within a dotted circle. The surviving pieces, mostly spoons, which show the mark are extremely rare. The mark also appears on some pieces, probably of provincial make, dating from the sixteenth century. After 1478 the leopard's head appears wearing a crown which it continued to wear until 1821 when it was removed. The exact form of the leopard's head and of the escutcheon in which it is shown have several times been altered, so that the details should be studied carefully when looking up a hall-mark. Though the leopard's head is generally regarded as belonging particularly to London, it has in fact been used frequently by provincial assay towns.

In 1363 a further statute decreed that every goldsmith should have a mark known to those deputed to survey their work. These marks seem originally to have been taken from the sign which hung over the goldsmith's shop. Such marks continued to be used until the reign of William and Mary, and, with the addition of letters, well into the eighteenth century. Initials began to appear before the end of the fifteenth century and became increasingly popular as time went on. In 1697 it was ordered that the maker's mark should comprise the first two letters of the goldsmith's name, but on the resumption of the sterling standard in 1720 a return was made to the use of initials. Most attempts to attribute marks to known goldsmiths working before 1697 are more or less conjectural, as the records of them kept by the Goldsmiths' Company have disappeared. After that date the Company's records are nearly complete,

though occasionally a mark will be found which cannot be identified. Though these later marks do not appeal to the imagination as much as those recalling shop-signs they are not always devoid of interest. It will be noticed that several of the Huguenot goldsmiths used marks resembling those enforced in Paris, having at the top an open crown above a fleur-de-lys between two pellets. The marks placed within a lozenge-shaped escutcheon will be found to belong generally to female goldsmiths who followed the heraldic convention in this matter. These ladies were usually the widows or daughters of goldsmiths who carried on the family business. It must not be presumed that they practised the art in person, although women appear to have been employed as burnishers as early as 1370 and women apprentices are found as late as the eighteenth century, though they do not appear to have proceeded to the mastership.

If we put aside for the moment the development of hall-marking in the provinces, the next matter to be recorded is the introduction of date-letters in London in 1478. No contemporary record of this innovation has been discovered and the date is derived solely from an examination of surviving pieces. In a statute of 1477 the Goldsmiths' Company had been made corporately responsible for the penalties incurred as a result of the marking by their wardens of plate which was not up to the standard. The motive behind the introduction of the date-letter appears, therefore, to have been to aid the company to fix the blame on any of their officials guilty of marking base plate, either through carelessness or dishonesty. Until the Restoration the date-letter was changed each year on 19 May, St. Dunstan's Day, but

since then the alteration has taken place on 29 May. The cycle used in London lasts twenty years and consists of all the letters of the alphabet except J, U or V, W, X, Y, Z. It is probably hardly necessary to emphasise the importance of examining the exact form of the letter and its escutcheon when looking up a hall-mark or to remind the reader that the provincial assay-offices have their own cycles of letters.

No record survives to explain the addition in the year 1544 of a new mark, a lion passant-gardant crowned, to the three existing ones. In 1542 Henry VIII had begun his progressive debasement of the currency, and it has been suggested that the addition of the lion-passant mark was to emphasise to the public that the standard for plate still remained as of old. After the mark had been in use for six years the lion lost its crown. From 1550 to 1821 it remained a lion passant-gardant (*i.e.* with head facing left) except when it was not used because of the higher standard. Since 1821 it became a lion passant (*i.e.* with head facing to front). Since the abandonment of the higher standard in 1720 the lion mark has been used by all the English assay-offices.

It is now necessary to refer to the reasons which led up to the adoption of the higher standard and the marks which denote it. During the period of the Civil War a large quantity of plate had been melted down and turned into coins and in the more settled times of Charles II there was a reversal of this process and much money was turned back into plate. Coins had been used for this purpose to such an extent that at the end of the seventeenth century there was an actual dearth of currency which was emphasised in the public eye by the fact that the surviving coins were largely in a very bad

state—rubbed and clipped money of the reign of Elizabeth was still in circulation. In order to remedy this state of affairs the Government decided to discourage the manufacture of plate by raising the cost of the raw material. The standard of purity for plate was raised so that each pound (troy) contained 11 oz. 10 dwt. of pure silver instead of 11 oz. 2 dwt. In order to signify this change the leopard's head and the lion were replaced by a figure of Britannia seated to left and by a lion's head erased (*i.e.* in profile to left, the neck ending in three points). The Goldsmiths' Company decided to start a new cycle of letters when the statute came into force on 27 May 1697, so that the old cycle went no further than the letter T, whilst the A of the new one was only used until 29 May when the letter was changed as usual. The silver famine which had caused the adoption of the Britannia standard gradually disappeared and as a result of another statute the manufacture of plate on the old sterling standard was allowed to be resumed from 1 June 1720. With the return of the old standard came a return of the old marks but it is very necessary to emphasise that the Britannia standard was not abolished. Plate is still allowed to be made at the higher standard and is still marked with the Britannia and lion's head erased, so that beginners must be warned against accepting a piece which bears these marks as a genuine example of the Queen Anne period without examining the dateletter. They should also familiarise themselves with the appearance of the figure of Hibernia which appears on Dublin plate made since 1731 and which bears a superficial resemblance to that of Britannia.

On the occasion of a duty being placed on all plate brought for assay after December 1784 a fresh mark

was introduced. This was a representation of the sovereign's head in profile. During the first two years the head was stamped in incuse but thereafter it appeared in relief as on a coin. The heads of successive sovereigns appeared on plate until 30 April 1890, when on the removal of the duty the mark was abolished.

It is now time to return to the marking of provincial plate. Whilst, as we have seen, the provincial goldsmiths had been obliged to use the sterling standard even before the statute of 1300, their work remained unmarked until the statute of 1363 compelled the use of a maker's mark. A few general remarks on provincial makers' marks may be useful. It has been found possible to identify with a fair degree of certainty the marks used in later times by many of the goldsmiths whose work was assayed at the provincial offices. Quite a large proportion of the marks used by goldsmiths in the greater provincial towns during the sixteenth and seventeenth centuries have also been identified. Very few of the marks used by the goldsmiths of the smaller provincial towns are attributable to known persons.

In the year 1423 a statute laid the obligations of assaying and marking the work of the local goldsmiths on the civic authorities of 'York, Newcastle-upon-Tine, Lincoln, Norwich, Bristow, Salisbury and Coventry'. Unfortunately this piece of 'progressive legislation' is not in point of fact the landmark which it would appear to be. There is evidence that the civic authorities of York had been assaying and marking silver since at least the year 1410–11. With regard to the other towns it seems to have been without effect and the legislators cannot be acquitted of not having taken into account the fact that some of these places had never possessed

any considerable number of goldsmiths. A petition of some Norwich goldsmiths in the year 1564 resulted in the establishment of an efficient system of hall-marking with date-letters in the following year. At Newcastle the practice of hall-marking has not been traced further back than the middle of the seventeenth century.

Although the statute of 1423 had made no provision for any increase in the number of assay towns, the practice of using a mark to denote the place of origin spread to numerous other towns during the sixteenth and seventeenth centuries. A great many of these marks have been successfully identified, but when the collector encounters a very rare mark he would do well to read through the evidence on which it has been attributed to a certain town and then draw his own conclusions. The balance of the evidence is, for instance, against the attribution of the fleur-de-lys mark to Lincoln.

The use of date-letters made very slow progress. The York series began in 1559, Norwich in 1565, Chester and Hull late in the seventeenth century.

No provision for any provincial assay-offices was made in the statute which introduced the Britannia standard in 1697. The more vigorous centres of goldsmithing continued to use their marks until a statute in 1700–1701 incorporated goldsmiths' companies and established assay-offices at York, Exeter, Bristol, Chester and Norwich. To these Newcastle was added in the following year. In actual fact neither Bristol nor Norwich appear to have availed themselves of these privileges, though a few isolated pieces of later date than 1700 are known with the marks of these towns.

The effect of this legitimation of provincial hallmarking can be seen in two directions. Firstly, the

silversmiths of towns, like Hull, which had continued to get their wares marked with their own town mark, now began to send them to one or other of the legalised assay-offices. Secondly, these assay-offices began to operate with considerably greater efficiency, though still displaying a certain individuality in the matter of their regulations. Date-letters now became general though the cycles of letters were not made uniform. The marks of the Britannia standard were, of course, used in the provincial towns in exactly the same manner as at London. From 1713 to 1770 the York assay-office remained closed. In 1773, as a result of the industrial revolution, it was found necessary to open assay-offices at Birmingham and Sheffield. At the date when our study ends, it will be seen that there were still seven assay-offices at work (London, Birmingham, Chester, Exeter, Newcastle, Sheffield and York) but in the course of the nineteenth century this number was reduced to four by the closing of York in 1856, Exeter in 1882 and Newcastle in 1883.

Anyone who has had the opportunity of examining the plate belonging to families long established in the remoter parts of the kingdom will have discovered that an overwhelming majority of pieces always bear the London hall-marks and only a small proportion bear the mark of a provincial assay-town, even when one of these is not far distant. Despite the number of town-marks illustrated in books of hall-marks, it is necessary to stress the fact that only a small proportion of the surviving pieces of plate bear provincial marks. Though quite a considerable part of the Post-Reformation ecclesiastical plate is of provincial make, the majority of secular pieces made out of London are articles of minor

importance, such as spoons. This very fact adds not a little to the difficulty of identifying the source of some of the more obscure provincial marks, since the provenance of an easily portable object is a dangerous foundation for any attribution. It is quite clear that in former times the ordinary purchaser postponed the acquisition of an important piece of plate until circumstances allowed him to visit London.

A variety of causes contributed to this state of affairs. In early days clients seem to have distrusted the purity of the metal used by provincial goldsmiths, even of towns which had marks of their own. According to the author of *The Touchstone* (1679) a number of provincial goldsmiths were in the habit of sending their wares to London to get marked since the marks of their own towns did not carry confidence. This practice became more general in the eighteenth century with the cessation of marking except at the assay-offices recognised by statute and it must be remembered that the opening of the Birmingham and Sheffield offices was intended to satisfy an existing want and not to anticipate one. Actually the practice of sending wares from these places up to London to be marked does not seem to have ceased with the opening of these offices. Very occasionally a piece will be found with the Sheffield mark overstruck with those of London and with the mark of a London silversmith overstriking that of the provincial one. This curious practice seems only to have been followed in the first years after the opening of the Sheffield office. At least one Edinburgh hall-marked piece of about the same time is known, which has been re-assayed and re-marked in London, but on which the later marks do not cover the original ones.

It is not improbable that the customers of the past had a shrewd suspicion that they would not get merely purer metal but better work in London. Generally speaking the artistic standard of the provincial workers seems to have been lower than that of their London contemporaries. Some towns at some periods provide honourable exceptions. The work of some of the Elizabethan goldsmiths at Norwich is quite as fine as the best that was then being produced at London at the time, whilst during the Adam period Birmingham gained a reputation for its bright-cut engraving and Sheffield for its candlesticks. The type of work ordinarily obtainable in the provinces would not be such as to develop the genius of an ambitious craftsman who would then, as now, be tempted by the greater possibilities presented by the capital.

There are not wanting, even to-day, recently enacted laws which can be broken with little fear of punishment and the collector of plate will learn at an early stage that our ancestors, if encumbered by fewer laws, were not thereby more strictly law-abiding. Despite the fact that the goldsmiths of London were obliged by the statute of 1300 to get their works assayed and marked, there still survives a considerable amount of genuine silver made in London as late as the eighteenth century which bears no hall-mark. A particularly large proportion of medieval and renaissance plate is unmarked. At the Exhibition of English Medieval Art, held at the Victoria and Albert Museum in 1930, there were shown thirty-four examples of domestic plate made after the introduction of hall-marking of which only eleven were marked. Though a few of these may have been made at some provincial town which had no mark, the majority were of such

artistic importance that they might be safely assumed to be the work of a London goldsmith. On the other hand, of the twenty-three spoons also exhibited, some of which were certainly of provincial make, only ten were unmarked. Though this state of affairs must partly be attributed to the incompetence exhibited by most medieval executive bodies, it would seem that until the end of the eighteenth century there was an accepted convention (unrecognised by any statute) that plate which was made to a purchaser's order need not be marked. Often there would be the additional justification that the goldsmith was using old plate brought in by his client and was only concerned with the fashioning of the new. It is noticeable that in accordance with this convention, the larger objects which were more commonly made to order are more often unmarked whilst the smaller ones of more standard design, such as spoons, are generally marked.

A great improvement was made in the enforcement of the hall-marking laws in London after the Restoration, and spread at the beginning of the eighteenth century to the provincial assay-offices, but a certain proportion of silver still continued to escape the assayer. Some workers seem to have succeeded in carrying on for quite a long time without getting their wares marked. In a petition, probably of the year 1679, John Cassen and John Cooqus stated that they had served the royal family for the best part of fifteen years but that they were molested by the Goldsmiths' Company because their method of working was different from the English and they were forced to employ foreigners. They requested, therefore, that the Goldsmiths' Company be commanded to assay and mark their works.

The collector will occasionally come across the peculiar phenomenon of a set of objects, *e.g.* candlesticks, half of which are hall-marked and half not. The explanation is probably that the original set of four did not suffice when an advance in the fortunes of the original owner allowed him to entertain on a larger scale. The additional candlesticks which were then made to match would not be hall-marked in accordance with the convention already mentioned. The situation has often been complicated by a subsequent division of the family plate in which no attention has been paid to the presence or absence of hall-marks.

It will be seen that the collector need not regard as spurious an unmarked piece or one bearing only a maker's mark. He must rely on his sense of shape and style to tell him to what period a piece belongs and whether it is a fake or not. The incompletely marked piece invariably fetches a lower price than a fully marked one, but is not necessarily inferior to it in any other respect. The experienced collector may therefore sometimes get the reward of his knowledge by acquiring an unmarked piece when his purse would not allow him to pay the price necessary to secure a marked one. The fraudulence of a fake does not depend on the presence or absence of spurious hall-marks nor can the vendor escape from the penalties for selling a modern piece which does not comply with the hall-marking laws.

The presence of marks must not be developed into a fetish, as there are circumstances which render even genuine marks deceptive. Our ancestors in the second quarter of last century often felt that the simplicity which we now admire in early eighteenth-century silver was unsympathetic and whilst having qualms about

sending family heirlooms to the melting-pot, had no scruples about having them 'beautified'. This process was usually synonymous for having them richly embossed or engraved. However much we may deplore the results of this falsification, we cannot but admire the skill which the craftsmen often display. Though the collector may never wish to acquire Early Victorian silver he must familiarise himself with some of the styles of ornament in vogue during that period in order to be able to recognise them when they appear on pieces with earlier hall-marks. For this reason it has been thought worth while to illustrate two typical examples. The styles for which our Victorian ancestors had a special devotion were the fluting and gadrooning of the Queen Anne period and the embossing of the Rococo. The former style could be imitated quite easily, though the copyist often got into difficulties with the cartouche which usually accompanies it. A slight suggestion of the Rococo was allowed to creep into it occasionally as in the two-handled cup of 1774 here illustrated (Plate XXI, 101). The style in question was popular throughout the reigns of William and Mary, and Anne, and there is often real difficulty in distinguishing a plain piece decorated in the nineteenth century from a piece with genuine contemporary ornament. The same difficulty does not arise when the piece with fluted and gadrooned ornament (often referred to by the trade misnomer of 'Georgian fluting') appears on a piece with George II or George III hall-marks. Of course it is always possible that some person in the latter part of the eighteenth century may have ordered a piece to match one which belonged to his grandfather, but this thought need not lead the collector to change his attitude. A con-

scientious copy made a hundred and fifty years ago is of
no more interest than one made to-day.

The nineteenth-century rococo ornament is not really
very closely related to that of the eighteenth century.
The scroll-work is, indeed, very much in evidence, but
it is usually combined with a realistic floral ornament
which should readily be recognised, as can be seen in
the case of the tankard of 1744 here shown (Plate XXI,
102). Combined with the rococo scroll-work are also
found little rural scenes in the Dutch style and
chinoiserie of a much more realistic sort than prevailed
in the seventeenth and eighteenth centuries. More
genuine difficulty arises with imitations of the simpler
form of George II floral ornament when it is found on
a piece of the period 1740–70 which had originally been
plain. It must be remembered that a piece to which
ornament has been added need not necessarily have been
originally entirely plain, so that care should be taken
not to acquit a piece solely on the ground that some of
its ornament is undoubtedly genuine. The presence of a
coat of arms or initials may sometimes give a clue, as it
may appear that the decoration combines clumsily with
their presence whereas in genuine pieces the whole
should form a unity. Frequently the Victorian crafts-
man carried out his commission to decorate so literally
that hardly any of the surface has been left plain. In such
pieces it will usually be found that an exaggerated re-
spect has been paid to the hall-marks which are found
isolated amidst a sea of decoration. At other times it will
be found that a piece has been clearly embossed after it
has been hall-marked, a practice which has been quite
contrary to the usage of the eighteenth century when
objects would be marked in the usual place for their

particular species without any regard for the presence of decoration.

Mention must also be made of a more insidious species of subsequently added decoration, fortunately much rarer. During the Rococo period a certain number of plain pieces of earlier dates were decorated in the current style. As the decoration may be only ten or twenty years later than the making of the piece the incongruity may not be observed until the hall-mark has been verified.

It has already been noted that help may be obtained from the position of the hall-mark. Up to the second half of the seventeenth century pieces were marked in conspicuous positions (though it may take several minutes to discover the marks amidst elaborate ornament). With regard to the later period we cannot do better than repeat the words of Sir Charles Jackson, remembering the tentative manner in which they are expressed:

'Early tankards are generally marked on the drum to the right of the handle and across the cover. Later ones with domed tops, as well as cups, casters, tea-vases, tea and coffee pots, are for the most part marked under the base out of view, and the covers of late tankards are generally marked inside the dome. . . . Spoons dating from about 1670 have all the marks on the back of the stem.'

To these remarks the following may be added. The hinged covers of later pieces are frequently marked only with the lion. The marks do not necessarily appear in the order in which they are shown in the textbooks. The hall-marks usually appear in a line preceded or followed by the maker's mark, but never separated by it. Pieces

marked on the bottom during the eighteenth century often have the marks arranged in a pattern and not in a line.

From pieces falsified by added decoration there is no great transition to those falsified by additions and alterations. It should be remembered that the Gold and Silver Wares Act of 1844 deals explicitly with such alterations. Any hall-marked piece which is so altered as to change its character or use must be rehall-marked as a new piece, as must also any piece to which an addition has been made which weighs more than 25 per cent of the original weight. If the addition should weigh less than this proportion it alone need be marked. Though the alteration of a piece contrary to these provisions may be illegal, the purpose may often have been quite innocent. A great many tankards have been spoilt by the cutting of a triangular piece from the lip and the addition of a spout, so as to convert them into jugs. Those which have been more drastically treated have had their handles cut and ivory washers inserted to prevent their becoming too hot to hold when filled with hot water. More extraordinary changes will sometimes be found, such as a Charles II dinner plate turned inside out so that the former bottom has become the inside, or a George III oval tea-pot which has been deprived of its handle and spout and converted into a tea-caddy. Such alterations have usually been made before the collecting of old plate became fashionable, those made nowadays are mostly dishonest in intent. Thus, since silver is sold by weight, the conversion of a mug into a tankard by the addition of a lid provides an illicit profit for an unscrupulous worker. It must be remembered that all pieces bearing the same hall-marks

are not of equal value per ounce since silver prices are largely conditioned by rarity, size, conservation, and suitability for modern use, quite apart from general circumstances, such as the economic position of the moment. Thus a trifid spoon with a damaged bowl has been turned into the much rarer fork. The almost un-marketable pap-boat has become a delightful sauce-boat by the addition of legs and a handle, and the snuffer-pan has become an inkstand by the addition of an ink-pot and pounce-box. The silver chamber-pots, kept in some of the more luxurious seventeenth- and eighteenth-century homes, have been known to be converted either into a handsome rose-bowl by the removal of the handle, or else into a two-handled cup with the help of a handle taken from another example or made to match.

The practice of erasing some of the marks on an object so that the remainder should appear to belong to some earlier period will not deceive anyone who has paid any serious attention to the history and development of hall-marking.

We may now pass on to the still more blatantly fraudulent device of transposing old hall-marks to new pieces of silver with the intent of selling them as antique. When the transposition has not been cleverly done it may sometimes be possible to see with the aid of glasses the outline of the insertion, but the only infallible method of detection is to place the object in an electric furnace so that the solder securing the insertion fuses and surrounds it like a frame. As collectors are unlikely either to have the courage or the opportunity to treat suspected objects in this manner and, as there is always the risk of fusing all the solder used in its composition if attempted by an amateur, it is perhaps well to add a

few less drastic suggestions. Transposed marks are usually obtained from objects for which there is a comparatively small demand such as dishes, spoons and forks, and are inserted in ones which fetch high prices. It is well, therefore, to bear in mind the manner in which the species of object is commonly marked and to note whether the marks on the piece in question are so arranged. The marks themselves should also be examined to see if the amount of wear which they display is consonant with their having been always in the position in which they now appear. If the marks have been transposed from an object of a similar species to the one on which they now appear, the task of detection is more difficult. The trick of giving objects, such as coffee-pots, a double bottom, the lower consisting of a piece bearing the hall-marks, should also be mentioned. In the old times marks were usually stamped heavily, so that those on the bottom of an object should normally show some sort of dent in the interior.

Though there are still numbers of pieces with transposed marks in circulation, the modern faker seems usually to prefer his pieces to be false throughout. The fakes which have been produced on the Continent (chiefly in Holland) are so puerile as hardly to deserve mention. The fakers have troubled neither to study English silver nor English hall-marks so that their productions can be recognised at a glance.

It is well to realise that the English faker ranges over every period of English silver which is collected, and not merely over the more valuable. In 1932 forgers were sentenced for making pieces with false hall-marks for the year 1820. Early spoons are sometimes cast, complete with marks, from genuine ones. The lack of sharp-

PLATE XXII

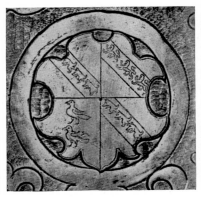

103

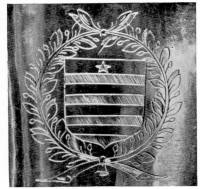

104

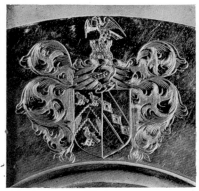

105

106

107

108

PLATE XXII

HERALDIC ENGRAVING

103

Myddleton.
Hall-mark for 1599.
Goldsmiths' Company.

104

Poyntz.
Hall-mark for 1646.
N. Ockendon Church, Essex.

105

Whitelock impaling Wilson.
About 1650.
Private possession.

106

Sterne.
Hall-mark for 1681.
Victoria and Albert Museum.

107

Fountain impaling Rice.
Hall-mark for 1678.
Victoria and Albert Museum.

108

Pengelly impaling Baines.
Hall-mark for 1683.
Victoria and Albert Museum.

ness of the marks on such fakes lays them open to detection. Larger fakes are marked with false punches. It is therefore necessary to examine marks carefully and to consider whether apparent discrepancies are due to the manner in which the punches have been applied or to the punches themselves.

It is as an art historian and artist that the faker is apt to fail most conspicuously. Sufficient eighteenth-century silver has survived to enable us to trace with a very fair degree of accuracy the evolution of design and decoration, and after a certain amount of experience the collector should be able to guess the date of a piece within a margin of ten years either way. When, there-fore, he encounters an object of a familiar type bearing the hall-mark of a date considerably earlier than that with which he has learnt to associate it, he may begin to allow his suspicions to be aroused. Before forming an adverse opinion of it, he must propound to himself all the possible explanations of such an anomaly and whether the evidence on which he has based his opinion of the proper date is adequate. It is here that a good knowledge of the different styles of decoration is helpful, for the faker is apt to produce unconsciously a mongrel piece. For this reason fakers tend to favour simple designs into which decoration hardly enters and except when producing pieces of pseudo-historic interest avoid inscriptions and heraldic adornments which are full of unexpected pitfalls for the unwary.

Super-fakers, equipped both with knowledge and technical skill, have appeared periodically in every branch of collectable art and have gathered in their profits for a certain time by producing objects of artistic importance. Being real artists they cannot avoid im-

parting to their works something of their own person-
ality, with the result that after a certain number of
masterpieces have appeared in the market, dealers and
collectors begin to recognise their style and their work
ceases to be remunerative. The intellectual and artistic
equipment together with the difficulties to be sur-
mounted before launching their works on the market,
have prevented the number of such fakers from be-
coming numerous, and those who have attempted
imitating early English silver have been few.

The ordinary faker is a much humbler being who
attempts no more than to reproduce pieces in the styles
which collectors have made fashionable. He does not
pretend to the knowledge necessary for producing im-
portant pieces and is often not sufficiently an artist to
be able to reproduce intelligently the commoner types
produced in the past. The collector who observes the
golden rule of buying only objects which are artistically
satisfying need have no fear at any rate of the baser of
the fraternity who seem capable of producing imitations
only of the worst work of each period. For the detection
of the more superior fakes the collector must rely on
the flair that is developed through seeing and handling
plenty of genuine pieces and on the habit of subordin-
ating his acquisitive to his critical instincts.

We dealt a little way back with the detrimental effects
of added decoration, but it should be realised that not
all types of decoration added after the completion of a
piece are equally vicious. The practice of engraving a
piece of plate with the coat of arms, crest or initials of
the owner is a case in point. The subject is well worthy
of a greater amount of attention than is usually accorded
it. A characteristic piece of heraldic engraving may often

help to fix the date, if not the original owner, of an unhall-marked piece or to trace the vicissitudes of a hall-marked one, so that a slight acquaintance with the principal styles of engraving on plate may be of considerable value to collectors. This knowledge may also protect him from paying undue respect to ancient pieces of plate which have been engraved in later times with the coat of arms of some person of historic interest which would, if genuine, greatly enhance its value. Such additions are as often the result of an attempt to bolster up an inaccurate family tradition as the work of a conscious faker but, in either case, are for the most part easily detected by stylistic incongruities in the engraving which are quite as fatal as actual heraldic blunders. The collector, however, should not allow himself to be obsessed by these baser motives for studying heraldic engraving since such work is seldom without a beauty of its own, as a very high standard of artistic skill was maintained right down to the end of the eighteenth century.

William Hogarth, it will be remembered, spent the years 1712–18 as an apprentice amongst the engravers who worked for the silversmith Ellis Gamble, at the sign of the 'Golden Angel' in Cranborne Street. Though he found the work distasteful there can be no doubt that the tradition of careful composition and delicate workmanship must have been very valuable to the juvenile artist. Richard Westall, who rose to be an R.A., spent six years from 1779 as an apprentice to John Thompson, an engraver of plate, at 44 Gutter Lane, Cheapside. Little has so far been gleaned about the engravers of plate, though their activities would well repay research. It was not usual for them to authenticate their work. A

few exceptions are known such as the monogram on the table at Windsor already mentioned, and the signature of L. King which accompanies the especially attractive heraldic compositions on a ewer and basin of 1685 and a two-handled cup of 1689 by two different London silversmiths, which belong to St. John's College, Oxford.

It will, of course, be realised that unless a piece was made to order the arms which it bears cannot be contemporary with its manufacture. On the other hand many purchasers have made a practice of getting their arms engraved soon after the conclusion of a purchase, even if not before the piece has left the shop. There can be no doubt that a finely engraved coat of arms or monogram adds to the interest of a piece. Only the purist will complain if a Charles II tankard bears a Queen Anne coat of arms, as the beauty of the addition is likely to outweigh any consideration of incongruity and it may be held that no heraldic engraving added before the decay of the art in the latter part of the eighteenth century can really damage a piece. There is something peculiarly satisfying in being able to trace the history of an acquisition to some former owner, even if he prove to be no more than a small squire or prosperous citizen.

Whilst commending the study of heraldic engraving both for its historic and artistic interest, the reader would be well to remember the two following points. The practice of erasing the arms of the original owner and filling the empty cartouche with those of its present one was certainly known in the latter half of the eighteenth century. The custom of sending an old piece of silver to have the arms copied on to a new one (par-

ticularly practised by corporate bodies whose arms were unaffected by matrimonial alliances) sometimes gives a piece an appearance of greater age than is the fact.

It is hoped that the following outline of the history of the heraldic engraving or plate will be of some use to those who have hitherto neglected the subject. As it is intended merely as an introduction, it is confined to common and typical forms and does not attempt to illustrate the finest work of any period.

During the Middle Ages the heraldic adornment of plate was usually carried out in champlevé or translucent enamel. That it was already in use at the end of the thirteenth century is shown by the mention of several vessels bearing the royal arms of England in the inventory of the goods of Pope Boniface VIII taken in 1296. The use of enamelled heraldic medallions continued into the Renaissance but gradually declined in popularity. It became more usual merely to engrave the coat of arms. Even this was not very general and when the goldsmith had included an empty escutcheon in his original scheme of decoration, the purchaser did not always trouble to have it filled in. When we do come on an elaborate piece of Elizabethan heraldic engraving, as on the cup of 1584 belonging to Lord Ducie, it is usually beautifully executed with square-topped escutcheons and strap-work or floral surrounds. The shaped escutcheon was also popular, a fine example being provided by the arms of Sir Hugh Myddleton (Plate XXII, 103) on the cup of 1599 belonging to the Goldsmiths' Company. These styles remained in vogue until the early years of Charles I.

A common form which appeared in about 1635 and lasted nearly to the Restoration showed the arms

on a square-topped escutcheon surrounded by a laurel wreath. The example illustrated (Plate XXII, 104) shows the arms of Richard Poyntz on the communion cup of 1646 given by him to North Ockendon Church, Essex. It should be noted that the barry effect is emphasised by shading the alternate bars. During the seventeenth century charges continued to be engraved merely in outline, though the use of shading was not uncommon. The practice of hatching, in order to show tinctures according to a code which began to be used in about 1600 and was popularised some thirty years later by the Jesuit Petra Sancta and the Franco-Scot Wlson de la Colombière, was but little used on English plate before the end of the seventeenth century. It made rapid progress in the early eighteenth century, but mere engraving in outline was still practised occasionally in the Rococo period.

As an alternative to the escutcheon surrounded by a laurel wreath, was used one surmounted by a helmet with crest and plumed mantling. The example shown (Plate XXII, 105) is taken from a plate of 1645 with the arms of Sir Bulstrode Whitelock (d. 1675) impaling those of his wife, Mary Wilson, whom he married in 1650. The helmeted escutcheon altered little during the seventeenth century, though towards its close the mantling tended to become more florid.

During the reign of Charles II the escutcheon remained squarish and had either a flat or a three-pointed top, but the form of accompanying ornament varied. Two palm-leaves, crossed and knotted beneath the shield, are found rather before 1660. A bill for plate bought in 1659 by Viscount Fauconbridge from the celebrated banker-goldsmith Edward Backwell contains

PLATE XXIII

HERALDIC ENGRAVING

109

1st Churchill, 2nd Wildyard alias Wid-
worthy, 3rd Tylle, 4th Winston, on
an escutcheon of pretence, Gould,
1702–14.
Victoria and Albert Museum.

110

Wood, cos. Kent and Sussex.
Hall-mark for 1733.
C. D. Rotch, Esq.

111

Martins impaling Atkyns.
Hall-mark for 1746.
G. C. Bower, Esq.

112

Stacye.
Hall-mark for 1753.
Victoria and Albert Museum

113

All Souls College (Chichele) and
Bowman accolé.
Hall-mark for 1782.
All Souls College, Oxford.

114

Roberts.
Hall-mark for 1795.
Merchant Taylors' Company.

PLATE XXIII

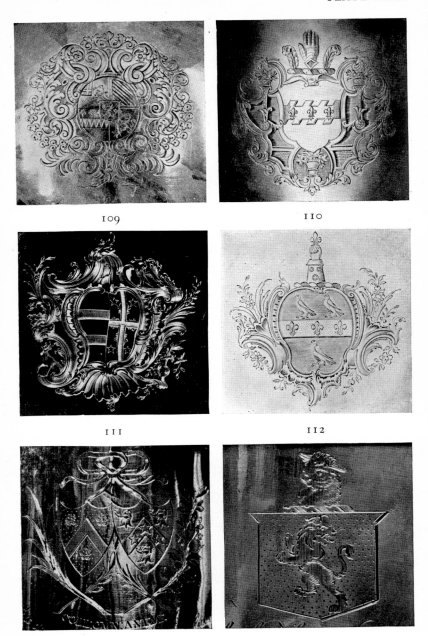

109

110

111

112

113

114

the item 'for graving 32 Armes wth Crownetts 2 palmes
18d a peece—£2 : 8 : 0'. The elaboration and con-
ventionalisation of the crossed palm-leaves proceeded
apace and by the early days of the Restoration they had
the characteristic 'feather ornament' so widely found on
plate throughout the reign of Charles II. The inaccurate
description of this ornament as 'feather mantling' is to
be discouraged. The varieties of this style of ornament
are numerous. The plumes range in even numbers up
to about fourteen, sometimes with all the ends of the
plumes leaning outwards and at others so arranged that
they fall alternately towards and away from the shield.
The former fashion is illustrated on a dinner plate of
1678 which bears the arms of Fountain impaling Rice
(Plate XXII, 106). The latter is shown on a coffee-pot
of 1681, with the arms of Richard Sterne (Plate XXII,
107) by whom it was presented to the East India Com-
pany. Between 1680 and 1700 the plumes become
more ragged in appearance and again more palm-like.
The example illustrated (Plate XXII, 108) is on a two-
handled cup of 1683, which has a certain historic
interest as it bears the arms of Thomas Pengelly, of
Cheshunt, impaling those of his wife Rachel Baines. In
the year that this piece was made its owners offered the
hospitality of their house to the ex-Lord Protector
Richard Cromwell, who continued to live with them
until their death.

At the end of the seventeenth century came the idea
of the embossed scrolled cartouches intended for a coat
of arms which we have noted on the two-handled cups
and monteiths. Though this lasted for only a short
time, it probably inspired the general change which
took place in the wholly engraved designs about this

time. The square-shaped shield gives way to a circular, oval or shaped cartouche which is surrounded by florid foliations and scroll-work, and latterly by swags of flowers, grotesque masks and palmettes. A typical early example of this style is afforded by the arms of General Charles Churchill (*d.* 1714) with those of his wife Mary Gould, on a pilgrim bottle (Plate XXIII, 109). The later works in this style, produced about 1730, are perhaps in their way finer examples of heraldic art than anything which had been produced since the Middle Ages. An illustration of the simpler work is provided by the arms and crest of Wood, cos. Kent and Sussex, on a tankard of the year 1733 (Plate XXIII, 110). It may be here remarked that during this period the use of designs comprising a helmeted escutcheon becomes much rarer (except on snuff-boxes where the shape seemed to demand it). The helmet when present usually seems to sink into the ornament which surrounds the cartouche.

The cult of irregularity and fantasy is very evident in the heraldic engraving of the Rococo period. The escutcheons left for engraving on the embossed work are usually formed of lop-sided scroll-work, as are also those engraved on the plainer pieces. Examples typical of the finer work are provided by two salvers. The first is by Paul Lamerie and is of the year 1746. It is engraved with the arms of Admiral William Martins impaling those of his wife Mary Atkyns (Plate XXIII, 111). The second is by William Preston and is of the year 1753 and bears the arms of Stacye (Plate XXIII, 112).

The heraldic escutcheons of the Adam period were drawn not from Trajan's Column but from Strawberry Hill—it is extraordinary that the eighteenth-century

Gothic revival should have left so little trace on English silver. The most typical shield of the period is a curved heater-shaped one with a three-pointed top. It is usually accompanied either by a light festooning or by two rather straggling palm-branches such as are shown in the example illustrated (Plate XXIII, 113) which shows the arms of All Souls College, Oxford, accolé with those of Richard Bowman, fellow, who gave a tankard to the college in 1662, which was remade according to the original shape in 1782. An alternative form of shield which appears at the close of the eighteenth century and which was destined to be very popular later on, is square with the straight sides splayed out at an angle just below the flat top. A cup of 1795, bearing the arms of Thomas Roberts by whom it was given to the Merchant Taylors' Company, provides an admirable example (Plate XXIII, 114).

Taken all round, the heraldic engraving of the close of the eighteenth century is disappointing. It has neither the spirited feeling of the Rococo, the well-ordered beauty of the Queen Anne or the simplicity of the seventeenth-century work. We somehow feel that the coats of arms on late eighteenth-century silver are purely a concession to the possessive instincts of the purchaser and that the designers of plate would gladly have seen the custom disappear. This was not to be and the engraving of arms continued unabated into the nineteenth century. The popular forms of Adam shields survived to be tilted against by the heraldic reformers of Victorian times. At the end of the first quarter of the century a very florid cartouche which seems in imminent danger of disintegration, came into vogue. The charges are shown with greater care than ever before, but though

the standard of craftsmanship was as high as ever, the artistic feeling was almost entirely gone.

The custom of engraving plate with the owner's initials is in all probability as old, if not older than that of engraving it with heraldic devices, and its prevalence can still be traced on a number of pieces of late medieval plate. The collector will find it well worth his while to study the various styles in which initials and monograms have been engraved at different times. It cannot be pretended that the general standard of workmanship was as high as that for heraldic engraving. The pounced initials in use from the late sixteenth to the early eighteenth century have a certain facile charm, but even this is wanting from the square letters with double-lined vertical strokes which prevailed from the latter part of the seventeenth century for nearly a hundred years and which are almost more accurately described as scratched than engraved. A certain improvement is visible in the flowery cursive of the Adam period. The partial supersession of the Adam lettering by black-letter fortunately does not come within our limits.

Whilst deploring the low standard prevalent for the engraving of initials during the earlier part of the eighteenth century, it must be remembered that the ornate interlaced monograms are not included in the condemnation. These are usually contained within cartouches similar to those used for the heraldic engraving and are artistically in no way inferior.

Though the limitations of the evidence obtainable from engraved decoration must be kept in mind, the difficulties to be overcome whilst pursuing the study of English plate are sufficiently real to make it foolish to ignore any possible source of help.

BIBLIOGRAPHY

of the principal books published on English domestic silver. Readers are reminded that much useful material has also been issued in periodicals or privately printed. The prices and publishers are given only in the case of works costing not more than 20s.

HISTORY

CASTRO, J. PAUL DE, *The Law and Practice of Hall-marking Gold and Silver Wares.* 1928.

Catalogue of a Loan Exhibition of Silver Plate belonging to the Colleges of the University of Oxford. 1928. (Oxford, Clarendon Press. 10s. 6d.)

CRIPPS, W. J., *Old English Plate.* 1878. (11th edn., 1926.)

DENT, H. C., *Wine, Spirit and Sauce Labels of the 18th and 19th Centuries.* 1933. (Norwich, H. W. Hunt. 10s. 6d.)

GASK, NORMAN, *Old Silver Spoons of England.* 1926.

HEAL, SIR AMBROSE, *The London Goldsmiths 1200–1800, a record of the names and addresses . . . shop-signs and trade-cards.* 1935.

JACKSON, SIR C. J., *An Illustrated History of English Plate.* 2 vols. 1911.

JONES, E. ALFRED, *Old English Gold Plate.* 1907. *Old Royal Plate in the Tower of London.* 1908. *Old English Plate of the Emperor of Russia.* 1909. *Old Plate of the Cambridge Colleges.* 1910. *The Gold and Silver of Windsor Castle.* 1911. *Old Silver of Europe and America.* 1928. (70 pages on English silver, 18s.). Also monographs on the plate of Eton College, 1938, Clare College, Cambridge, 1938, and of the following Oxford colleges: Merton, 1938, Queens, 1938, Christ Church, 1939, Magdalen, 1940, Oriel, 1944.

MOFFATT, H. C., *Old Oxford Plate.* 1906.

Victoria and Albert Museum:—*Catalogue of English Silversmiths'*
Work, Civil and Domestic. 1920. (Paper 4s., cloth 5s. 6d.) *Catalogue*
of an Exhibition of Works of Art belonging to the Livery Companies of
the City of London. 1927. (With 40 illustrations of plate. 10s. 6d.) *A*
Picture Book of English Silver Spoons. (20 photogravure illustrations.
6d.) *A Picture Book of English Domestic Silver, 14th-16th Century.* (20
photogravure illustrations. 6d.) *A Picture Book of English Domestic*
Silver, 17th Century. (20 photogravure illustrations. 6d.)

PHILLIPS, P. A. S., *Paul de Lamerie, His Life and Work.* 1935.

WATTS, W. W., *Old English Silver.* 1924.

FOR REPRODUCTIONS OF HALL-MARKS, ETC.

BRADBURY, FREDERICK, *Collectors' Guide to Marks of Origin on Silver*
Plate made in Great Britain and Ireland, 1544–1932. (3rd edn., 1933.
Northend, West Street, Sheffield. Paper 5s., morocco 10s. With
Sheffield Plate Makers' marks: paper 6s. 6d., morocco 12s. 6d.)

FOR MAKERS' MARKS ALSO

JACKSON, SIR C. J., *English Goldsmiths and their Marks.* (2nd edn.,
1921.)

INDEX

THE END